SEE / SAW

Also by Geoff Dyer

SEE/SAW

Looking at Photographs

Essays 2010–2020

GEOFF DYER

Graywolf Press

First published in Great Britain in 2021 by Canongate Books Ltd, Edinburgh.

Please see p. 317 for details of pieces previously published.
Please see p. 331 for permission credits.

This publication is made possible, in part, by the voters of Minnesota through a Minnesota State Arts Board Operating Support grant, thanks to a legislative appropriation from the arts and cultural heritage fund. Significant support has also been provided by Target Foundation, the McKnight Foundation, the Lannan Foundation, the Amazon Literary Partnership, and other generous contributions from foundations, corporations, and individuals. To these organizations and individuals we offer our heartfelt thanks.

Published by Graywolf Press
250 Third Avenue North, Suite 600
Minneapolis, Minnesota 55401

www.graywolfpress.org

Published in the United States of America

ISBN 978-1-64445-044-4

2 4 6 8 9 7 5 3 1
First Graywolf Printing, 2021

Library of Congress Control Number: 2020944207

Cover design: Kapo Ng

Cover photo: Chris Dorley-Brown, *Sandringham Road, Kingsland High Street, London, 10.42am-11.37am, 15 June 2009*

FOR REBECCA

'Reality as a thing seen by the mind . . .'

Wallace Stevens, 'An Ordinary Evening in New Haven'

CONTENTS

PART TWO
EXPOSURES

PART THREE
WRITERS

INTRODUCTION

'He loiters in the neighborhood of a problem.
After a while a solution strolls by.'

Harold Rosenberg, *Discovering the Present*

Writing about photography – looking at photographs in order to write about
them – has been an important and pleasurable sideline for the past couple
of decades. I say sideline, but there's not really been any main line, or at least
the main line is made up of a multitude of sidelines. Photography, though,
has continued to engage my critical enthusiasm to such a degree that it has
become my main sideline. I only became aware of this retrospectively as I
sorted through files for this book, surprised by the amount of stuff there was
to rummage through.

Naturally, I have no method. I just look, and think about what I'm looking
at, and then try to articulate what I've seen and thought – which encourages
me to see things I hadn't previously noticed, to have thoughts I hadn't had be-
fore the writing began.

No-method claims like this often mean being unconscious as to how the al-
leged lack can itself constitute a method, with its own traditions and ideological
underpinnings. I did English at university and my way of writing about pho-
tography might be an extension of the practical criticism I learned at school en
route to Oxford: reading a poem or a piece of prose and then examining the way
rhymes and word choices etc. work to create certain effects. Getting the hang
of this was probably the primary skill necessary for passing exams. (Harking
back to school and university in this way may seem a bit puerile, but writing,

for me, has always been part of an ongoing project of self-funding education.) I like doing a version of close reading – close looking – using pictures instead of texts. But whereas practical criticism plucked the text from its historical roots and shook off any clinging biographical dirt, a sense of tradition, of the culture and historical situation of poem and author, is crucial to an understanding not just of what a text is about but what it *is*. That has been one of the incentives to learn about photography, to attempt to see the history contained in any given increment of the tradition. The goal is best summed up by Rilke in one of his letters about Cézanne: to try to stand 'more *see*ingly in front of pictures'.[1]

'Sit' would be more accurate than 'stand', since although I look at photographs on the walls of galleries – and online – my preferred way of looking at them is in books, at home, with my feet up on the sofa, and I doubt this will change any time in the future. The writing that results from looking is not always or not *only* about the photographs. In the pieces on Fred Sigman and Thomas Ruff, for example, the pictures serve as pretexts or occasions for more general discussions of Las Vegas motels and pornography respectively.

Garry Winogrand was always insisting that a photograph has no narrative ability. In a single image, he said, it's impossible to tell whether a man is taking his hat off or putting it on. Stephen Shore, meanwhile, has spoken admiringly of the 'descriptive power' of a large-format camera. The combination of narrative inability and abundantly stalled description renders photography far more amenable or susceptible than music – in which great rhythmic propulsion can be generated with no descriptive support – to the inherent narrative potential of words. (Occasions when we can hear something as tangible as fate knocking at the door in a piece of music are rare indeed.) So photography, for me, might be as much an incentive – a series of incentive schemes – for descriptive narrative as it is an area of critical expertise.

Overall, photography might be easier to write about than music, but some photographs are, of course, harder to fathom than others. When writing about difficult pictures – or music or poetry – it's important not to forget, deny or

disguise one's initial (or enduring) confusion or perplexity. Criticism offers an opportunity not to explain away one's reactions but to articulate, record and preserve them in the hope that doing so might express a truth inherent in the work.

This book includes a lot – but by no means all – of the shorter things I've written about photography since the publication of the essay hampers *Working the Room* (UK, 2010) and *Otherwise Known as the Human Condition* (US, 2011). A regrettable omission is the piece I contributed to An-My Lê's *Events Ashore* (2014), but since this took the form of little notes to twenty-one photographs, it was not feasible to reproduce it here. Maybe in ten or fifteen years from now the contents of this book will be combined with some of the pieces on photography from those earlier collections of essays, including the still earlier *Anglo-English Attitudes* (1999) and stuff that I'll have written (strange tense) since this one in a kind of pre-senility, deathbed or – yikes! – posthumous edition.

Over the years I've written enough columns on various topics, in various papers, to be convinced of two things. First, a quarterly column comes around monthly, a monthly column weekly and a weekly column daily. Second, and partly as a result of that first point, I'm not a columnist. The quality of what I've written in columns has tended to decline precipitously from the first couple of instalments, after which I've succumbed to a quickening sense of dread as the deadlines hurtle towards me with terrifying frequency. The one exception was the 'Exposure' column for *The New Republic*, which involved picking a photo from the news and writing about it. I loved doing that from first to last, but in Part Two have included only ten from the two dozen or so pieces that I contributed. Another gig that worked out nicely was taking over the 'On Photography' column for the *New York Times* magazine when Teju Cole was away. This came close to the oxymoronic ideal of an *occasional* column.

The last piece of the final section – three pieces about writers on photography – is the introduction to a collection of John Berger's writing on photography, which doubles as a sort of after-intro to *this* collection. My love and admi-

ration for John and my gratitude for his inspiration and guidance are undying. I'm also grateful to the many photographers and curators who asked me to contribute essays to their catalogues or monographs. Writing introductions to books by writers or artists one loves is an intimate honour. If I'd known as a twenty-three-year-old that I'd one day end up between the covers of *Camera Lucida* with Roland Barthes I'd have been delirious with happiness – almost forty years later I still am.

The pieces in Part One have been arranged roughly chronologically according to the date of birth of the photographer. As a history of the medium the result is highly – even perversely – selective, but it extends the tradition sketched in *The Ongoing Moment* to the present day and fills in more of the gaps that were not covered by *Working the Room* and *Otherwise Known*. Some slight shuffling has been done to account for when the work under discussion was made: the precocious Alvin Langdon Coburn comes before August Sander even though he was born six years later. At the other end of this section, it makes obvious sense to close with Chloe Dewe Mathews rather than Mike Brodie. Further tinkering of this kind encourages narrative or thematic flow and bunches related artists together. So, like a trio of Ethiopian distance runners, the Düsseldorf maestros Thomas Struth (born 1954), Andreas Gursky (1955) and Thomas Ruff (1958) are not elbowed apart by Prabuddha Dasgupta (1956) or spiked by Pavel Maria Smejkal (1957), who can be seen here, appropriately sandwiched between Gary Knight (1964) and Chris Dorley-Brown (1958). A side effect is that the order of composition has become jumbled, as essays written within months of each other have ended up at opposite ends of the book, and vice versa. The date at the end of each piece refers to the year of original publication. Minor cuts and a few small restorations and additions have been made to some of the original texts.

G.D., California, December 2019

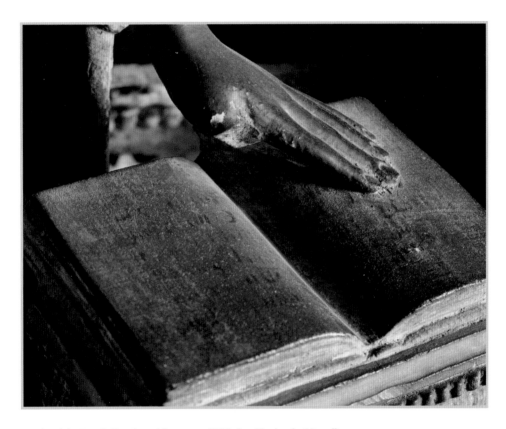

Book with Hand, Gardner Museum, 1998, by Abelardo Morell

Courtesy of Edwynn Houk Gallery

PART ONE

ENCOUNTERS

Eugène Atget's Paris

It is – or was – the photographer's ideal: to be highly regarded – literally, much looked at – yet almost anonymous. Very little is known about Atget the man. There are no daybooks or diaries. In books about his work the biographical facts rarely run to more than a couple of paragraphs. The same few stories are always cited, most notably his refusal to be credited for the picture used by Man Ray on the cover of *La Révolution surréaliste*. We have a photograph of him, taken by Berenice Abbott, but it doesn't prove – or enable us to deduce – anything except *this is what he looked like*.

Through his physical absence Atget becomes photography's practising patron saint. Apart from a few shots in which the photographer's blurred form and his camera equipment can be seen reflected in the windows of shops, he is all but invisible, existing solely in terms of what he saw and enabled others to see. It is legitimate to wonder about the extent to which Walker Evans's signature vision was derived from the prior example of Atget (especially since Evans, while acknowledging Atget's importance, denied that he was an influence). Atget himself was treading consciously in the footsteps of Charles Marville, but one does not feel that he was dependent on his predecessor for his style or way of seeing. In that sense Atget is a source, a beginning. We are drawn back to him in the way that those receding streets and alleys lead us deeper into his pictures. One of many instances of the way that Atget seems entirely embodied in his photographs – which were, Evans noted, 'the projection of Atget's person'[1] – this tendency of the pictures to be somehow about themselves, to be, in a non-derogatory sense, *self-regarding*, is part of their allure. (Those occasional glimpses of the reflected camera in shop windows are, in this respect, clues, evidence.)

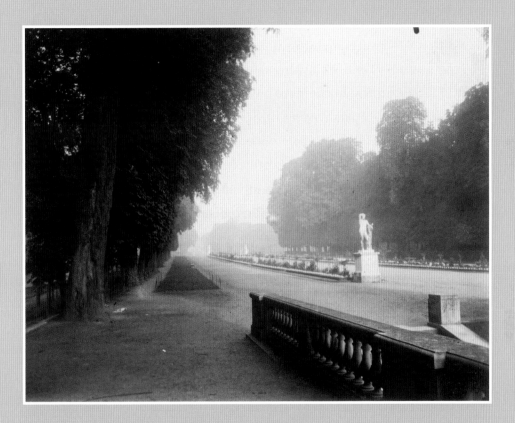

Saint-Cloud, 1924, by Eugène Atget

Working with 'a camera the size of a typewriter and a stack of glass-plate negatives', Atget, in the words of *New Yorker* writer Anthony Lane, 'bore the whole burden, more than forty pounds of it, around on his back'.[2] The typewriter comparison is apt: in his industriousness Atget resembles those nineteenth-century novelists banging out books the size of society at large. Apt, too, that after Atget's death a friend lamented the way we would no longer see 'that figure out of Balzac',[3] traipsing around Paris in his threadbare overcoat, hard at work.

Atget's capacity for work and his abundant output – he took and preserved about 10,000 pictures – do not make him a great photographer, but while poets can build immense reputations on the basis of slim plinths of work, the great photographers have tended to be prolific, have produced a *lot* of first-rate images. There's a congruity, in other words, between the medium's capacity for abundance and the photographer's urge to photograph heavily.

At the risk of sounding ungrateful, Atget's abundance permits us the luxury of being very choosy about which pictures we decide to concentrate on. We can discard all manner of images and still be left with a surfeit. I don't mind reading about nineteenth-century interiors in Balzac, Flaubert or Dickens but, even when photographed by Atget, can hardly bear to look at them. They're too oppressive, heavy with furnishing and knick-knacks, burdened with Victorian-ness. Joseph Brodsky was right: 'There's no life without furniture',[4] but it sometimes seems more deathlike than life-giving. One look at these interiors of Atget's and you feel claustrophobic, suffocated. This, of course, is a tribute to the pictures' quality, to the way they are stuffed, like cushions, with what they depict.

Ditto the clothes. Terrible to live – and die – in those rooms, and awful to have to wear the clothes, which look and feel like interior decoration with arms and legs attached, or, if you prefer, like a form of exterior decoration designed with the body in mind. Jackets and coats look like they weigh about the same as a sideboard; a sideboard you can clamber into and walk around in. One thinks of the character in Edith Wharton's *The House of Mirth* (1905), his 'clothes fitting him like upholstery'.[5]

There are not many people in Atget's pictures – John Szarkowski, former head of photography at the Museum of Modern Art (MoMA) in New York, reckoned that 'not two in one hundred of his pictures include people as significant players, and few of this two percent can be thought of as portraits'[6] – and I rarely find myself dwelling on the ones that feature people prominently. If the scale of Atget's project is reminiscent of Balzac's, then his is a *comédie humaine* largely devoid of humans. It seems appropriate: the photographer identified by his absence, producing pictures in which people are everywhere suggested by their absence. Or in which they are mere spectators, onlookers sharing our curiosity – 'Where'd everybody go?' – playing their part in the pictures' interrogative mode. Walter Benjamin reminds us that 'Atget's photographs have been likened to those of a crime scene';[7] the nature of that crime is unclear, but there are, occasionally, a few witnesses whose testimonies may or may not stand up to cross-examination.

So my personal edit of the Atget archive would mean no interiors, no furniture and, for the most part, few or no people. Now, obviously, there's no reason why anyone should care about my whims and preferences – unless they coincide with or are in some kind of alignment with (are even, conceivably, formed by) the essential gravitational pull of the pictures themselves. I like the outdoor photographs of empty streets and deserted parks – and these are the pictures in which Atget's Atgetness is most clearly manifest.

The long exposure times used by Marville drastically emptied the streets of moving things and people. Pedestrians passing slowly survive as smeared vestiges of themselves: blurred, incorporeal, insubstantial, ghostly. Working with faster exposure times, Atget did most of his photographing between March and October, often early in the morning, soon after the sun was up, when there were fewer people around. Even so, in some pictures there is the blurred residue of someone walking quickly past, as if it were still occasionally possible to catch traces of these ghostly beings on film. Hence Colin Westerbeck's conclusion in *Bystander*, his history of street photography, that 'Old Paris was for

Atget a necropolis, a city from the past inhabited by ghosts'.[8] For Benjamin this emptiness was Atget's defining quality: 'the city in these pictures looks cleared out, like a lodging that has not yet found a new tenant'.[9] Note the way that whereas Westerbeck is reminded of the people who are *no longer* there, Benjamin's image puts us in mind of people who are not *yet* there (which in turn raises the possibility that the crimes mentioned earlier are yet to be committed). Both share the idea of the pictures' being inhabited by people who are not there, by fugitive witnesses and the photographer's invisibly suggested representatives.

The corollary of the relative lack of foot traffic is that the streets and buildings – the things that *are* there – are granted a permanence that is palpable, utterly intransigent. Atget's walls are impregnable. Closed doors look like they can withstand the siege of centuries; open ones look like they will never shut. A mixed blessing, this: bread, in Atget's pictures, never looks fresh – but it looks like it will never go stale either.

Something similar can be said of Atget's photographs themselves. We tend to forget that for part of Atget's long career he was photographing at the same time as pioneering modernists such as Edward Weston and Paul Strand. So, strictly speaking, it was slightly misleading of me to talk about nineteenth-century novelists and Victorian interiors – some of Atget's best work was made after the publication of *The Waste Land* and *Ulysses*, and well after *Les Demoiselles d'Avignon* and the coming of futurism – but the pictures urge us and themselves back in time. Partly this is because the Paris photographed by Atget is old and pre-dates these cultural milestones. (To make the same point the opposite way: would Atget's pictures have pre-dated themselves in this way if he had photographed new – rather than *old* – Paris?) Partly it is because his work lacks the conspicuously experimental, manifesto-fuelled strategies that underwrote the modernist project (though this, conversely, is what gives much of his best work its quality of floating free of a specific period).

It is no accident that this discussion has drifted in the direction it has.

Something about Atget's pictures encourages one always to reflect on time and the permanent evidence of its passing. Anthony Lane found himself succumbing to precisely this temporal hypnosis. 'You are left with the extraordinary sensation that perspective is a matter not only of space but of time: in front of your eyes it is high noon, but day seems to be breaking at the end of every street.'[10] If the spatial and the temporal can stand for each other in this way then those characteristic elements of the Atget pictures mentioned earlier – streets or alleys winding their way into the depths of the picture – effectively reach back not only into the distance but into the past.

Remembering that observation of Benjamin's about Atget's street scenes resembling a lodging waiting for its future tenants, we notice that time, in certain of Atget's pictures, stretches in *both* directions – and, in spatial terms, well beyond the city of Paris. Consider the pictures he made of buildings and neighbourhoods in the process of being demolished. A good number of these were done in 1913–14, just prior to the outbreak of the First World War. A later picture (1924–5) of chairs outside a café is perhaps suggestive of the men who did not come back from the front, but these photographs of half-demolished buildings look forward to the general condition of many cities in Europe – especially Germany – in the aftermath of the Second World War. Roland Barthes said photographs were prophecies in reverse, but they can be straightforward prophecies too.

This matter of time prompts us to go back to the photographs again, to further refine our search and edit, to ask in which pictures this abiding interest in time, its passing and persistence, is most deeply imprinted. Which pictures – which subjects – tell us most about time?

There are two subject areas, I think. First, pictures involving water, the Seine, most obviously, where the river flows past or interacts either with man-made structures – bridges, buildings – or with the slower cyclical changes of the seasons as registered by trees. The key picture, in this regard, is of the man standing by the Pont-Neuf (1902–3), next to a marker measuring the height of

the river so that it becomes a record or gauge. If time is a river then this picture serves as a kind of chronometer – watch! – and calendar. (Barthes barely gives Atget the time of day in *Camera Lucida* – recalling that there are moments when he 'detest[s] photography', Barthes asks 'what have I to do with Atget's old tree trunks'? – which is strange, passing strange, given his delighted realisation that cameras were originally 'clocks for seeing'.)[11]

Lakes do not flow. Timeless and unchanging, they reflect the way that things change around them. To that extent they're like the still centre of the clock face. There's a feeling, in Atget's pictures of lakes and pools in Sceaux, Versailles and Saint-Cloud, of deep, non-human time – against which the bustle of peopled time pits itself in vain.

It is in photographs of statuary, however, that time imprints itself and Atget's genius reveals itself most lucidly. Marguerite Yourcenar, in her reflections on the composition of *Memoirs of Hadrian*, remarks on 'the motionless survival of statues' which are 'still living in a past time, a time that has died'.[12] She has in mind specifically the head of Antinous Mondragone, which has been removed from its original setting and time and placed in a museum – which is, effectively, a mausoleum. The statues photographed by Atget may be rooted in a past time but, because they remain at large in the world, that time lives on in them. They age, as we do – but far more slowly. It is said that in the Falkland Islands the fluctuating climate is such that one can experience four seasons in one day. That's pretty much what a year feels like from a statue's point of view anywhere in the world. And the years, inevitably, take their toll. Of certain statues in Florence, Mary McCarthy wrote: 'Battered by the weather, they have taken on some of the primordial character of the elements they endured'.[13] In the case of the Paris statues photographed by Atget that sentence needs to be recast in the present continuous: they *still* endure.

Atget is the godfather of the purely documentary style, the man who established what, for Szarkowski, was 'photography's central sense of purpose and aesthetic: the precise and lucid description of significant fact'.[14] That is

the magic of photography – the magic that enables Atget, in these pictures, to make statues sentient: to depict them *from their own point of view*, as if gazing into a mirror – mute witnesses to their own captivity.

Cartier-Bresson said that the world shown in a picture could be reconfigured 'by a simple shifting of our heads a thousandth of an inch'.[15] Unable to move their eyeballs even a fraction, statues are permitted no such freedom. With no conception of space, they exist solely in relation to time. Their consciousness is entirely and narrowly of time. Allowed into the slot of their consciousness, we retain a sense of the fleeting human time of the people who sit or pass nearby – *even if they are nowhere to be seen.*

Inevitably, there are a few photographs in which we see both statues and water, pictures in which we get both a multiplied idea of time *and* the sense that the image is self-conscious or, in the best possible way, *full of itself*. Lakes are mini-photographs, brimful of the scenes that surround and frame them. (They might even be considered reservoirs of 'the optical unconscious', revealed – according to Benjamin – by the invention of photography.)[16] Sometimes the exposure times flatten out the wind-rippled surface of the water and cause reflections of naturally permanent features – trees, hills – to blur as if they too are transitory. Surrounded by the leafless veins of winter trees at Sceaux, a statue contemplates a shrunken pool of image-water only a few feet away. It may be eternally beyond reach, but latent in the scene is the knowledge that in no time at all (a year's worth of seasons in a day, remember) the pool will fill up again and the trees return to full leaf like a picture that has not yet finished developing (and which will never be permanently fixed). Hovering over the landlocked equivalent of deep oceanic time, statues by the lake at Saint-Cloud are faced with dark forebodings of their own eventual dissolution, when they will exist only as we see them now, as photographs.

2011

Alvin Langdon Coburn's
London and *New York*

The original editions of *London* and *New York* were published in October 1909 and November 1910 respectively: 110 years ago at the time of writing or, looked at the other way, approximately eighty-three years after the first photograph was taken. So if time since the advent of photography is imagined as a kind of see-saw (not a bad synonym for photography) with 1909/10 as the fulcrum, then it would tilt only slightly our way. This is surprising and, in a sense, misleading. 1910 *seems* very early rather than just under midway through the history of photography to date. The number of photographers of comparable stature whose names come before Alvin Langdon Coburn's in a reasonably comprehensive survey of the medium is small compared with those who come after. Post-1910 the number of *photographs* taken becomes hard even to imagine. I am guessing that more photographs have been taken today – or in the last *hour*? – than were taken between the invention of photography and the original publication of *London*. Part of the idea of facsimile reissues – as opposed to looking at Coburn's work in a modern exhibition catalogue or monograph, buttressed by the latest research and sandwiched by scholarly essays – is to coax us back to an approximation of that time, that experience, of relative scarcity. But since Coburn was not entirely happy with one aspect of *his* experience, complaining that Hilaire Belloc's lengthy preface 'completely ignored my pictures',[1] this essay will try to make good that earlier lack by focusing closely on them.

Back in 1909–10 they represented the culmination of recent developments and trends in photography. Aesthetically they were in keeping with

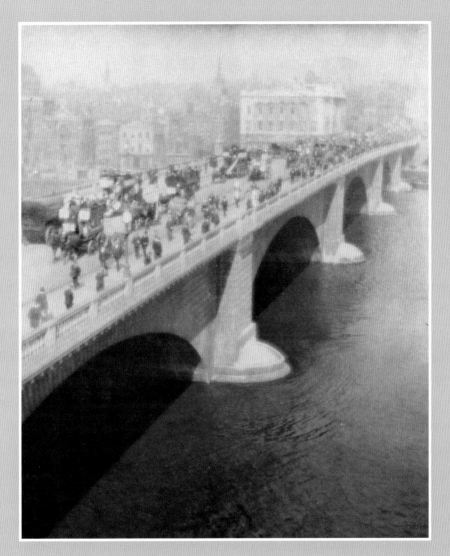

London Bridge, 1904, by Alvin Langdon Coburn

By kind permission of The Universal Order

the signature effects of the Photo-Secession and pictorialism, as energetically promoted by Alfred Stieglitz: slightly blurred, hazy, with an emphasis less on documentation than atmosphere and mood. This was the quality Coburn sought to emphasise, enthusiastically quoting the verdict of his friend and patron George Bernard Shaw (whom he had photographed in 1905 and 1906 and whose brief foreword to *London* was rejected by the publisher) that his intention was 'always to convey a mood and not to impart local information'.[2] That mood is as much the photographer's as it is inherent in the scene. The picture's atmosphere is not simply a matter of weather or air quality (itself a combination of meteorology and industry, of the natural and the man-made) but of the artist's vision. The trick was to impose his vision in such a way that it looked like it had not been imposed while leaving ample evidence – traces of artistic DNA – of how expertly it had been.* One way of doing this – of displaying an abundance of artistic sensibility and, in the process, consolidating photography's status as art rather than trade – was to make a photograph look like a painting, ideally, in Coburn's case, one by James McNeill Whistler. His photographic views of the Thames are daylight nocturnes. If the new way of depicting the city tried to look old – if it took on board some of the recent innovations (Impressionism) of the old medium (painting) – this all contributed to a sense of visualised memory, memories of previous visuals (Whistler's, most obviously). On the one hand the Thames carried a load of associations deeper and heavier than the railway had yet developed the capacity to bear; on the other, some of these associations were of more recent provenance than Turner's *Rain, Steam and Speed* (1844). The murky Thames of *Great Expectations* (1861) or *Our Mutual Friend* (1865) flows straight into Coburn's photographs of London. It does not, however, flow beyond or through them. Time's flow is stalled by the longish

* A note on that word 'trick': by 1913 Stieglitz had turned on Coburn, whose work he had actively supported: 'His little game is so transparent . . . at times, the continued littleness becomes actively irritating . . . there is no depth in his work. There is no real love, and therefore it can never have a lasting value. His work is like himself, subtly tricky.' (Quoted by Pamela Glasson Roberts in *Alvin Langdon Coburn*, Madrid: Fundación MAPFRE, 2014, p. 46.)

exposure times – ten minutes at midday if the weather was foggy – which flatten out the river's surface, stilling its treacherous currents so that it appears almost to have congealed. The water is framed by the photograph, but the dulled reflection of its surface presents mirror images of parts of that photograph. We are thereby sealed within what we are seeing, though with nothing approaching the idyllic clarity of Vermeer's *View of Delft*. Like the thickened water, light itself in Coburn is densely textured, as heavy – and often as dark – as earth.

This means, I think, that the photographs are full of past-ness while containing, for the most part, few traces of what might happen in the future – further downstream if one follows the long history of picturing the temporal in riverine terms. There are two exceptions, both of which have a prophetic quality. One is of London Bridge seen from above: from the top floor of a riverside warehouse, to be precise. The bridge runs diagonally from bottom left to top right and although everything below this is given over to the almost abstract mass of the brooding Thames, everything above – bridge, people, buildings – is in sunlight. It is by some measure the brightest picture in the book (though even this brightness has a slightly mushy quality). That alone, one might have thought, should be enough to shake off the gloom of the past, but the future it evokes could hardly be more mournful. The water retains some slowed suggestion of motion, but the real movement is all above it, on the bridge. It is the *crowd* that flows, as will be memorialised in one of the landmarks of modernism. Four years after the end of the immense cataclysm of the First World War, T.S. Eliot will write in *The Waste Land*, 'so many,/I had not thought death had undone so many.'

The other photograph, of St Paul's from the river, looks further ahead, to the Second World War. While the cathedral calmly resides over the Thames, the picture, to our eyes, is infused or overlain by the more recent memory – a *future* memory, as it were – of another photograph, taken by Herbert Mason on 29/30 December 1940, showing the great dome blazing symbolically and brightly amidst the roiling smoke and fires of the Blitz. As with Coburn,

it is both a documentary record – albeit one that benefited from extensive post-production enhancement – and an evocation of a mood (of defiance and eternal endurance). When the fires have been extinguished and the enemy vanquished, Mason's picture declares in suitably Churchillian tones, the scene will once again be almost indistinguishable from how it was when photographed by Coburn.

Before leaving *London* for *New York* it will be helpful to call briefly on an author whose fiction habitually dwelled on encounters – and the consequences of those encounters – between Europeans and Americans, between the old world and the new. Coburn met Henry James in 1905 in New York; in England in 1906 James sat for a portrait to be used as the frontispiece to an edition of his collected works. At some point their collaboration expanded to include a series of photographs intended not to illustrate the books – 'not to keep, or to pretend to keep, anything like dramatic step with their suggestive matter', as James expressed it in the preface to *The Golden Bowl* – but to attempt something subtler (and in a very Jamesian way), simultaneously vague and precise. The author's reservations were not specific to Coburn but concerned the risk of any photographs being used indexically, as documentary evidence against which the invented stuff of fiction might be checked. The pictures, James continues, should therefore be 'mere optical symbols or echoes, expressive of no particular thing in the text, but only of the type or idea of this or that thing.' As an example he mentions that nothing would serve so well 'as a view of the small shop in which the Bowl is first encountered.' This place 'was but a shop of the mind, of the author's projected world . . . not "taken from" a particular establishment anywhere, only an image distilled and intensified, as it were, from a drop of the essence of such establishments in general'. [3]

It was nowhere in particular, but through the magic of fiction, it achieved a kind of universal particularity. The task, then, was to find a particular in-

stance of somewhere that didn't exist – or to find a particular place that would mould itself to the claims of the imaginary. 'And we actually found it,'[4] Coburn recalled later (while following James's discretion by not revealing the site's location). Similarly, for the second volume of *The Golden Bowl,* James felt 'some generalized vision of Portland Place' was needed, and this too was discovered – created by being recognised. 'The thing was to induce the vision of Portland Place to generalize itself.'[5] All of this can profitably be borne in mind not only as we look at the photographs Coburn took in London but as we approach work made on the other side of the Atlantic, in New York.

The issues of time and its place in history that we considered in London become more subtly complex in New York: the first sight, for immigrants from Europe, of a new country, a new kind of city, new kinds of buildings. It was first glimpsed as a port, from the sea, in a way that ended with the coming of air travel. Stieglitz famously titled his 1910 view of New York Harbor *The City of Ambition*: an assessment of what he saw and an expressed projection of the ambitions he had nurtured for photography. Coburn was part of Stieglitz's circle of devotees, who strove to make this vision a reality. In 1912 he paid explicit homage to Stieglitz's influence in the form of a strikingly similar, closely cropped version of exactly the same scene. But the sight of New York Harbor had already brought home to him a wider 'kinship of the mind that could produce those magnificent Martian-like monsters, the suspension bridges, with that of the photographer of the new school . . . The work of both the bridge-builder and the photographer owes its existence to man's conquests over nature.'[6] Though heartfelt, this pro-constructivist – almost sci-fi – vision of the symbiotic creations of the engineer-photographer contains a number of ironies and contradictions. The pictorialists photographed New York in a way that made it appear as if through a gauze of memory; the newness of the city manifested itself through a kind of visual patina, a product of the ageing process. 'A tremulous, waning crepuscular light affects this pictorial vision of

the ultra-modern,[7] writes Max Kozloff in *New York: Capital of Photography*. Stieglitz, Steichen and Coburn photographed the newly completed Flatiron Building in 1903, 1904 and 1909 respectively. For Stieglitz it was 'a picture of the new America which was in the making,'[8] but for Coburn and especially Steichen this new dawn gives way almost instantly to a no less symbolic twilight – because the brief heyday of pictorialism is itself waning. (In fairness, as Kozloff concedes, if the artist-photographers 'had not yet found a visual language expressive of the technological moment', then 'neither had the skyscrapers', which were themselves often adorned with the flourishes of Gothic revivalism.) Coburn's repeated assertions of contemporaneity – that photography is 'more suited to the art requirements of this age of scientific achievement than any other', that 'photography born of this age of steel seems to have naturally adapted itself to the necessarily unusual requirements of an art that must live in skyscrapers'[9] – were urgent and determined. But in practice, as Kozloff explains, this meant translating or importing 'the indistinct visual seductions' that Coburn had discovered in London and superimposing a 'European sensibility upon his photography of New York'. It's a new manifestation of the merging of meteorology and temperament, of air quality and mood noted earlier. H.G. Wells picked up on this in his foreword, singling out the Fifth Avenue picture as the one he liked least on the grounds that it looked 'hazy, and I never saw New York hazy. It must have been a passing, unrepresentative mood.'

It was indeed passing. As soon as *New York* was published, Coburn went on to make photographs of the city that seem suddenly new in a way that only a few pictures in that album – the sheer and teeming might of the Stock Exchange, the bustling street outside the Knickerbocker Trust Company – aspire to. The first picture in the book, of the Metropolitan Tower, looks like it could have been taken in a slightly etiolated Renaissance city; by 1912 the Woolworth Building is like a rocket straining to blast off into space. While he gazed admiringly up at the Metropolitan Tower, both Trinity Church and

the Liberty Tower of 1912 – the latter also known as 'The House of a Thousand Windows' – reel vertiginously from above, as if seen from a future perch alongside Aleksandr Rodchenko. Looking back on the view he had recorded of Madison Square (better known as 'The Octopus'), Coburn recalled: 'At the time this picture was considered quite mad, and even today it is sometimes greeted with the question "What is it?" The answer is that it is a composition or exercise in filling in a rectangular space with curves and masses. Depending as it does more upon pattern than subject matter, this photograph was revolutionary in 1912.'[10] It certainly was, anticipating the 'abstract' work made by Paul Strand when, in the words of Maria Morris Hambourg, 'he cleared the fog from his photographs'[11] in 1915. And far from Coburn's blowing his own trumpet – something the artist who, as a twenty-three-year-old, had chosen the pseudonym 'The Hustler' had no fear of doing – this actually understates the picture's revolutionary qualities. It was first published in 1909, three years earlier than he had recalled. So the future is already there in Coburn's New York but not quite in *New York*. The unseen is taking shape in the seen, beckoning beyond it.

2019

August Sander's People

In 1962 Diane Arbus asked John Szarkowski, head of photography at MoMA, for August Sander's address, 'because there is something I would like to write to him about'.[1] Several things make this request remarkable. First, there's the fact that Sander (1876–1964) and Arbus (1923–1971) were alive, for so long, at the same time. Then there's the casual presumption of the proposal, as if an up-and-coming songwriter might casually ask for Bob Dylan's email. Finally, there is the *appropriateness* of Arbus's presumption. Sander's photographs played a crucial part in the development of Arbus's mature style, but her work, in turn, is a path that leads viewers back to his – whereupon a reversal takes place, because the Arbus influence on work made before she even held a camera seems unmistakable.

Szarkowski, of course, knew better. Put in mind of Sander by one of Arbus's pictures, he pulled out some photographs for her to look at. Not having seen Sander's pictures before, she was, according to Szarkowski, 'floored' by them. The epiphany is perfect except in one small detail: it's not quite true. In 1960 Arbus had dashed off a card to Marvin Israel: 'Someone told me it is spring, but everyone today looked remarkable just like out of August Sander pictures, so absolute and immutable down to the last button feather tassel or stripe. All odd and splendid as freaks and nobody able to see himself, all of us victims of the especial shape we come in.'[2] Note how Arbus, with the characteristic flash and style of genius, first fixes the Sander style ('absolute and immutable') before immediately changing that which is immutable into something subtly closer to her own peculiar ends ('splendid as freaks').

Arbus's insight was based on only a small sample of Sander's pictures; the

Writer and Journalist [Otto Brües], 1926, by August Sander

Gelatin silver print, 10³/₁₆ x 7³/₈in. (25.8 x 18.7cm). The Museum of Modern Art, New York. Acquired through the generosity of the family of August Sander. © 2019 Die Photographische Sammlung/SK Stiftung Kultur–August Sander Archiv, Cologne; ARS, New York, 2020

latest iteration of *People of the 20th Century* (2013) contains more than 600 of them. Having conceived the idea of a physiognomic portrait of Germany by 1925, Sander photographed hundreds of individuals and families to create 'a true psychological expression of our times and nation'.[3] He drew on work made as early as 1910 and spent the rest of his life either taking more pictures or reshuffling the results into an order destined never to be definitively fixed. In 1925 he expressed a desire to exhibit the work 'as soon as the project reaches some degree of completeness' – before instantly checking himself: 'if one can even speak of completeness'.[4] A selection of pictures was exhibited in 1927; sixty were published, two years later, in a book, *The Face of Time*. The people in *People* shifted around but the overall idea remained pretty stable: an initial portfolio of twelve Archetypes followed by seven Groups – 'The Farmer', 'The Skilled Tradesman', 'The Woman', 'Classes and Professions', 'The Artists', 'The City', 'The Last People' – comprising forty-five portfolios, some of which were subdivided so that 'The Nationalist Socialist', for example, is a subcategory of 'The Soldier' within the overall Group of 'Classes and Professions'.

Since the individuals depicted are types, it is natural to be reminded of *Middlemarch* and the Reverend Casaubon's efforts to find and write *The Key to All Mythologies*: the archetypal project doomed by the scale of its ambition. Sticking with photography, we have W. Eugene Smith, whose Pittsburgh Project of the mid-1950s saw him make 10,000 exposures of every aspect of the city before spending years failing to edit the mass of material into some kind of form. Smith eventually came face to face with his inability to do justice to 'the tremendous unity of [his] convictions'.[5]

Sander experienced his share of frustrations – his work was censored because, in Roland Barthes's words, the faces he photographed 'did not correspond to the Nazi archetype of the race';[6] his studio in Cologne was bombed by the Allies; 25,000 negatives were lost in a fire in a cellar in 1946 – but he seems to have stuck at his 'incredible task' with unfailing resolve. *People of the 20th Century* was not just the work of a lifetime, it was a work with a life of its own,

its shape shifting to take into account the changing times it sought to preserve. Sander was justifiably proud of the portfolios showing persecuted Jews and political prisoners (including his own son, Erich), which had played no part in his original plans. It is, in fact, Sander's inability to contain the project within his imposed grid that stops it being a monument to thwarted ambition, for the thinking behind it now seems pretty loopy: an objectively compassionate amalgam of ideas about types and physiognomies that was being turned, with an added racial bias, to darker purpose at exactly the time that Sander was working. (The final Group, 'The Last People', comprises 'Idiots, the Sick, the Insane' – among the first to fall victim to Nazi eugenicist policies.) When you consider the way that a picture of a 'Turkish Mousetrap Salesman' (!) is included in the 'Gypsies and Transients' subsection of 'Travelling People' (under the larger umbrella of 'Group VI: The City'), the pseudo-scientific taxonomy seems more akin to the caste system of Hinduism, with its handful of primary social divisions and thousands of subdivisions. And the rigour of the method, it should be stressed, was Sander's way of pressing his claim to *artistic* seriousness. In a way that is, depending on your frame of reference, either Hitchcockian or Borgesian (remember the encyclopedia of animals whose categories include animals 'that are included in this classification'[7]), a self-portrait of the project's creator is tucked among the section 'Types and Figures of the City'.

So although it is correct that the editors should scrupulously follow Sander's intentions in the way an orchestra aims to be faithful to the score of an unfinished – and unfinishable – symphony, what we are left with is an abundance of photographs that hold our interest in spite of the wonkiness of the immense structure designed to lock them in place. The most common type on offer, it turns out, is the sort whose individuality is revealed most nakedly.

The other irony, in so comprehensive a body of work, is the way that it has tended to boil down to about a dozen much-reprinted stalwarts: the doughty, bowl-faced baker; the student whose cheeks are proudly slashed by duelling scars; the Arbusian blind girls and midgets; the hod carrier with the weight

of *der Erde* on his shoulders; the attorney with his pointy dog (a favourite of Barthes's) and so forth. And then there's 'Three Farmers on Their Way to a Dance'. Used on the cover of both this volume and an earlier edition published by the Massachusetts Institute of Technology in 1986, and also the subject of a novel by Richard Powers and a brilliant essay by John Berger ('The Suit and the Photograph'), this image has become Sander's logo in the way that 'Migrant Mother' has come to stand for Dorothea Lange (if not the Great Depression as a whole).

What of the rest? The first thing to emphasise is that there's so much more to them than faces and bodies. Sander attempted, as Rebecca West said of a compendious effort of her own, 'to take an inventory of a country down to its last vest-button'.[8] These vest-buttons – along with cufflinks, ties and boots, together with the buttons, feathers, tassels, and stripes mentioned by Arbus – offer such an abundance of information that Berger, in his essay, concentrates not on the men but their clothes. For casting directors, wardrobe or set designers on any film set in Germany between the wars, the Sander archive is the first stop – possibly the only one. This is not simply a matter of period detail: Sander gives us the very texture of the times, the psychological cloth from which the Weimar Republic was cut.

What's surprising is that it's not only the clothes and hair – which change most noticeably over time – that seem solidified in the past; the faces, too, are stuck like fossils in the geology of time. People just don't look like this any more. Look at the portraits Edward Weston made of Charis Wilson in the 1930s: you could fall in love with her today. Going further back in time, a woman I knew at university in the 1970s was shocked to discover that Julia Margaret Cameron had prophetically taken her likeness in 1866. There are, by contrast, only a couple of women in the Sander vaults who look like they could walk around in today's shoes. The men are identifiably the same species, but the bulk of them look as extinct as mammoths: a negative testament to how thoroughly Sander succeeded in capturing the face of *his* time. Gener-

ally speaking, it's only the members of the nomadic and racially mixed circus world – particularly the black guy sitting comfortably in his muscled skin and singlet – who could pass as contemporary. In the portfolio of 'Artists' almost none could manage this (the avant-gardists have ended up defiantly behind the times) except, interestingly, Sander himself, who returns the viewer's gaze as if from across a table, free of the deadlock of old time. In almost every other instance, since the people stubbornly refuse to advance towards us, we have to go back in time to them.

Take, for example, the 1926 portrait of Otto Brües. As is the case with everyone else featured in the portfolio of 'Writers', Brües's work and name are almost entirely lost to us today. All that I know of him is that he looked like this – and he doesn't look terribly happy. What might be the source of this unhappiness? Yes, the round glint of the glasses and wedding ring are both touched by light, but clearly there is something *weightier* going on here. The weight of . . .? Not despair – that would be far too melodramatic – but the weight of time and vocation. There are no books in the background (of any of Sander's portraits of writers) and he's not sitting at his desk. Why not? Because he doesn't need one. His trouser legs are almost like a soft desk behind which he is sitting, and on which his hand is resting. 'I am become a name,' moans Tennyson's Ulysses; Sander's Brües, whose name means nothing to me, has become *his desk*. In *The Information* by Martin Amis, little-known novelist Richard Tull reflects on his life: 'Richard was sitting at his desk. His life was desks. Life had changed. But life was still desks. Always desks, there in front of him. First school, and twenty years of that. And then jobs, and twenty years of that. And always, in the early mornings and the late evenings, more desks. Homework: forty years of that.'[9]

That's the life of the writer – a life of *homework*. As we continue to look at the picture it seems almost as if the dark mass of legs might be more than a desk. They could be almost a plinth, the kind on which statues are supported, or memorials . . . to the unknown soldier, for example. Maybe that is what we have here: a photographic memorial to the unknown writer. And perhaps we

could push this further and suggest that the legs are like layers of geological strata, compacted and weighty evidence of the swampy ooze from which intelligent life emerged over the course of millions and millions of years – a lengthy exposure time by any standards. So here we see the deep genealogy of literacy and eventual literariness. But to what end if, in this case, both the work and its author have been all but forgotten? Variants of this question are simultaneously *posed* and documented by Sander in many of his pictures, taken at the moment when the identifiable evidence of the social gives way to the infinite recesses of the existential, the blank mysteries of the ontological. It's the question put, unanswerably, by Emily Dickinson: 'I'm nobody – who are you?'[10]

Given the all-consuming psychological pull of the pictures, their immense and draining gravity, it's no surprise that the experience of looking at page after page of faces becomes so oppressive, so exhausting. It's a relief, frankly, to come to 'The City' and discover the odd street scene. Further afield, in a monograph published by Taschen, one can take in Sander's landscapes, trees and views of Cologne, both pre- and post-bombing. A photograph of the bombed-out remains of his studio serves as a ruined emblem of how badly one craves escape from the density of faces and clothes – of people.

The same urge is subtly satisfied by Michael Somoroff's profoundly beautiful *Absence of Subject* (Buchhandlung Walther König, 2011). Somoroff takes some of Sander's best-known pictures and digitally removes the people from them. Time, at last, has loosened its grip, let them go. But they have, as it were, soaked into their surroundings, so that their absence has become entirely present. Where there was once a baker, a pianist or a family of nine, now, serene and invisibly haunted, there is just a silent kitchen, a vacant room, an empty chair and grass.

Ilse Bing's Garbo

Whereas captions usually explain what we are seeing in a photograph, in this instance the photograph articulates the experience of looking at it. As with any palimpsest (strictly speaking, a photograph of a palimpsest), it's not that an ultimate meaning lies hidden beneath various layers; its mysterious truth *is* the combination of erosion and accumulation achieved by these layers. So although we'll examine some of the photograph's qualities sequentially, it's important to bear in mind that, in the picture, they are revealed – and concealed – simultaneously.

A photograph about photography, it was taken by Ilse Bing in 1932, which seems – and looks – like a long time ago. It *is* a long time ago; perhaps that's why it makes us think of the still older Paris of Atget's photographs, parts of which had disappeared by the time this picture was taken. The self-captioning poster also recalls Walker Evans who, while acknowledging Atget's importance, denied that he was an influence. Bing would seem to have had Evans in mind, but this image pre-dates his famous shot of a billboard for Carole Lombard in *Love Before Breakfast* on a street in Atlanta by four years. Again, a palimpsest is not like geology, where one form overlies another chronologically. Its entire history is ever-present at any given moment – which is not to say (as Evans understood) that it does not contain a great deal of time.

As well as enabling us to look back in time (to a star's heyday) this one looks ahead – to a time when the face of Garbo would come in inverted commas, in the form of an essay of that name by Roland Barthes. The key thing about Garbo's face, according to Barthes, was that its 'essence was not to be degraded'. That essence 'became gradually obscured, progressively veiled with

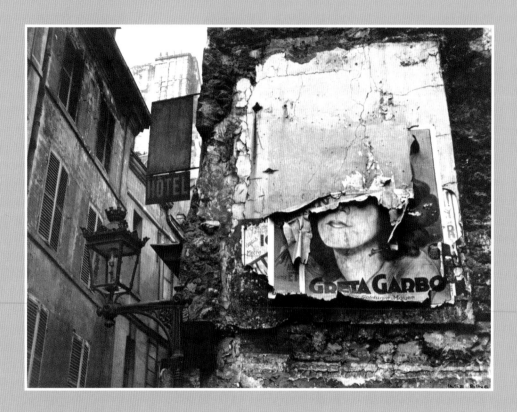

Greta Garbo Poster, Paris, 1932, by Ilse Bing

dark glasses, broad hats and exiles: but it never deteriorated'.[1] What we see here is an advertisement for that eternal essence in a state of advanced deterioration which, thanks to this photograph, will undergo no further deterioration. The poster, on the other hand, will continue to deteriorate, fading into the wall as a forgotten body will stain the floor of a room in which it lies. It's possible that both wall and poster deteriorated to the point where they disappeared completely, ceased to exist.

The same, of course, can never be said of Garbo. In *The New Biographical Dictionary of Film* David Thomson considers various arguments about her life and career before deciding that 'sooner or later such trivia will evaporate and a mysterious truth will be left – she was photographed.'[2]

2016

Helen Levitt's Streets

Will anyone ever capture childhood as Helen Levitt did? Or has that phase and possibility of social and photographic history passed as surely as our own childhoods?

Levitt was a true original – partly because she was so clearly indebted to Henri Cartier-Bresson. Without his example she might not have become alert to the subtle poetry of the street: the visual tangles, echoes and rhymes, the fleeting geometries of everyday life that he discovered lurking everywhere in the world. Prior to Cartier-Bresson no one had quite noticed this latent overflowing of life. Once he had it became obvious that there was more than enough to go round. (How extraordinary to think that the visible had been lurking unseen for so long!) So Levitt strolled around, casually attempting, in James Agee's formulation, 'to perceive the aesthetic reality within the actual world'.[1]

Levitt was also the beneficiary of a now almost vanished world when parents permitted their kids to roam the streets without fear of lurking paedophiles or speeding traffic, before they became a cosseted subspecies requiring their own sanctuaries. As a result of this change a greater part of children's lives has now become privatised and domesticated. Left to their own devices, kids play more and more interactive, screen-based games rather than games that are exercises in communal ingenuity or ludic choreography. The kids in Levitt's pictures are having a lot of fun – even if that fun involves someone getting hurt – in streets that are as much playgrounds and theatres as thoroughfares.

So there was all this abundant life being played out before Levitt's eyes. But it's not just that she made a documentary record of kids at play. She also managed

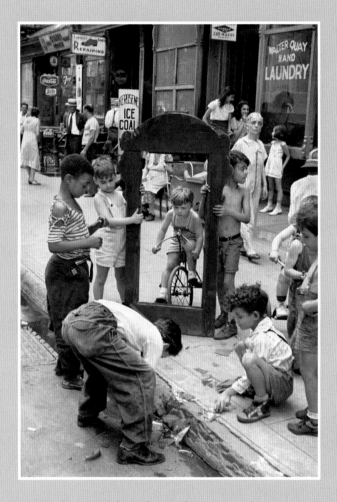

New York, c. 1940, by Helen Levitt

to capture the experience of childhood, of what it is like to *be* a city kid, when the real melts away so easily into the pretend or imaginary. This comes, of course, with its own dangers. Fighting high up on a ledge above a street door is incredibly precarious. But while seeing what to adults is a clear and present danger, we also participate in the kids' combative obliviousness to it. This is one way in which the easy pleasure of observing such scenes is complicated or exacerbated by inevitable tensions. While the pictures have an idyllic quality – not least because of the racial intermingling – there is no trace of sentimentality. Nothing is airbrushed out and no one would ever think of Levitt's pictures or the kids in them as 'cute'. We are conscious, always, of the determining poverty, the rough-and-tumble, hardscrabble quality of life. Adults and parents in the pictures serve like a participating chorus, never allowing us to forget this. (Bitching about yuppies or creeping gentrification was an inconceivable luxury back then!) Also, although it seems to these kids that they have all the time in the world – remember how, as a child, afternoons were prairie-vast? – the watching adults (us included) know how fleeting that eternity will turn out to be.

Of all Levitt's marvellous pictures, the one of the kids, the bike and the mirror is by far the busiest and most complex. I refer to it like that because there's a nice rhythmic similarity to *The Lion, the Witch and the Wardrobe*, the first of the Narnia novels by C.S. Lewis, in which children pass into another world through a wardrobe. In this image that other world (of childhood) is glimpsed *through* a mirror, which offers not a reflection but a clear and direct view so that it – like the larger body of work of which it's a part – serves as a kind of portal or conduit. There is nothing separating us from the world of these kids. Or, to put it another way, the two boys holding the frame are staging their own real-life photo featuring the kid on the bike in the hope that no one will notice that they have broken the mirror. I mentioned earlier the danger in Levitt's scenes; here it takes the form of shards of glass, the broken fragments of the mirror itself: a threat both to the bike's tyres and to the hands of the kids

picking them up (like responsible adults). The mirror may be broken, in other words, but its loss is being made good. Not least by Levitt, who has arranged things – i.e. positioned herself and her camera – in such a way that the kid and his bike are tacitly reflected by another bike off to the right.

Within the larger frame of the photograph a universal childhood is revealed to us in all its incidental or fragmented particulars. The adult world, meanwhile, goes on all around, with its talking, strolling, lounging, sitting – and looking. It occurs to me as I look – and what a rewarding way of passing one's time it is, just looking at Levitt's pictures – that there are few photographs in which so many different *consciousnesses* are present. (Why – and I ask this genuinely, because I don't know the answer – do we not get a comparable sense even in Garry Winogrand's busy streets?) The photograph becomes some sort of demonstration of a philosophical claim that the world is the sum total of all the separate but interlinked consciousnesses within it.

I began by asking if someone would ever depict childhood again in this way. For all the reasons outlined above, this seems unlikely. But there is an additional reason why it would be not just unlikely but impossible. There is perhaps a loose fit between the childhood that Levitt depicted and the stage in the development of photographic history when many of her best-known pictures of kids were taken. It would be an exaggeration to say that the medium was in its infancy, but it had not attained the saturated maturity of the present. (This becomes even more striking if you look at Levitt's colour pictures, many of them taken before colour properly came of artistic age.) There is a confidence in her work, obviously, but it is not a confidence that has been thoroughly institutionalised. These pictures are absolutely not postmodern or conceptual, are not preoccupied with what is 'real' or with interrogating the medium and so forth. The number of things Levitt does *not* have to wrestle with frees her to concentrate absolutely on what is unfolding – and refolding in the endless origami of gesture – before her eyes. Perhaps photography now considers itself too grown-up, takes itself too seriously (with the predictably

paradoxical result that it can seem quite puerile) and is too conscious of its history to achieve such freshness again. Pictures taken today of kids playing in the streets would necessarily remind us of Levitt's. They would evoke not only memories of childhood, but memories of the way that Levitt depicted the same thing. They would be allusive commentaries on – and tributes to – her.

2015

Vivian Maier

It occasionally happens that a writer who was unable to find a publisher is discovered, after his or her death, to have written a masterpiece. John Kennedy Toole's *A Confederacy of Dunces* is an example of this – and of the way that the term 'masterpiece' gets applied almost as compensation for the regrettable delay. In the world of photography numerous different prints can be made from a similar negative. Photographers can amass a body of work and then disappear from sight. Sometimes they enjoyed a degree of fame and celebrity (E.O. Hoppé, Ida Kar) before succumbing to an obscurity that is only lifted posthumously. Sometimes they were appreciated in photography circles (William Gedney) and then faded even from the view of their peers. Occasionally the work is discovered in time for the photographer to enjoy belated recognition in his own lifetime. If Jacques-Henri Lartigue was the great example of this, then Miroslav Tichý was an instance of the weirder syndrome whereby discovery came so belatedly that acclaim felt posthumous even while he was alive. Then there is someone like E.J. Bellocq, about whose work and life almost nothing was known until after his death.

Vivian Maier represents an extreme instance of posthumous discovery, of someone who exists entirely in terms of what she saw. Not only was she unknown to the photographic world, hardly anyone seemed to know that she even took photographs. While this seems unfortunate, perhaps even cruel – a symptom or side effect of the fact that she never married or had children, and apparently had no close friends – it also says something about the unknowable potential of all human beings. As Wisława Szymborska writes of Homer in her poem 'Census': 'No one knows what he does in his spare time.'[1]

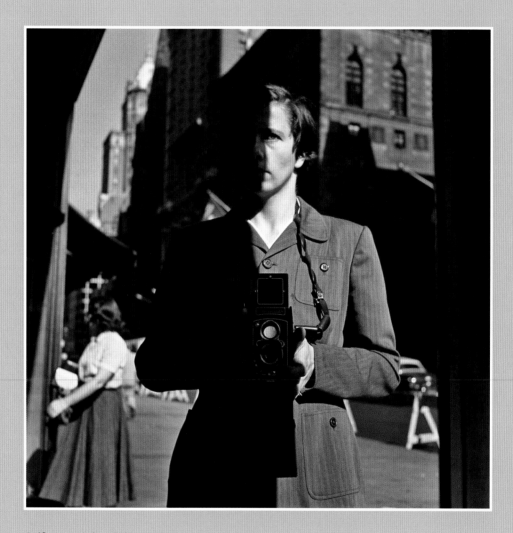

Self-portrait by Vivian Maier

From *Vivian Maier: Street Photographer*, edited by John Maloof, by kind permission of powerHouse books

This alerts us to a remote possibility, or rather to two versions of a similar possibility. First, that one of the people photographed on the street by Maier might also have been a closet photographer who pursued the same hobby with a shared obsessiveness. Second, that if we searched long and hard we might find Maier in images taken on the street by one of the famous photographers whose work her own occasionally resembles.

The numerous glimpses in her work of scenes reminiscent of Lisette Model, Helen Levitt (in both black and white and colour), Diane Arbus, André Kertész, Walker Evans and others raises questions about the extent of Maier's knowledge of these photographers and of the larger history of the medium. Did she take certain pictures because, consciously or not, they resembled work she had seen in exhibitions or magazines, or is it just coincidental? Perhaps this point, too, can be usefully reversed: do we respond to these pictures so readily because we know the work of Model *et al.* and see their ghosts in Maier's work?

Either way, it is important to retain a sense of critical perspective. After the inevitable shout from the rooftops to attract the attention a discovery like this deserves,* it is not necessary to exaggerate the value of the work in order to bestow on it the quality of a miracle. Maier is an important addition to the canon of street photography; some of her images are outstanding. But even leaving aside the question of quality – and the quantity of quality – the discovery-lag means that Maier's work has not played its part in shaping how we see the world in the way that Arbus's has (even if she seems occasionally to have chanced on Arbusian subjects *before* Arbus). It necessarily has the quality of visual echo, a series of echoes that serve the useful purpose of questioning the ways in which photographic identity and style – more closely bound up with content than any other medium – are established and defined.

One aspect of Maier's content exists in particularly telling relation to her

* It needs emphasising that this piece was written as the preface to the very first book of Maier's photographs, before the huge interest in her life and work that followed. (G.D., August 2019)

style and situation. Many of her pictures of women show them squeezed historically – their clothes are the expression of this – between the narrowly confining roles of the 1950s and the often frustrated freedoms of the 1960s and beyond. Maier earned her living in the same way as that quintessential figure of Victorian fiction, the nanny (or governess), an outsider whose privileged access to domestic life permits the development of no gift other than observation. In Maier's case it is as if a sensibility exquisitely adapted to, and the robust product of, these long-prescribed circumstances – of which *her* clothes, the habitual floppy hat and coat, are the perfect expression – has been set free to discreetly prowl the streets of Chicago and New York. There is, inevitably, a poignancy about the way Maier was drawn to old ladies who serve as prophetic representations of her own destiny: solitary, kooky-looking, wrapped up in overcoats, harbouring some lifelong secret intuited by the camera's gift of momentary scrutiny.

2011

The Boy in a Photograph by Eli Weinberg

Attempts to stage photographs – to create fictions – rarely work as powerfully as the kind of quotations from reality that we get in documentary photographs. Larry Sultan said he 'always thought of a great photograph as if some creature walked into my room; it's like, how did you get here? . . . The more you try to control the world, the less magic you get.'[1] Garry Winogrand had no objection to staging things; it was just that he could never come up with anything as interesting as what was out there in the streets. But when does the staging start?

I first saw this photograph of a crowd of protesters at the Museum Africa in Johannesburg, part of the massive photography exhibition *The Rise and Fall of Apartheid*, in 2014. Lines of black people, three or four deep. In the foreground, to the left of the frame, a man whose armband marks him out as some kind of steward, his old and very worn jacket sagging from his shoulders. Women are in the front, holding placards reading 'WE STAND BY OUR LEADERS'. There's a range of ages, the youngest looking like they might be in their late teens. So almost all of them would now be either dead or in their late seventies.

The picture was taken in 1956 after 156 members of the Congress Alliance were charged with treason. Later the number would be reduced to ninety-one, then to thirty. Eventually, in 1961, all were acquitted. At the time the photo was taken, all of that, including the imprisonment of Nelson Mandela following the Rivonia Trial of 1963–4, was still to come. Which is perhaps another quality of great photographs: the way these essential records of the past often seem imbued with the future.

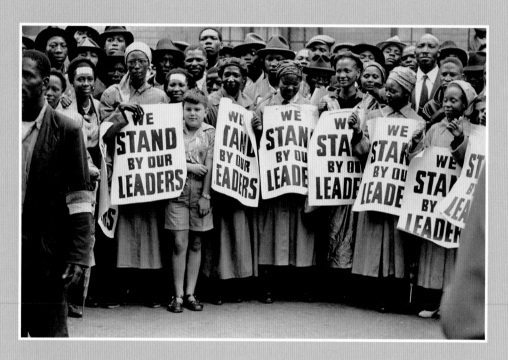

Crowd near Drill Hall on the first day of the Treason Trial, Johannesburg, 19 December 1956, by Eli Weinberg

Courtesy of UWC-Robben Island Museum Mayibuye Archives

The demonstrators fill the frame so that – in a way familiar to any film-maker who has to do crowd scenes with a limited number of extras – the feeling is unanimous, the solidarity absolute. Beyond the frame of the picture lies the apparatus of the apartheid state with its immense resources of physical intimidation, bureaucratic control and psychological coercion: the police and soldiers making sure that the opposition stand in – and know – their place. (In a picture taken the following day you can see Peter Magubane – best known for his photographs of the Soweto Uprising of 1976 – being arrested, his face pushed up against the wall.) Filling the frame with the demonstrators like this would seem to be the extent of the aesthetic choice made by the photographer. Aside from that, it's strictly of documentary or photojournalistic value.

Except, of course, there's one crucial component that I haven't mentioned. Squeezed in at the front, visible in a gap between the placards, is a solitary boy with a pudding-bowl haircut. I'm guessing he's about thirteen. His right arm is reaching across and touching his left – a gesture that people sometimes make when they are nervous. He's wearing shorts, sandals and a short-sleeved patterned shirt. He's smiling slightly – and he's white. He is there, that is the fact of the matter – his watch might even enable us to tell the time he was there, the exact moment the picture was taken. We look at the photograph and the question on our lips articulates its mystery and magic. Or, to put it the other way around, the photograph remains stubbornly silent in response to the question it insists on our asking: what is he doing there? How, to go back to Sultan's phrase, did this creature walk into the room?

Several explanations suggest themselves: he could be the son of sympathetic white liberals. He could have been brought along by a domestic worker or nanny who was also a demonstrator – running the risk, surely, of offending her employer unless that employer was of not just liberal but revolutionary commitment (so that the boy becomes the symbolic expression of the transracial nature of opposition to apartheid). Neither exhibition caption – 'Crowd near Drill Hall on the first day of the Treason Trial, Johannesburg December

19, 1956' – nor catalogue offered any clue about how the boy had ended up here, welcomed into the front row of history like this.

The photographer was Eli Weinberg. He was born in Latvia in 1908, and arrived in Cape Town in 1929 where he joined the Communist Party and was active in the trade union movement. He was arrested, detained, and lived under a succession of banning orders. He died in Dar es Salaam, Tanzania, in 1981. A life, then, of repeated displacement and exile, illuminated by the long-dreamed-of homeland of justice.

Hoping to find out more about the boy in the picture, I contacted the co-curator of the exhibition, Rory Bester. He was, he said, '90 per cent sure it's the photographer's son. [Mark] often accompanied him while he was working (presumably after school or in the holidays), both when he was a trade unionist and when he was a photographer.' A 2014 investigation on a South African news website, in which friends of the Weinberg family and fellow activists who were present on that day were asked if they could identify the boy in the picture, casts doubts on this score – some were certain it was Mark; some didn't recognise him. When I checked back with Bester he said that 'No more information has come to light about E.W.'s son, except that nobody has contradicted the "belief" that it is indeed his son.'

So, assuming Mark was there with his dad, why not put him to work and include him in the picture? In a sense, then, Weinberg could be said to have staged the picture, to have worked on its magic. But the protest was itself staged, with placards printed in advance; it was not a spontaneous gathering. In an entirely benign way the presence of the boy silently disrupts the racial opposition of the protest and subtly demonstrates a crack in the implacable armour of apartheid. The chubby innocent might grow into the narrator of J.M. Coetzee's *Waiting for the Barbarians*, who declares that 'if there is ever anyone in some remote future interested to know the way we lived, that in this farthest outpost of the Empire of light there existed one man who in his heart was not a barbarian.'[2]

Of all the people in the picture, the boy is the one who, by virtue of his

youth, is most likely still to be around to answer the questions raised by his presence, sixty years on, in our remote-ish future. We want to hear his version of what happened. According to Bester, several people in photographs in the show came by to identify themselves and to be re-photographed in front of the old pictures. This has been done in other situations, by other people photographed in the midst of historical events. It's often illuminating, partly because of the way people's memories are contradicted, reinforced or even *created* by the existence of a photograph.

Consider, for example, a picture that is in some ways the mirror image of this one, taken less than a year later, by Will Counts in Little Rock, Arkansas. Instead of a solitary white boy surrounded by crowds of peaceful, welcoming black people, there is a solitary black girl surrounded by a baying mob of whites. The black girl is Elizabeth Eckford, one of nine African American students who were supposed to be entering the school together as the start of desegregation. At the last moment plans changed and she found herself walking alone, being abused by the crowd. One snarling white face – that of fifteen-year-old Hazel Bryan – became the symbol of intransigent racial bigotry. Some people can spend their lives living up to an ideal. Hazel came to feel that in some ways she had spent her life living *down* the incident caught on film that day.

Bryan herself, though, was not so intransigent. In 1963 she looked up Eckford's number in the phone book and rang to apologise. The conversation was brief, Elizabeth accepted her apology and got on with her life. In 1997, on the fortieth anniversary of the desegregation of the school, the women met in person – at the suggestion of Counts, who photographed them again, this time as symbols of racial healing and togetherness. They became friends, spoke in public about the need for harmony and – the apotheosis! – appeared on *Oprah* together. A wonderful ending and an advertisement for the long-deferred, much-broken promise of racial equality.

Except it wasn't the end. There were lingering resentments, doubts on Eckford's side about Bryan's motives. So their relationship ended as it had begun,

with estrangement. And, in a way, Counts's original picture refuses the possibility of redemption. If it contains a suggestion of the future, it is in the way that the future will insist on remembering them. The people in the picture are stuck in the amber of history: a history the photograph played its part in creating.

Let's go back in history to that day in December 1956 in Johannesburg, to other photographs of the same scene. One of them, taken by an unidentified photographer from a different angle, shows a musician conducting the crowd in songs and hymns. In the background, slightly blurry, we recognise many of the same faces from the previous picture, including the ladies on either side of the boy. Frustratingly, the conductor's raised arm is exactly where the boy's face would be, but if we look down there is no sign of his bare legs and sandals. Which makes me realise something that hadn't quite registered about the earlier photograph: he's dressed for completely different weather from almost everyone else. The people around him are dressed as if for a rainy, cold day and a long stay. In the second picture they are still standing by their leaders, but he is nowhere to be seen. He has disappeared from history.

I kept wondering how he came to regard this picture later in life. Presumably it was a source of pride and happiness in the same way that the image from Little Rock became, for Hazel, a source of shame: a memory of solidarity and a lovely souvenir of a day out with his dad. This was all just speculation, rendered pointless by the two things I did find out about Mark. First, that he had died in 1965 at the age of twenty-four – so his dad was the one left to look back with love and pride at the vision of belonging he had witnessed and created. Second, that as a result of a car accident Mark had been deaf since he was a young child. So there is isolation in the midst of solidarity. These facts change nothing about the photograph but they add to its mystery. A picture of history – a moment in history – and of fate, it is documentary evidence of the unknowable.

2016

Roy DeCarava: John Coltrane, Ben Webster and Elvin Jones

It's quite easy to tell the story of how certain photographs were taken, to link what's going on within the frame to the situation or circumstances around it. In other instances photographs *imply* a narrative that can be expanded and expounded upon. Here all we have are two faces in tight close-up, so slurred and dimly lit that the picture barely succeeds in the most basic task of photographic portraiture: to enable us to identify who we are looking at. Would you be able to see that this is John Coltrane and Ben Webster without being told? Given the uncertainty, it makes sense to begin by mentioning what the photograph is not.

It is unlikely ever to be used to decorate the walls of jazzy bars in the way that Herman Leonard's seductively smoky photographs regularly did in the 1990s. Often posed, Leonard's pictures are always perfectly composed, but perhaps that's not the ideal way to show people playing music that depends on improvisation, on going beyond composition. In the spirit of the old joke among photographers – that the best camera is whichever one you have with you – the technical shortcomings of *this* picture are in keeping with a form of music where technical excellence counts for little without other hard-to-focus intangibles.

The Coltrane-Webster picture is very different from a famous image by Dennis Stock, also posed, of Lester Young in 1958, where the visual context – the Alvin Hotel, where he ended up – serves as a prelude to narrative. The scene has been set. To look at the picture is to hear a story, a ballad, preparing to count itself off. Here there's no story, no context – no room for anything but faces. So we have to reframe the picture by providing the absent context.

John Coltrane and Ben Webster, 1960, by Roy DeCarava

It was taken by Roy DeCarava in New York in 1960, but excluded – presumably due to its technical failings – from the selection of his jazz images belatedly published as *The Sound I Saw*. DeCarava was born in Harlem in 1919 – two years after Thelonious Monk and Dizzy Gillespie; the same year as Art Blakey; a year before Charlie Parker – and ten years after Ben Webster, who would have been fifty-one in 1960. John Coltrane was born in 1926, and so was about thirty-four when the picture was taken.

The difference in age between Coltrane and Webster is seventeen years. How is that measured – and what does it mean in the context of the fraction of a second it took to make this picture? Webster, with his silky growl and big-bellied sob, began playing with Duke Ellington and his orchestra in 1935, taking over as lead tenor in 1939 before leaving for good in 1943 after some kind of bust-up. Rumours have it that he slapped Duke or slashed one of his suits. Coltrane had played with Monk and Miles Davis – most famously on *Kind of Blue* – and, the year this picture was taken, released an album announcing his status as a leader in his own right: *Giant Steps*. He formed his classic quartet with Elvin Jones (drums) and McCoy Tyner (piano) in 1960, but it was not until late 1961 that the position of bassist was permanently filled by Jimmy Garrison. Compared with the shattering beauty and sublime intensity of what was to come, those giant steps soon sounded almost tentative.

It could be argued, then, that Webster represents the past (when jazz could be considered a form of entertainment) and Coltrane the future (when it would not even entertain such an idea). But Webster outlived Coltrane, who died in 1967 at the age of forty.

Coltrane would never get to be as old as Webster in this picture.

In 1965 Webster moved to Europe, where he died, in Leiden in 1973, aged sixty-four. He is buried in Copenhagen, where he spent most of the last decade of his life, playing with Danish and visiting musicians from America but audibly conscious of all that had been left behind – and, as old friends died, of how he was being left behind. A street in the city is named after him.

The tightness of the framing shrinks the differences in age and era, adding to the intimacy of the moment – an intimacy that was preserved by DeCarava rather than intruded upon. He is, quite literally, close to the two people in the photograph. A closer look at that closeness reveals something about the status of jazz musicians, or more exactly, about their three-tiered status. Racism means they are second-class citizens. DeCarava is, as it were, on equal terms with them in this position of inequality, and so Coltrane and Webster are photographed in the same way that he would picture any other African Americans on the street. 'I don't think of musicians as musicians but as people – and as workers,' he said. This picture, like his other images of musicians, is part of a larger and ongoing dedication to photographing the people of Harlem. As he had put it in a Guggenheim application grant in 1951: 'I want a creative expression, the kind of penetrating insight and understanding of Negroes which I believe only a Negro photographer can interpret.'[1]

To a part of the public, however, these second-class citizens are great artists. In Europe they will be revered not just as artists but as gods – gods who walk the earth, like anybody else. They're not stars like Elvis or, later, Michael Jackson, to whom access is restricted. It's not as if they had to be papped from a distance with a massive telephoto lens. All sorts of ordinary people interact with them, coming away with their own stories, their own photos. This is brought out movingly in *Cool Cats*, a documentary by Janus Køster-Rasmussen about the years Webster and fellow tenor-in-exile Dexter Gordon spent in Copenhagen. The janitor of the apartment block where Webster was living was called Mr Olsen. He spoke no English, Webster spoke no Danish but, as one marvellously homey piece of footage shows, they were united by a love of that international elixir . . . beer!

What we have so far, then, is this: a picture whose technical shortcomings are shared by any number of amateur snaps, of second-class citizens/artists/gods, taken by a photographer of undisputed international stature.

Coltrane's eyes are shut; he seems almost a baby in Webster's rough, tender

embrace. (As *Cool Cats* makes plain, Webster could go from teary affection when sober to threatening to pull a knife when drunk.) Coltrane had not yet become a legend, a legend who said he wanted to become a saint, the holy figure as immaculately conceived by Charles Stewart for the cover photo of the album *Ascension*. He had not yet made the radical assault on the tradition of which Webster is the mature embodiment. Webster had been around long enough to see and hear earlier revolutions in the music and would live to hear several more. It may look as if he is giving Coltrane his blessing, but it's impossible to tell whether we are witnessing a greeting or a leave-taking. This is entirely appropriate, since in jazz, the two are often the same (as when we recognise the opening bars of 'Ev'ry Time We Say Goodbye').

What we see is what we hear in many of Coltrane's greatest recordings: a greeting that is also a leave-taking. More broadly, the jazz tradition is made up of assaults on what's gone before and elegies for what has passed: Lester Bowie's joyous tribute to Louis Armstrong (on *All the Magic*) or George Lewis's heartbreaking *Homage to Charles Parker*. In some cases assault and elegy occur simultaneously, throw their arms around each other, so to speak, as happens when Cecil Taylor goes to town on Mercer Ellington's 'Things Ain't What They Used To Be'. We look back elegiacally on this moment in 1960 when so much revolutionary jazz and so many elegies lay in the future.

In an interview with the photographer Lee Friedlander and his wife Maria, the soprano saxophonist Steve Lacy said how lucky he was to have played in the 1950s when so many of the greats were alive. Friedlander responded that 'in 1950, 85 per cent of the history of photography were living people'.[2] We can quibble with this – obviously Friedlander is referring mainly to twentieth-century photography – but between them, he and Lacy enable us to appreciate the extraordinary convergence taking place in a picture made ten years later, in 1960. In a photograph with no setting, nothing external to itself, there is so much context, so much history. A picture of two musicians, it is also necessarily the record of a trio session with DeCarava as leader

so that, in the context of *photographic* history, Coltrane and Webster are sidemen.

Jazz, it is often said, is about being in the moment. By excluding all narrative context DeCarava affirms the importance *of* the moment while simultaneously expanding it. In one way the shutter speed is too slow to record clearly what is happening in this moment. But this technical failing succeeds in allowing more time to leak into *and* spill over from the picture. So let's articulate the way it's framed through a different form of improvisation. Imagine that it was part of a patterned carpet of images. We can't know exactly where it was located in that pattern but we do know that whereas history is concerned with beginnings (in jazz with Buddy Bolden or Louis Armstrong), with the chronological order of events, the pattern on a carpet *converges* on a centre. This picture looks as if everything around it has been eaten away by time. We are always working our way out from it – or back towards it. In that sense it is the central photograph in jazz.

2017

* * *

There are two well-known photographs by Roy DeCarava featuring drummer Elvin Jones. The first, taken in 1960, is primarily a picture of John Coltrane. The saxophonist's familiarly impassive face is in profile, clearly focused but perhaps not fixed quite as sharply as the harsh, metallic intricacies of the horn. (That saxophone might be the most sharply observed detail in the whole of DeCarava's repertoire.) The caption explains that the blurry shape in the background is Elvin Jones, but if we had only the blob of a head and the hazy outline of a white shirt to go by . . .? Well, it could be anybody. It could be Roy Haynes (who occasionally deputised for Jones). It could almost be McCoy Tyner bent over the piano, but something about the hunch of the shoulders suggests the limitless reserves of strength and power that will be forever identified with Elvin. More to the point, who else *could* it be? In

Elvin Jones, 1961, by Roy DeCarava

terms of the kind of identification demanded by police or a passport, the picture has no validity at all. In terms of the visual rhythm of the composition, there can be no doubt. Perhaps it's worth adding as well that while each member of the classic quartet was crucial, the band came to be dominated in its final phase by duets between Jones and Coltrane – one of several signs that the quartet was exhausting its potential.

Our idea of Elvin as a drummer is often defined by those epic battles with Coltrane. We think of his amazing drive, his ferocity, the rhythmic onslaught and battery. A young pianist likened the experience of soloing with Elvin to 'trying to light a match inside a hurricane' – and that was when he was in his mid-seventies! This aspect of his playing demands emphasis. But listening to him now, especially to recordings from the time of these photographs, it's another and underestimated part of his art that I am drawn to: the ability to set up a rhythmically complex but relaxed mid-tempo groove and maintain it, so to speak, *till the end of time*. Listening to the original version of 'My Favorite Things' (recorded in 1960), to 'Africa/Brass' (1961) or 'Out of This World' (1962) I sometimes wish – heretically – that I could edit Coltrane out of the mix, that the rhythm section would just keep rolling along without him. In other words, I'd like to remove the sharply focused foreground – saxophone – and retain the blurred background of rhythm.

That is what we have in the other picture of Elvin. Taken in 1961, it's still blurry and very dark, but here we have not just the man's features but the essence of his art. The only bits of white are the shirt and the gleam of sweat on his face. In later years, when he was leading his own bands, Elvin would play in a t-shirt. Here, in 1961, he is still in the jazzman's formal attire of blazer, shirt and tie. There seems to be a symbolic aptness to this. Elvin revolutionised drumming but never sought to burn his way free of time in the style of what has been termed 'dashiki jazz' – a style ushered in by Trane himself. The drums were played with unprecedented complexity and rhythmic freedom but, in his hands, were always *tied* to time.

DeCarava captures Elvin in a trance of his own making, a trance that has to be constantly maintained, that can be surrendered to only if actively and painstakingly sustained. While the sax in the Coltrane picture was glinting sharp, the metallic cymbal here in the left of the frame is no more than a vague throb: a suggestion of the swirl of forces from which the cosmos emerged. But, again, don't forget the jacket and tie. Soon after Coltrane opted, in the words of trumpeter Charles Tolliver, 'to go cosmic',[3] Jones called it a day, leaving drummer Rashied Ali to follow the saxophonist into *Interstellar Space*. In a way, then, Elvin remained as rooted to the actual and the real – to the smallest details of time – as the photographer who preserved this moment of earthly transcendence. Trane, Elvin and the other band members played 'My Favorite Things' many, many times. DeCarava's description of his own work has also been quoted many times, but it's worth listening to him again: 'My pictures are immediate and yet at the same time, they're forever. They present a moment so profoundly a moment that it becomes an eternity . . . It's like the pole-vaulter who begins his run, shoots up, then comes down. At the peak there is no movement. He's neither going up nor going down. It is that moment I wait for, when he comes into an equilibrium with all the other life forces . . . The moment when all the forces fuse, when all is in equilibrium, that's the eternal . . . that's jazz . . . and that's life.'[4]

2016

Old Sparky: Andy Warhol

The fact that a point is obvious, as Warhol realised early on, does not mean it does not need making. So let's not forget that Warhol's images of death and disaster did not exist until he made them! To that extent they're like accidents. Seconds before an accident everything is as usual, unnoticed, normal. And then, immediately after, everything is changed, changed utterly – including our perception of what life was like before the accident. In extreme cases – and the immensity of Warhol's success and influence makes it is easy to forget just how extreme a case he was – there is no before, only after. His screen-print paintings (not only the death and disaster ones) have played a defining role in creating not just how *they* are viewed but how *we* see. They exist not simply in order to be looked at; they are part of how we do our looking. Our minds' eyes have been recalibrated by them. Those eyes are not the same instruments that they were in the hard-to-conceive days pre-Warhol. People might have thought they were looking at paintings, but what was also happening was that a whole mode of perception was being *forged* (the way his work could look 'faked' was a defining part of its originality). To that extent Warhol was not simply a phenomenon; he was also a phenomenologist.

There is, as always with Warhol, a massive irony (at his weakest there is *only* irony) in saying that these images did not exist before he created them because they so evidently did – as products or as photographs. Works that had never been seen before were made out of things that had been seen so often that they were invisible: hiding in the broad daylight of supermarket shelves (the Camp-bell's Soup cans) or in the plain view of newsprint. The dates on the front pages and the accompanying captions tie photographs to a particular time and place,

Lavender Disaster, 1963, by Andy Warhol

Acrylic, silk screen ink, and pencil on linen, 106 x 81⁷/₈in. The Menil Collection. © 2020 The Andy Warhol Foundation for the Visual Arts, Inc. / Licensed by Artists Rights Society (ARS), New York

as news stories. Warhol lifted them from the news, rinsed out all trace of story, and made something new, quite distinct from the images of murder and death by Weegee, which also broke free of their obvious contextual moorings. Based on a photo-essay by Charles Moore that appeared in *Life* magazine in 1963, Warhol's version of what he titled *Race Riot* had actually been no such thing – unless the police can be said to have run riot in their violent dispersal of a peaceful protest in Birmingham, Alabama. In the case of photographs deemed too gorily explicit to have appeared in print, it is as if he dredged images up from the suppressed visual unconscious of the news. Having done this, Warhol leaves (his famous passivity makes that the word of choice even though the correct term should be 'causes') the news content of the pictures to bleed out – for what seems like an eternity. But since there's no time in eternity they never *can* bleed out. So they are, in a sense, self-cauterising; or, as is said of certain indispensable works of art, deathless.

In a way that was entirely of its time, taking full advantage of the technical and formal possibilities that were available, Warhol, the artist who defined an era, whose subjects were so conspicuously of their time (Jackie Kennedy, Marilyn Monroe) removed events from time and place (so that Jackie and Marilyn are left *stranded* in beauty). The events he reprocessed were taken out of the realm of causality, which always assumes a temporal sequence (this happened as a result of that, and then, as a consequence of that . . .). This happened here and now, the newspapers announce. This happened nowhere in particular and at no time, Warhol suggests, thereby making them *un*happen, as it were. We might as well be witnessing a depiction of the Virgin Birth – that immaculate denial of beforeness, of anything having happened prior – though not, of course, the Crucifixion, with the vast procession leading up to it and an aftermath so protracted we are still coming to terms with it, trying to reach some kind of settlement. In Warhol's screen-prints, instead of the logic of sequence, there is the serial reiteration of isolated moments – moments that are not even moments (since those are fractions of time) but, well, I'm not sure what to call them. Put it this

way. It's not that he expands the moment so that it occupies a larger expanse of time; it's more like time itself is shrunk, shrink-wrapped. The same non-moment is repeated over and over, endlessly, in slightly new arrangements, altered sizes and different colours. So the event, whatever it is, exists entirely in the realm of the aesthetic, which serves as an anaesthetic. Nobody, as Warhol's well-known rival for Edie Sedgwick's affections later put it, feels any pain. 'The more you look at the exact same thing,' Warhol himself famously said, 'the more the meaning goes away.'[1] In the artworks derived from photographs of violence and death, the bleaching of one kind of meaning and value proceeds in tandem with the radical enhancement of others.

Was this shocking? It's difficult to say because we are still in the prolonged, possibly permanent state of shock induced by Warhol. This state goes by different names and presents an array of different symptoms, the most common of which are as follows: a belief that all attempts to shock, breach taboos or stir up controversy are calculated attempts to enhance the market value of the offending item and raise the profile of its creator; a belief that taking offence is the sign of a lack of understanding of art, whereas the weary sophisticate is like King Lear ('None does offend, none, I say, none') in the backwash of the culture wars; an acceptance of the devaluation of the calling of 'artist' so that it has become a near-synonym of 'hustler'. (Needless to say, each of these symptoms merges into and becomes hard to distinguish from the others.) As a result we look back on the comment of Warhol's friend, John Giorno – 'the car crashes don't work because you can't have them in your living room'[2] – as if hearing some quaint scruple from another, almost prelapsarian age. (Warhol was the agent of this Fall – the thrower, and the thrown. The strange thing, for him and for us, was that where he landed turned out to be indistinguishable from the place from which the self-expulsion originated – and it was called America. *Gee!*) Nowadays the only concern is to make sure you've got sufficient real estate to do justice to the death and mayhem on display. Some of the pictures of accidents taken by Mexican photographer Enrique Metinides remain beyond the residential pale,

but to come down each morning and see a Warhol *Electric Chair* sitting across the breakfast table is about as unsettling – and almost as satisfying in terms of reflected self-worth – as luxuriating in a major work by Matisse (who wanted his art to be like a 'comfortable armchair'). Especially since Warhol's colours are often so pretty.

And after all, it's not like the old masters had any aversion to death and destruction. On the contrary, as Susan Sontag wrote in 'The Imagination of Disaster', an essay on science-fiction films (published in 1965, just after Warhol was wrapping up the first phase of his death pictures), 'disaster [is] one of the oldest subjects of art.'[3] Given that the Bible is the source book – the pre-modern version of the newspapers from which Warhol derived his original images – for so many scenes on which the Western artistic tradition has drawn, it's inevitable that titillating atrocity and hardcore S&M should constitute a major part of what we used to call 'the image repertoire'. Supplementing the Bible, the costume drama of history was another reliable source of horror and massacre – it's just that familiarity has dimmed our sense of how atrocious the scenes recreated in some of our most revered masterpieces really are. *The Rape of the Sabine Women* is exemplary in this regard. As for the crucifixion . . . Well, Dostoevsky's reaction when he encountered Holbein's *Dead Christ* in the Basel Museum in 1867 is quite exceptional. His wife recalled how the writer's face took on 'the frightened expression I often noticed on it during the first moments of his epileptic fits'. The picture 'haunted him like a horrible nightmare',[4] a nightmare that recurs in fictional form in *The Idiot* when Prince Mishkin exclaims, 'Why, some people may lose their faith by looking at that picture!'[5]

Imagine the contemporary equivalent of that: I mean, imagine how bad the crash would need to be in order for a collector to lose faith in art – a derivative of a derivative that has proved more economically resilient than the sources from which it is derived – as an investment. It would be an unimaginable disaster and catastrophe. Again, no artist was as responsible as Warhol for this state of affairs, for opening the floodgates to the kind of contradictory experience – a weird

combination of numbed demoralisation and ground-level vertigo – that assails visitors to Art Basel in Miami or one of the world's other high-end art fairs. But then – the ironies are endless – you come across one of his death and disaster numbers and its power is undimmed. They look incredible, have somehow survived or even transcended the deadening they've helped induce. Impossible to prove, but they may look more purely beautiful than they did back in the days before we'd got used to them. They are shockingly great. Usually this would be termed the judgement of posterity; in this case it's more accurate to speak of its aftermath.

Looking at some of them in turn, I realise a few amendments need to be made to what's been said above. Take the *Suicides*, for example. I'd said that there was no before, only after, but in the images of people falling from buildings that *after* is nowhere to be seen, is outside the pictorial frame of reference. At the risk of reintroducing the idea of narrative – and therefore time – which Warhol assiduously removed, I'm reminded of the joke in the film *La Haine* about a guy who jumps from a building and, as he falls past storey after storey, says to himself, 'So far so good.' Warhol's images of people en route to their deaths remove the extreme gravity of the situation; the figures seem almost weightless, suspended in time and space so that the canvas itself becomes a vertiginous but all-encompassing safety net. 'A sense of time abolished weighs on that picture,' writes Julia Kristeva of Holbein's *Dead Christ*.[6] In Warhol the same apprehension weighs almost nothing. Compare that with the insistent and meticulous temporal sequencing of a similar incident in Truman Capote's *In Cold Blood* (1965): 'Then, one summer night, she fell from the window of a hotel room. Falling, she struck a theatre marquee, bounced off it, and rolled under the wheels of a taxi.'[7]

If the views of falling bodies merge into those of car wrecks, the link is not just the image of the woman who jumped from the Empire State Building and ends up dead, but miraculously intact, in the dented cradle of a car. It's also what Murray, a character in Don DeLillo's *White Noise*, will later call 'the suicide wish of technology'. Murray is teaching a seminar in car crashes in the movies. He

tells the narrator (whose kids are regularly glued to the TV, watching disaster footage), 'Look past the violence, Jack. There is a wonderful brimming spirit of innocence and fun.'[8] Doesn't that sound like a description of 5 *Deaths* (1963), in which two of the survivors stare out from beneath the upturned car towards us, dazed, naturally, but strangely indifferent to the catastrophe of which they are both witnesses and participants? They look at us looking at them, held in a trance of reciprocal serenity. The picture is absolutely still, devoid of movement, and we are quite unmoved, exactly as Warhol himself claimed to be in 1963: 'When you see a gruesome picture over and over again, it doesn't really have any effect.'[9]

DeLillo's fascination with Warhol is made explicit in the title of a later novel, *Mao II*, but it's in *White Noise* that we get lengthy essays in dialogue that can usefully be read as patterned conversations with Warhol, about the representation of death and disaster in – and in the wake of – his work. Even Murray's little talk about Elvis seems to ricochet off Warhol's iconic representations of the icon, to reflect the oddly premonitory quality of the star standing there, gun in hand: 'Did his mother know that Elvis would die young? She talked about assassins. She talked about the life. The life of a star of this type and magnitude. Isn't the life structured to cut you down early?'[10]

As fate would have it, Warhol was the one almost cut down, by a gun wielded by Valerie Solanas. Five years previously he had 'realized that everything I was doing must have been Death'. Warhol's biographer Victor Bockris quotes someone who says that, at the Factory, Andy 'loved to see other people dying'.[11] To put it crudely, then, Warhol had it coming. All of which makes you wonder, makes you worry: might there be a kind of karmic payback in the offing? Don't you feel, after deriving pleasure from contemplating these beautiful car wrecks – scenes from which you would normally recoil with horror – that your own chances of being involved in a crash, of being maimed, injured or killed, have been subtly increased? Isn't there a gleam of pufferfish frisson in having risked . . . nothing?

How extraordinary that we had to wait so long for the n-word to make an appearance! Warhol said that he chose to paint soup cans because they

were 'the essence of nothing',[12] but for the visual apprehension of nothing-ness, nothing can surpass the multiple variants of the *Electric Chair*. Let's start – as this essay started – with the obvious. It's a *chair*. In his book on Atget, John Szarkowski reminded us that we have looked at empty chairs differently since the invention of photography; they have become images of absence.[13] In this case the absence is as absolute as the self-captioning injunction 'SILENCE' (with its silently abbreviated echo of Hamlet's dying words, 'the rest is silence'). The in-tensity of the black makes it seem as if oblivion is encroaching on or eating in to the image in a way that is entirely absent from the original photograph on which the artwork is based. A vacuum emanates from and converges on it. Everything about the picture – its stillness, its emptiness, its claustrophobic silence – urges one to comment on the corresponding absence of time. Again, one can imagine Dostoevsky as a witness to such an apocalyptic scene, quoting, as he does in var-ious places throughout his work, the strange line from the book of Revelation: 'There should be time no longer.'

But hey, this is Warhol, remember, so it's best not to lose all sense of irony, es-pecially since external time *has* changed how we perceive the chair in the picture. Put as briefly as possible, its days are numbered. For while capital punishment has not been put to rest in the USA, the electric chair has been rendered largely obsolete by the lethal injection. There's almost a nostalgic quality to the chair as it sits there, brooding on its standing, so to speak, as an icon of outmoded dread: of a punishment it only rarely has the power to dispense. A memorial to its own redundancy, it has, as a consequence, something of the quality of a chair in a bar-ber's shop that's gone belly-up. With its future looking anything but bright, the best it can hope for is probably some Alcatraz-like repurposing, whereby visitors will be able to sit in it and, for a few moments, do what we're supposed to do all the time: live each moment as though it's our last. In the meantime it does what chairs do. It takes the weight off its feet and waits – like eternity itself.

2017

Dennis Hopper

Lost books by great writers occasionally turn up, but 'lost', in a literary context, usually means 'not worth publishing in his or her lifetime'. The history of photography, on the other hand, is constantly getting updated and rewritten as entire bodies of work are discovered. Vivian Maier is the most recent and celebrated case: until her photographs came to light few people seemed to have any idea that she had even existed.

The same, of course, cannot be said of Dennis Hopper, though for chunks of his life people in close proximity to him – wives, friends and collaborators – experienced that existence as a deranged threat to theirs. His mania found a perfect outlet, years later, when he invested the role of Frank with intensely psychotic charm in David Lynch's 1986 film *Blue Velvet*. Former wife Brooke Hayward (the first of five, the second of whom was only around for two weeks) speaks tenderly and respectfully of him in the book accompanying the 2014 exhibition of her husband's *Lost Album* of photographs at the Royal Academy of Arts. She also remembers him as 'a sweetheart' in Peter Biskind's *Easy Riders, Raging Bulls*, but that was before she had her nose broken and became scared that he was going to kill her.[1] Not so Rip Torn who, when Hopper pulled a knife on him, twisted it out of his hand and turned it on his assailant. W.H. Auden wrote that 'It's better to be . . . liked than dreaded';[2] Hopper would seem to have been loved *and* dreaded, especially once his directorial debut, *Easy Rider,* became a paradigm-busting hit.

David Thomson considers this success one of the biggest disasters in the history of cinema (on the grounds that '"youth" was given the kingdom – not just as filmmakers, but as the controlling element in the audience').[3] For Hopper

Double Standard, 1961, by Dennis Hopper

the consequences may have been even more catastrophic. The combination of enormous wealth, acclaim as a revolutionary genius, freedom from studio constraints and massive use of cocaine (a drug that famously moderates one's sense of self-worth before eliminating any tendency towards paranoia) meant that he pretty much went gaga. Hopper claimed that *Easy Rider* put coke on the map of mainstream USA, but for him it was just another ingredient in the mix of booze, speed, pot and acid fuelling his progress from bohemian to beatnik to hippy to casualty of the counterculture of which he was an icon. He came back from an LSD 'be-in' in San Francisco, Brooke recalls, with blood-red eyes, a ponytail and 'one of those horrible mandalas around his neck'. But well before that, before things fell apart and the centre stopped holding, he was full of passionate intensity. Nicely photographed by Hopper as a lobbyist high on the cosmic importance of his campaign, Timothy Leary provided the happy mantra of the 1960s – 'Tune in, turn on, drop out' – but the decade's epitaph was spoken by Peter Fonda in *Easy Rider*: 'We blew it.'

The aftermath of Hopper's first film as director saw the global superstar and *auteur* on a self-exiled binge in Taos, New Mexico. Wrangling footage of his second, *The Last Movie*, into something approaching coherence while remaining true to shifting principles of incoherence proved predictably tough going – not least for anyone expected to sit through the result. Hopper's banishment was by then complete, but it was not unprecedented. After repeated run-ins with director Henry Hathaway on the set of *From Hell to Texas* he was effectively blackballed by Hollywood at the tender age of twenty-one.

He went to New York, where he studied with Lee Strasberg and fell in love – with modern art and Brooke. James Dean had urged him to start taking photographs when they were filming *Rebel Without a Cause* in 1955 but Hopper did not get a serious camera – a birthday present from Brooke – until 1961. Back in LA the couple discovered a simmering art scene that was about to come to the boil. Hopper was in its midst as collector (he bought one of the first Warhol soup-can paintings), participant, friend and witness. He was shy,

he said later, and liked the way the camera gave him something to fiddle with. As in a low-budget indie production, the nascent scene had a cast of dozens, some natives of this coastal paradise (like his lifelong friend, curator and impresario Walter Hopps), others, like Hopper himself (Kansas) and Ed Ruscha (born in Nebraska, raised in Oklahoma) from the Midwest. In opposition to the psychological depths plumbed by Abstract Expressionism (Hopper's first painterly passion in New York), LA art relished and reflected the mass visual culture of southern California. 'Pop' may have been a conceptual import, but its raw materials could be locally sourced. The streets were full of stuff that would end up in the paintings (and the photographs): cars, gas stations, billboards for the movie stars whom Hopper counted among his friends. They brought a glamour to the art which, in turn, celebrated the profundity of the superficial. The marriage of showbiz and art has been enduring; as a merger, it has proved stunningly lucrative.

A year after the first ever show of his soup cans, in 1962, at the Ferus Gallery on La Cienega Boulevard, Warhol returned to LA for another exhibition. Hopper, who had hung out at the Factory, threw a party for the putty-faced maestro at his house in West Hollywood. 'This party was the most exciting thing that had ever happened to me,' Warhol recalled. 'Vacant vacuous Hollywood was everything I ever wanted to mould my life into.'[4]

With the camera constantly around his neck, always snapping, Hopper's friends jokingly called him 'the tourist'[5] but he was, quite literally, at home among these artists, their creations (the walls were soon as crammed with art as a Paris salon) and the swirl of imminent happenings. As with Frank in *Blue Velvet*, Hopper channelled this early version of himself as the camera-toting photographer at Kurtz's compound in *Apocalypse Now*, interrupting a crazed monologue to Martin Sheen with the image addict's compulsion to score: 'I wanna get a picture.'

So although Hopper *was* in one sense an internal exile, the ability to stake a claim as some kind of outsider was fast becoming a requirement of admission

and a sign of belonging, both in a local art scene freeing itself from the gravitational pull of New York and a movie business ossified by its own commercial might. More generally, since *Rebel Without a Cause* – playing alongside Dean was the formative experience of Hopper's life – rebellion of one kind or another was emerging as a legitimate aesthetic option; *Easy Rider* would make it a fully institutionalised obligation. The urge was manifested most threateningly by biker gangs like the Hells Angels. Politically it was ennobled by the civil rights movement, which reached a brutal climax in Selma, Alabama, in 1965. Hopper was there for the third march, having been asked along by his friend Marlon Brando, star of the biker movie *The Wild One*.

Hopper photographed all of this: artists, Angels, actors, marchers, and the streets (of Mexico as well as LA). Photographs of mini-riots in LA foreshadow escalating protests against the war in Vietnam, the sense of something not so much slouching as hurtling towards Bethlehem. So it bears stressing that these images ended up on the walls of the Royal Academy not simply because Hopper was a celebrity who took a few pictures. He acquired a reputation as a photographer early on and was widely published before hanging up the camera in 1967. The retirement was sufficiently precocious that an exhibition in Fort Worth, Texas, in 1970, which might have served as a mid-career survey, took on the character of a full-blown retrospective. 'Without doubt,' editors of *The Lost Album* insist, the work on show in London is the same as that in the Texas exhibition. The prints were selected by Hopper, attracted a lot of favourable attention when the show opened – and were then lost: part of the flotsam and jetsam generated by someone swamped by the wake of his own legend. These vintage prints did not come to light again until after his death, in 2010. The more lavish overview of work assembled by Tony Shafrazi (published by Taschen in 2011) was made from negatives and contact sheets salvaged from the chaos of Taos by Hopps in the mid-1970s. Taken together, both undertakings are part of an attempt not to belatedly insert Hopper's name into photographic history for the first time but to reclaim and develop a prematurely vacated space.

Some context is helpful when assessing the success of this attempt. Robert Frank's *The Americans* (1955–6) offered a radical reconception of what a photograph could be. A beneficiary of this legacy, Hopper didn't take photography into the realm where content almost overwhelms form, as did Garry Winogrand; he did not have the visual complexity of Lee Friedlander; nor did he have the obsessive eye of Diane Arbus. While he didn't invent or significantly extend a way of seeing, he was fully articulate in the visual language of the time. As Fonda put it, he had an understanding 'not just of the frame of the camera but the frame of the life'.

And he had the simplest and most important gift of any photographer: he was there, not just in the same room as, but on familiar terms with Warhol, beach-blond David Hockney and the strikingly handsome Ruscha. We associate this kind of casual intimacy with Nan Goldin's later *Ballad of Sexual Dependency*, but whereas Goldin's photographs have become mirrors recording their *own* historical importance (she was the only person in them who ended up doing anything except drugs), Hopper's are a source of biographical data about people who have helped make the world look the way it does. In these photographs we can see not just history as it was happening but documentary evidence of myths in the process of formation. The value of such work only ever increases over time. In that regard, Hopper's photographs seem more important now – when the dudes in them are either dead or grey-haired billionaires – than when they were taken. This is made more pronounced by the way the prints were lost from sight for so long, preserved like treasure capsules from another era.

The Selma pictures do not have the front-page power we expect of a world-historic event; they seem instead like fairly discreet souvenirs of a day in the lives of the people who were there – and are all the more special for that. For someone who became a raging megalomaniac, Hopper had a surprisingly modest visual style.

The photographs of bikers may not have the immersive narrative power of

Danny Lyon's contemporaneous *The Bikeriders*, but with California as a back-drop they are shot through with the same 'lost angel of a ruined paradise' thing that Shelley saw in Keats. Coming from Dodge City, having acted in numerous westerns, it was easy for Hopper to see the Angels both as oily descendants of cowboy-outlaws – and as a bunch of rednecks. One picture in particular, of an Angel and (as the argot of the tribe had it) his 'old lady', performs a service that seems almost prophetically useful. Looking at a photograph by William Klein of some kids in New York, Roland Barthes famously noticed – was 'pricked by' – 'one boy's bad teeth'.[6] This guy's mouth is half full of fucked-up teeth. It's like he and Hopper, between them, pre-emptively knocked Barthes's idea of the *punctum*, the accidental detail, down his throat before he even got a chance to say what it was.

Among an impressive haul of pictures there are a number of masterpieces. A famous shot of shirtless Paul Newman (1964) rendered calmly feminine courtesy of the fishnet shadow cast by a chain-link fence is one of the most *gorgeous* pictures ever of a man – and a naked demonstration of the actor's subtle knack for manifested interiority. And then there's the so-called *Double Standard* photograph used as a poster for a 1964 exhibition of Ruscha's gas-station paintings: a highly cinematic and self-captioning view of two Standard Gas station signs through a car windshield, with another car reflected in the rear-view and a glimpse of sky through the sunroof. So much photographic traffic converges here – Walker Evans, Frank, Friedlander, Stephen Shore *inter alia* – that if you had to distil post-war American photography into a single image, you could do a lot worse than choose this one.

2014

They: William Eggleston in Black and White

At the risk of asking a crazy question, could it be that too much has been made of William Eggleston and *colour*? In the popular consciousness he *is* colour photography, the man who dared challenge the choir of Robert Frank, Cartier-Bresson and Walker Evans, who held that black and white were the colours of photography, that colour was vulgar, and so on.

In Eggleston's own words, 'people just hit the roof'[1] when his colour pictures were exhibited at MoMA in New York in 1976. Having got all the opprobrium, he has since enjoyed the lion's share of the applause. But a bit of context complicates the accepted narrative. First, with every year that goes by, we are treated to new books or exhibitions of work by photographers (Saul Leiter, Keld Helmer-Petersen, Helen Levitt and Bruce Davidson, among others) who, it turns out, had been using colour for their own peculiar ends before colour gained institutional acceptance and respectability – courtesy of Eggleston – in 1976. Joel Sternfeld talks wryly of the early 1970s as 'the early Christian era of colour photography'[2] when a small band of persecuted devotees dared to practise and share their newfound faith. Just as the geological investigations of Charles Lyell forced the Victorians to concede that the earth was much older than Christian teaching allowed, so the date of BC (Before Colour) is constantly being pushed back from 1976 to accommodate some new heretic and prophet or other. (Raghubir Singh's claim that if photography had been invented in India it would have *started* in colour represents an extreme backward extrapolation of this tendency.)

As Sternfeld's remark suggests, by the mid-1970s a number of photographers were gearing up to contest the near-total domination of monochrome.

Untitled by William Eggleston

What Walter Benjamin said about the dawn of photography itself – 'the time was ripe for its invention, and was sensed by more than one, by men who strove independently for the same objective'[3] – can be applied to the reinvention of photography as a colour medium in the 1970s. Moving outside photography, it is striking how often something long assumed to be beyond the capacity of human beings – travelling to the South Pole, running a mile in under four minutes, putting a man in space – becomes so suddenly plausible that it ends up as a sprint, not to the finish but the *start*. The role of John Szarkowski, head of photography at MoMA, was therefore crucial in deciding that the moment had come, that Eggleston was the person best equipped for an assault on the summit – even if it seemed, to many critics and viewers alike, exactly that: an aesthetic assault – colour snaps! – on the very idea of a summit.

Lest it seem we are diminishing Eggleston's importance by making him the passive beneficiary of a moment, let's insert the name of one of the unassailable geniuses of Western culture and see how his achievement can also be viewed in the light of historical circumstances. Here is Theodor Adorno's analysis of Beethoven as outlined by Fredric Jameson:

> It is, of course, not a question of degrees of genius, but rather of the inner logic of historical development itself, and of a kind of accumulation of formal possibilities of which Beethoven is the beneficiary and which suddenly makes possible an unexpected carrying through to their conclusion of all the unfinished trends, a filling out of all the hitherto empty spaces, and an actualization of the potentialities latent in the musical raw material itself.[4]

Substitute 'Eggleston' for 'Beethoven' and 'photographic' for 'musical' and you have a persuasive sense of the situation in which photography made its great leap forward. The publication of *William Eggleston: Before Colour* in 2010 offered abundant evidence of the extent to which Eggleston was experimenting with and mastering the formal possibilities bequeathed to him by Evans and Frank, along with those still in the process of being articulated by Garry

Winogrand (whose colour work from the year 1964 did not come to the attention of the public until 2002). Frank is especially important in this context if we bear in mind a comment by Diane Arbus about a photo in *The Americans* of gas pumps near Santa Fe, New Mexico. 'His pictures always involve a kind of nondrama,' she told a master class in 1971, 'a drama in which the center is removed. There's a kind of question mark at the hollow center of the sort of storm of them, a curious existential kind of awe, it hit a whole generation of photographers terribly hard, like they'd never seen that before.'[5]

Returning to the passage about Beethoven, it could be objected that instead of filling out the empty spaces, Eggleston made them central to his work, that he filled them, so to speak, with colour. Eggleston himself thought that 'the empty centers'[6] in his pictures came from his study of 'Japanese prints and Chinese paintings', but it's worth bearing in mind that he was part of that 'generation of photographers' who had been struck by the quantity of emptiness or hollowness a centre could – or could not – hold.

There is perhaps a more definite sense of place – a more precisely situated or localised quality – to the black-and-white work. Some of the photographs seem more obviously to address the legacy of the South, the way that, however it is celebrated, the Southern past is, in the words of Jason Sokal, 'rooted in racial discrimination.'[7] (*There Goes My Everything*, Sokal's history of 'white southerners in the age of civil rights', featured an Eggleston photograph on its cover.) That aside, it is actually the continuity in Eggleston's work, from pre- to post-colour, that is remarkable. This does not undermine the claim made earlier about the cumulative presence of Evans, Frank and Winogrand in the black-and-white work. Without them Eggleston would not have been Eggleston. The question is at what point he went from absorbing his influences to becoming William Eggleston – and the answer, I think, is *before colour*. Szarkowski necessarily made a big to-do out of the phenomenological dimension of the shift to colour, how Eggleston 'really learned to see in colour'[8] and, in so doing, reconceived the world. On the one hand, yes, it's good

– in an era when the hegemony of colour is almost as complete as was that of black and white in the period that preceded it – to be reminded that it was no small thing to photograph 'as though the world itself existed in colour, as though the blue and the sky were one thing'.[9] And the dye-transfer colours are amazing, of course. But the corollary of this is that the pre-colour work must have been different in some equally fundamental way, that previously Eggle-ston was seeing as though the world existed in black and white. In fact, his way of seeing seems to have remained surprisingly consistent.

Compare many of the black-and-white pictures with those in colour and they're really not so different. It would be interesting to see how many viewers, in some photographic equivalent of a musical blindfold test, could tell the dif-ference between prints made from black-and-white film and black-and-white prints made from colour film. Or it could be done the other way round: col-ourise the black-and-white prints and *they* don't look that different from actual colour images. Either way, it's not the case that the black-and-white pictures look like apprentice work, like the track leading up to the record-breaking jump into the sandpit of colour. And it's certainly not the case that the black-and-white pictures *need* colour to achieve a standard of excellence uniquely represented by the later work. No, in a quite extraordinary way some of the black-and-white stuff looks more radical, more forward-looking than the col-our work.

Take, for example, the shot of the guy in a white jacket with beard and receding hair stepping off a grass verge onto a suburban street. It's like one of those Jeff Wall tableaux in which every little detail has been so carefully woven as to make the whole image self-sealing. In Eggleston the mystery ap-pears accidental and open-ended, susceptible to a narrative clarification that never looks like happening. While this may be common to both his colour *and* black-and-white work, the lack of resolution and its attendant emptiness is more glaringly present in the black-and-white work precisely because there is no colour to fill the void. As a result, some of the black-and-white pictures are,

as it were, like Eggleston – *only more so*. They may be 'before colour' but there's no sense that Eggleston before colour was somehow pre-Eggleston.

After colour, the next most important topic in any discussion of Eggleston is that of literature. The photographer has encouraged this, remarking to curator Walter Hopps that he thought of his pictures 'as parts of a novel I'm doing'.[10] And the sense of an adjacent or conjoined literary presence is hardly unique to Eggleston. Walker Evans famously considered himself a man of literature, citing Baudelaire as spiritual influence and Flaubert as crucial to the development of his idea of 'the nonappearance of author'[11] (which paradoxically enables us to identify an Evans photograph *as* an Evans). And yet something about Eggleston's work encourages an unusual array of writers to whoosh into the vacuum at its centre. *Faulkner's Mississippi* was a collaboration with writer and editor Willie Morris. Eudora Welty, another Mississippi-born writer (who was also an accomplished photographer), contributed an important essay to *The Democratic Forest*. Beyond this, commentators on Eggleston invariably bring along other writers for company, writers with whom Eggleston is shown to have a special affinity. For Michael Almereyda it's the off-the-cuff poetry of Frank O'Hara. For Thomas Weski it's the curtailed lyricism of Raymond Carver. In *The Ongoing Moment* I made a big deal out of the way that parts of Walker Percy's *The Moviegoer* could be read as a vicarious catalogue essay on Eggleston's work (a claim I stand by).

All of which is a testament to the tacit beckoning of narrative, especially tantalising because it is neither linear nor explicit, never manifesting itself as a plot or story. The black-and-white work is, inevitably, *noiry* in atmosphere, which means – as happens when the Percy comparison is made – that the literary also carries with it a freight of cinematic associations. This accidental extension proves instructive. It reminds us of how often, when we say that a photograph – or a collection of photographs – is 'cinematic', 'novelistic' or (expanding the catchment area still further) 'painterly' or 'musical' (another comparison encouraged and legitimised by the fact that Eggleston is an

accomplished musician) what we really mean, in variously nuanced ways, is *photographic*.

In the black-and-white photographs something might have happened or might be about to happen – even if that something (which often turns out to be nothing) has no causal relation to what has gone before or might happen next. Instead of plot there are fragments and patterns, fragments of patterns. There are guns around and we all know, courtesy of Chekhov, what happens when we see a gun on the wall in the first act. Except there are no second acts here. Come to think of it, there's no first act either, just trailers for unread scripts, stills featuring uncast actors for unmade films. Often there's felt to be a manifest lack of destiny, the visual representation of a psychological condition whose symptoms are, simultaneously, identifiable, cohesive – and so varied as to resist collation. So we stare and stare, falling prey to the very thing we're attempting to diagnose. That failure to identify – which becomes a kind of identification and recognition *through its failure* – is perhaps the point. At the risk of inviting in yet another literary guest, I can't help thinking of a passage in Jesmyn Ward's *The Men We Reaped*. The book is a memoir about growing up in Mississippi, framed around the deaths of five young black men, including the author's brother. After the death of a guy called Rog, two other friends of Jesmyn's, Tasha and Brandon, say something along the lines of, 'They picking us off one by one.' Jesmyn drives home, weighing up what she has heard:

> I thought about what Tasha and Brandon had said, and I wondered who they were. Rog had died by his own hand, by his own heart; were they us? Or was there a larger story that I was missing as all these deaths accumulated, as those I loved died? Were they even human? My headlights lit a slim sliver in the darkness, and suddenly *they* seemed as immense as the darkness, as deep, as pressing. I turned off my music and rode home without the narrative of song, with only the bugs' shrill cry and hot wind whipping past my window. I tried to hear

the narrative in that, to figure out who the they that wrote our story might be.[12]

I'm wrenching this passage violently out of context, but something of its interrogative power – the way that the ultimate rejection of the consolation of narrative is generated by a narrative of questioning – seems so close in spirit and style to Eggleston's black-and-white photographs as to answer some of the questions they insistently provoke.

2015

Fred Herzog

Just down the road from where I live, a store is trying out a new retail marriage: pricey eyewear and photography books. Their patron saint ought to be Ralph Eugene Meatyard, who was an optician and photographer, but his books, as far as I could make out, were nowhere to be seen. The volume in the window that caught my eye – possibly because the cover image was of a (barber's) shop window – was Fred Herzog's *Modern Color* (Hatje Cantz, 2017) . Herzog's work offers the latest instance of a form of eye exam that has enjoyed increasing visibility in the last few years.

Traditionally exams test one's knowledge of the syllabus. These latest exams, by contrast, reveal the syllabus to be in a state of constant revision. Surveys of post-war fiction tend only to need updating by the addition of chapters at the end to take account of whatever has been published since earlier editions went to press; histories of photography require enough newly discovered names to be inserted in the middle as to shuffle or reshape the accepted narrative. Especially when it comes to colour. So much colour work, it turns out, was being done before William Eggleston's paradigm-shifting show of colour photographs in 1976. Herzog is one of the pioneers who mastered colour photography before such a thing respectably existed.

William Gedney, another photographer lifted retrospectively from obscurity, copied out in his notebooks some lines from W.H. Auden's 'In Praise of Limestone': 'examine this region/Of short distances and definite places.'[1] Born in Germany in 1930, Herzog emigrated to Canada in 1952, where he lived out the poet's admonition with benign dedication. Although he took some photographs in various places in the world, Vancouver has remained his colourful

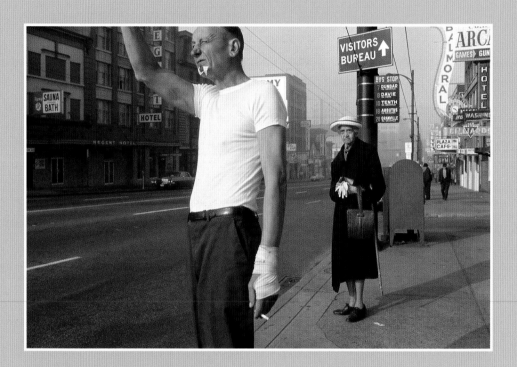

Man with Bandage, 1968, by Fred Herzog

Courtesy of Equinox Gallery, Vancouver

stamping ground from the late 1950s onwards. As with Saul Leiter, the sense of a distinct and determining sensibility is enhanced by the relatively limited geographical frame of reference. Since the same bits of real estate crop up in multiple frames, a given view can be triangulated with other shots so that we are enclosed within an artist's world. To look at Herzog's work is to inhabit it.

So let's put on our eyewear and take a look around, starting with one of the first plates in the book. A quiet belter of a photograph from 1968, 'Man with Bandage' might justifiably be called Herzog's signature shot – in several senses. First, because one of the many signs on view helpfully directs first-timers to the VISITORS BUREAU. Second, because the titular man actually bears no small resemblance to another Herzog, film-maker Werner, as he looks these days. Telegraph wires connect the heads of this surrogate Herzog to the old lady behind him so perfectly that they serve almost as a perspectival diagram. The two are further associated both by his white bandage and her white gloves and by the way that his manly injury (wrist) is sympathetically echoed by her implied infirmity (legs, walking stick). Someone better acquainted with Vancouver's geography and the picture's orientation would know whether the long shadows are pointing towards evening or morning (the shaving cut on the man's chin tends to suggest the hurry of a.m., but if this is rush hour, where's the traffic?) as they stare into the distance, straining to make out which of the buses routinely promised by the sign might be approaching. The light is hazy but the man is shading his eyes as if staring into the face of divine radiance – a reminder that buses are anticipated as eagerly as the Second Coming and that timetables are best regarded as prophecies of dubious reliability. Who is to say that the bandaged hand is not the result of a botched crucifixion served up by the serial obstacles of daily life, with the bloodied tissue paper on his chin covering a wound self-inflicted by safety razor (as opposed to a spear in the ribs) and the bus stop as a station of the commuter's cross? The blob of blood on his chin is amplified, behind the old lady, by what I'm assuming is a mailbox, though the red is so featureless that, if painted, it would appear as a solid

abstraction. Beyond that is a dense tangle of signage, which can be more fully decoded in a corroborative or QED sort of way by reference to another photograph taken further down the street.

Thus alerted, the curious visitor soon becomes conscious that Herzog's world – especially as revealed by the abundance of signs – is simultaneously covetous and quasi-religious, sensual and unworldly. A photographed ad for Mount Pleasant Chapel urges us to 'Give thought to the reason for this holiday season'. Um, OK: to *buy* stuff? Except even something as practical as a sledgehammer displayed outside a storefront window becomes an article of faith when offered at a 'Sacrifice Price'. Gamblers at a fair or casino gaze beyond the frame in an ecstasy of optimism, keeping faith with the idea of an against-the-odds windfall (a.k.a. a miracle), while visitors to an air show turn their eyes skyward as if Christ might, at this very moment, be ascending to heaven. All transactions, however mundane, are the manifestation of some deeper testament of which Herzog is the patient stenographer. Easy on the eye, the resulting transcripts are hard to disbelieve. Rarely have the neon dreams of night looked as tangible as they do when rendered in Herzog's colours. No wonder the two Jehovah's Witnesses are selling copies of *Awake!* (though the printed alarm call is sleepily muffled by the way they're standing behind a garbage can for 'Waste Paper').

If you doubt me, Thomas, look closely as I direct your finger towards the instrument of the wound and its preservation. The relatively lengthy shutter speeds necessitated by Kodachrome – a slow, not very light-sensitive film – meant that Herzog was not only temperamentally unsuited but technically unable to snap events on the fly in the sly manner of Cartier-Bresson. Drama passed him by. He waited for time either to slow down or – in another diagrammatic shot of watches, clocks and cameras in an aptly named second-hand store – come to a functional standstill. In lieu of the fast time of second hands and their snatched fractions a strong sense of photographic history can be seen to converge on Herzog's work.

From the past there is Walker Evans, whose photographs Herzog encountered in 1962 or 1963. In the vicinity of Evans's stilled, often empty buildings all sense of hurry has vanished. There was no need for Evans himself to rush because of his faith in his own vocation. 'It's as though there's a wonderful secret in a certain place and I can capture it,' he claimed. 'Only I can do it at this moment, only this moment and only me.'[2] I like to think that Herzog accidentally alluded to his great predecessor's sentiment in a picture of a smartly dressed black man on a street corner in San Francisco in 1962. A sign to the right of his head is cropped by the edge of the frame so that only that single word – ONLY – is visible. (If the picture had been taken in Alabama, where Evans was photographing in the 1930s, the word would, of course, have had an added and unwelcome abbreviated meaning.)

Evans famously declared colour photography 'vulgar' and there are a number of Herzog's shots that seem to teeter on that edge. The problem is that Kodachrome encourages reds to blossom so powerfully that unless the slow work of time – corroding, fading, lending Vancouver's northerly cars and walls a southerly touch of Havana – makes itself felt then this red gobbles up attention with the ghastly insistence of a child's plastic plate. That may be why, to avoid us becoming oversaturated, the book's editors have cleverly included some black-and-white pictures to serve as shaded oases, though some of these – a billiard table and balls! – positively blaze with absent colour. At its best Herzog's colour palette is resiliently, sometimes drearily muted, a testament (that word again!) to what Jeff Wall, in an introductory essay, calls 'the aging of paint, the transformation of colour over time'.[3]

Born and bred in Vancouver, Wall is the force converging on Herzog from the other side of Evans – again in several senses. First, he is from the future (our present), living and working in the city at a time when many of the buildings photographed by Herzog have gone the way of those documented by Eugène Atget in Paris. Second, he represents another alternative to speediness, eschewing decisive moments in favour of large, meticulously constructed

tableaux which are as free of urgency as the history paintings of old.

Ironically Herzog occasionally chanced upon small-scale Walls ('walls', as it were) in real life. In 1973 he had just enough time to preserve kids fighting on a neat square of lawn in such a way as to make it look exactly like the kind of enigmatic scenario painstakingly created by Wall years later.

This is not to say that Herzog was ahead of his time. Pictures like the one of the fighting kids have acquired an extra quality – a kind of glow – in the light of Wall. And it's not just that we view Herzog's work differently on the other side of the Wall, as it were. Our whole sense of what constitutes the street and street photography has been reconfigured by Wall's art of animate suspension. Herzog enables *us* to see this with a clarity that is both new and old.

2017

Lee Friedlander's American Monuments

Lee Friedlander's *The American Monument* was first published in 1976. That's 'monument' singular, though one of the many singular things about Friedlander is that he's nothing if not a pluralist. Whitman-like, he is great, contains multitudes. In an essay appended to the sumptuous new edition of this landmark work, Peter Galassi (who curated the 2005 Friedlander retrospective at MoMA) deems it 'pointless' to try to count precisely how many books the photographer has published since 1976, but settles on roughly one a year. The retrospective was huge and, inevitably, the accompanying catalogue was almost too hefty to lug home comfortably. It was sort of monumental, though monuments tend to be erected to the dead. On receipt of a Lifetime Achievement Award from the International Center of Photography (ICP) in New York in 2006, the seventy-one-year-old Friedlander responded that the honour, while welcome, was premature. At the swanky reception and dinner held for all prizewinners he spent the evening *photographing*, snapping guests and the other honorees like a cub photographer eager to make the most of what might prove to be his big break. That break had actually come in 1967 with the *New Documents* show at MoMA when he, Garry Winogrand (who died in 1984) and Diane Arbus (died 1971) were chosen to represent a shift in documentary photography from social concerns towards more personal ends. It's possible that his reputation, as it has risen in the decades since then, has also suffered somewhat in the way of Dizzy Gillespie's in comparison with that of his doomed fellow bebop pioneer Charlie Parker.

Almost inevitably for an artistic career stretching over more than five decades and encompassing many phases, the quality of the work is uneven.

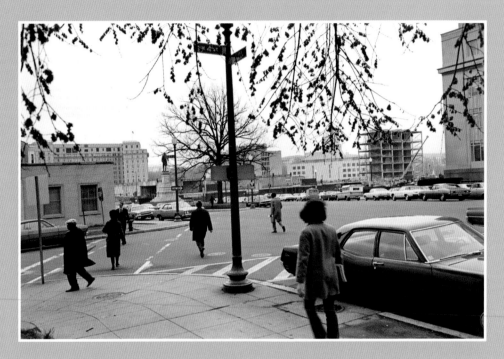

Brigadier General Albert Pike, Washington DC, now removed, 1972, by Lee Friedlander

Unlike Winogrand, Friedlander hasn't given up on editing, but is more interested in taking pictures and getting them out than in scrupulously curating his own *oeuvre*. 'It's a generous medium, photography,' he is quoted as saying in the epigraph to the MoMA catalogue. He was thinking particularly of a picture of his uncle Vern, which also included a bunch of other unintended information: 'a bit of Aunt Mary's laundry and Beau Jack, the dog, peeing on a fence, a row of potted tuberous begonias on the porch and seventy-eight trees and a million pebbles in the driveway and more.'[1] *The American Monument* came about in similar fashion when he noticed that memorials and statues of all kinds cropped up in multiple contact sheets, some of which were primarily concerned with other matters. After that he began seeking out such monuments in the course of his travels throughout the States. Eventually he had enough pictures for a book, which, in Friedlander-ese, always means more than enough. The original edition boiled thousands of potential candidates down to 213 photographs, the bulk of them taken between 1971 and 1975, supplemented by a brilliant afterword by Leslie George Katz. That essay still feels remarkably fresh in the 2017 reprint from Eakins Press, even though Katz's observations occasionally gleam with a faith in the assumption of monuments' continued worth that may turn out to be 'discredited', 'outmoded' or ironically apposite, as when he says of their power, 'Something like racial memory is at work.'[2]

Robert Musil wrote that nothing is as invisible as a monument, and Friedlander in the 1970s relished the simple and complex task of making the invisible visible. He did this by showing how monuments hide in plain sight: subsumed by traffic, by familiarity, by the abundance of incidental detail he'd 'got' in that picture of his uncle. Siegfried Sassoon expressed the cruel paradox of remembrance while contemplating the Cenotaph – dedicated to the dead of the First World War – in London: 'Make them forget, O Lord, what this Memorial/Means'.[3] Friedlander's photos read like an almost random survey of the aesthetics and meanings of all kinds of monument – and of how easy it is to forget what is meant to be remembered.

It is entirely coincidental that the book is being reissued at a time when the silent claims of monuments on our attention have become more audible than at any period in their long and dormant history. Misgivings about a few make us newly attentive to the many. The album is essentially the same as it was in 1976 but we view its contents rather differently – and vice versa. Monuments, after all, are also mirrors. So, for that matter, are the windows (often of cars) through which we see them – and few photographers have had more fun than Friedlander exploiting, exploring and reflecting on the capacities of these two pieces of technology to complicate what is shown in a picture frame. Dependent on all manner of mirroring, both felicitous and contrived, the slim volume Friedlander published before *The American Monument* was a collection of self-portraits. The self of which the pictures in the reprinted book offer a composite portrait is, of course, America.

By another coincidence the caption to the last picture in the book reads 'Brigadier General Albert Pike. Washington D.C. Now removed.' If Pike's statue were any more distant, then photographically it might as well not be there. Unlike the pedestrians hurrying towards it, the statue intends going nowhere, but visually it's already on the way out. To the right a large building is under construction. The last leaves are clinging to the trees. A sign says 'STOP'; photographs do that to time all the time – but not to history. To be strictly accurate, the statue was not permanently removed, just moved or relocated due to construction work, but the picture of the now-altered past indicates a potential for future photographic endeavours.

In preparing the new edition a researcher for the Eakins Press identified another ten or eleven statues in the book that are, depending on your point of view, either at risk or static fugitives from historical justice. Some people may have experienced an unexpected tug of sympathy when President Trump lamented 'the removal of our beautiful statues and monuments' commemorating the Confederacy even if, rationally, they recognised the need for such a cull. Neighbours possibly felt the same way in Argentina when the kindly

old chap who lived downstairs was arrested as a war criminal. The difference is that the statues are out in the open as though they have nothing to hide. Treading a fine line in legal niceties, they appeal to a jury comprising, partly, of people who have known them for years: Am *I* complicit in the deeds or views of the man in whose image I have been cast and trapped? Hoping to be granted immunity from prosecution, their only hope is to persuade us that, over the years, they have become permanent residents of recent history as opposed to symbolic representatives of a more distant and guilty past.

Striking photographs have already been made of what happens after arguments for a stay have exhausted themselves. Hauled from his pedestal outside the County Courthouse in Durham, North Carolina, a Confederate soldier lies slumped on the grass as if laid low by two kinds of time: one new (and less deferential), the other, *im*memorial, as it were. This symbolic 'death' offers a potential political compromise in the midst of the current purge. Yes, the statues can remain – but only if they are unseated, thrown to the floor and left to take their chances amid the fallen leaves. Let them join the ranks of history's down-and-outs so that they become symbols not of service to the Confederacy but the dereliction of larger civic duty. The vacated plinths or spaces formerly occupied by statuary give rise to another photographic possibility whereby their felt absence might be documented and gauged. Entire surroundings are altered by this absence – for a start they're no longer surroundings! Such a project would be an inverted extension of Joel Sternfeld's *On This Site*, where photographs become memorials of atrocious events that occurred in hitherto unmarked places.

Friedlander has always been an artist with a strong sense of photographic history, of carrying on – and preserving – the work of those who came before. That might be why he took a picture of the statue of Brigadier General Lloyd Tilghman and his horse in Vicksburg, Mississippi, that had been photographed by Walker Evans in 1936. The focus, in Evans, is tight, almost devoid of context and background; Friedlander shows, quite literally, the disorderly possibilities

that lie beyond the frame of Evans's quietly rigorous aesthetic. In the process the maker of *The American Monument* constructs a discreet and quick – as in the quick and the dead – photographic memorial to the creator of *American Photographs*. A sign in that photograph of Albert Pike reads 'ONE WAY' but the tradition of any art form must work both ways if it is not to become an ossuary or a chronology of obituaries. The final words of the final caption in the book – 'Now removed' – also mean 'To be continued'.

2017

Bevan Davies's *Los Angeles, 1976*

Formally the photographs Bevan Davies made of homes and streets in Los Angeles in 1976 have much in common with those made by Walker Evans in the American South in the 1930s. Often full frontal, they are marked by a similar stillness: a stillness that registers not only the absence of physical movement – people, cars, wind – but also of the implied movement or passage of time. Los Angeles is thought of as the quintessential city without a past, where nothing is preserved, where the old makes way for the new without regret or nostalgia. Emptied of time as they are, I am tempted to say that these pictures represent an eternal or unchanging *idea* of Los Angeles. There is none of the sense that we get, in the work of Atget, of seeing an old Paris that must be preserved before it makes way for the new. Nor is there the urgency expressed by the title of Berenice Abbot's *Changing New York*. The possibility of drama – of *anything* happening – is as dangerously remote as on those days of 'stagnant pressure' when, according to Eve Babitz in *Slow Days, Fast Company*: 'You could not drive down a residential street without someone backing straight out of their driveway in front of you as though the world were empty.'[1]

Even if these buildings are still standing, unchanged, the photos show them at a very precise stage of their existence. This is emphasised by pictures in which house numbers – 1432 or 1517 – seem to double as records identifying not only where but exactly *when* the photographs were taken. (Too bad he didn't find a house numbered 1976, so that we could have triangulated location, time of day and year.) That's an illusion, obviously, but the earlier comment about time and its absence perhaps needs to be rephrased, recalibrated.

From *Los Angeles, 1976* by Bevan Davies

By kind permission of the artist and Joseph Bellows Gallery, La Jolla

Davies's pictures extend the photographic moment so that we *see* time as experienced by the buildings in them.

Davies's aesthetic also has similarities with that of Lewis Baltz and the New Topographics: each photograph is a statement of fact; taken together they amount to an inventory of what is there without stylistic embellishment. They have, in this regard, something in common with the photographs taken by the narrator of Babitz's novel *L.A. Woman* who, in opposition to the apocalyptic 'hogwash'[2] of Jim Morrison, wanted to make it plain 'that the bungalows and palm trees were only bungalows and palm trees and not out to kill the rest of the world'.[3] Avoiding swinging too far in the opposite direction – of unflinching rigour and stern objectivity in the service of painstaking taxonomy – there is an implied gentleness in Davies's work: almost, though the focus is sharp, a softness.

Why? How to account for this quality? I think it has something to do with familiarity. Although I've never seen any of these buildings before, I look at the photographs of them not with astonishment but with the kind of fondness a neighbour might feel. Not a human neighbour – this is not the viewpoint of someone looking through the curtains of the house across the way or sitting on a porch. No, this is the viewpoint of a neighbouring building. This is how a given house might appear to one of its kind. We have the sense, in other words, that this is how these buildings might, *in time,* photograph themselves. And there is, it turns out, a kind of confluence here between architectural and photographic style since, as Babitz points out in her story 'Self-Enchanted City', 'a lot of Hollywood architecture seems to have been designed to look good in a photograph rather than to keep out the rain'.[4]

Even in a place famed for its perfect weather there is always *something* to be kept out or at bay. Consider, for example, the black cypress trees against the white walls. In *Twilight in Italy* D.H. Lawrence wrote that 'as we have candles to light the darkness of night, so the cypresses are candles to keep the darkness aflame in the full sunshine'.[5] These photographs prove that what Lawrence observed in San Gaudenzo also holds true in the long sunlight of Los Angeles.

2018

Luigi Ghirri

A recent Google image search for 'Luigi Ghirri' threw up a large number of photographs by Ghirri, many of which I was already familiar with, some of which I had not seen before. These pictures – certifiably by Ghirri – gave way to photographs of Italy that looked like Ghirris but were actually by other people. They were followed by pictures of places Ghirri had never visited, taken after his death in 1992, aged just forty-nine, but which looked very like the kind of pictures he might have made had he lived long enough to travel to these places. What happened, in other words, is that glimpses of the world as photographed by Ghirri gave way to an extended Ghirri-esque world view.

As with Walker Evans – the photographer Ghirri 'love[d] and admire[d] more than any other'[1] – it has become hard to distinguish between scenes and objects out there in the world and the artist's way of photographing them. The act of documenting simultaneously created what was there and made it available for others to photograph. Recording *brought into existence* or, at the very least, made visible what had hitherto passed unnoticed. In this respect, Ghirri's project harks back still further in photographic history, to the dawn of the medium when Daguerre (in Ghirri's striking formulation) 'simultaneously approach[ed] the frontier of the *already seen* and that of the *never seen*'.[2]

Needless to say, Ghirri's principled avoidance of aesthetic tricks and gimmicks constitutes an aesthetic in its own right – something else he shared with Evans. 'I also try to absent my own self,'[3] he observed, thereby echoing Evans's fondness for the Flaubertian method whereby the author's defining trait is, precisely, his absence. The appearance and appeal of those pseudo-Ghirris is, in this light, inevitable.

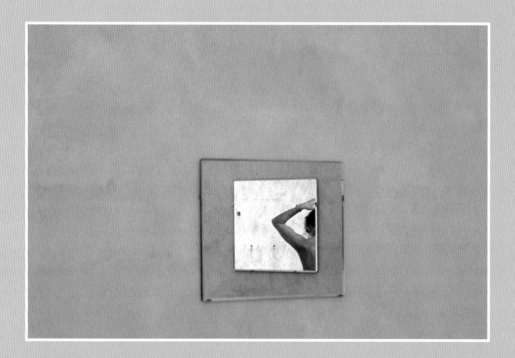

Île Rousse, 1976, by Luigi Ghirri

Ghirri's work seems to have a near-universal effect on anyone who encounters it. You see a handful of his images – an empty basketball court, a puddle in a road reflecting a palm tree, a kids' slide on a beach, a red Coca-Cola flag against a pale blue sky, a view of an Italian countryside that seems haunted by its own ordinariness, an empty piazza that looks like a de Chirico in broad daylight – and fall quickly under his spell. The initial enthusiastic reaction – 'What a great photograph!' – gives way, on the basis of only a little further sampling, to the conviction, 'He's a great photographer!' Actually, that might be understating things. E.M. Cioran wisely warned that the further a person advances in life, the less there is to convert to, but even at an advanced state of photographic appreciation you do not simply become an admirer of Ghirri's work; you become a convert.

The Ghirri cult is all the more powerful because it is posthumous. Considerable though his reputation was in Italy – as both artist and proselytiser for serious photography – international appreciation of his work has been predominantly retrospective. Many of us did not follow his artistic development incrementally as it unfolded. Instead the treasure trove of a life's work has been discovered and is in the process of being sifted, examined, curated and presented in his absence. Or, to put it in the kind of terms he seems to have favoured, we are still working out which of the various available projections offer the best ways to map the territory Ghirri made his own.

Lessons in Photography (2020), a collection of lectures he gave in 1989 and 1990, details the mechanical or technical components on which our subsequent faith is built. The fascination with technique that underpinned his dedication to the task of picture-making brings us to 'the threshold' – a vital word for Ghirri – of the metaphysical. Manifesting itself in several forms, this threshold is consistently located at 'the strange and mysterious equilibrium between our inner worlds and the external world'.[4]

Within the broad and devoted church we each have our own individual sense of the works or series of works in which this equilibrium is best achieved.

For me these would include certain beach scenes and the depictions of the Italian landscape – especially those in which some kind of frame is included within the framing of the picture: a goalpost (in the first picture of Ghirri's I ever saw, without even realising who the photographer was), windows, mirrors, gates, gateposts, arches. Arches and gates seen from the road seem often to offer a view of – and lead to – nowhere in particular.

The arch at Bagnolo San Vito or the gate posts at Formigine, Modena, serve no functional purpose in that you don't need to pass through them to get to what lies geographically or visually behind, but they are aesthetically essential. They *create* a picture that was already there: 'a photograph which *already exists* in the form of framed structures'.[5] Or, as Ghirri says of a picture of a white gate: 'Located at a given point in space, this gate becomes the focal point of the whole image. A continuous dynamic exchange occurs between a representation of reality and the underlying reality: it becomes a mechanism in which reality gradually dissolves into its own representation, creating something in which it is hard to distinguish between reality and representation.'[6]

The effect of all such framing devices is to usher us more deeply in to the pictures. They serve as portals to another world, which turns out to be the same world. No pictures better illustrate the line variously ascribed either to W.B. Yeats or Paul Éluard: 'There is another world, but it's in this world.' Ghirri himself makes a similar point when he describes framing as 'an exploration of a reality that lies within reality itself'.[7]

This reality is dreamlike – as long as we concede that the dream is real. Everything is 'immediately familiar yet mysterious'[8] – and the mystery is fathomless *because* it is quite transparent. ('Transparency' is another key word in Ghirri's personal lexicon; repeating the practical/metaphysical pattern observed earlier, the literal production of transparencies was a way of approaching 'the very idea of transparency itself'.[9]) Nothing is hidden, everything is

withheld. How, our eyes demand of our brains, can clarity be so opaque? Every mirror is also a window – and vice versa in that we are sealed within by that which offers potential egress. The possibility of escape is indistinguishable from the illusion of confinement. (Not that anyone wishes to escape, to wake from these lucid dreams.) What lies beyond is deeper immersion in the surface. Every bit of the phenomenal world – toilets near the coast at Île Rousse, say – is consistent with every other bit, even the parts of it that remain unseen, beyond the frame. The larger world is implicit in the smallest part; the smallest detail contains the whole. Photographs, by virtue of Ghirri's theory and practice of framing, exist within the photographs, some offering up mirror images of a poolside paradise, others (in the mirrors of the men's urinals!) revealing the photographer himself, 'inside the narrative, an individual inside the story'.[10]

Except, within a given picture, there *is* no story. The possibility of narrative only emerges when the photographs are viewed in sequence. In this regard the stillness of the individual pictures – no moving trees or people hurrying and going – is both symptomatic and causal. Again the logic is circular, hermetic. The stillness is the spatial manifestation of the absence of time and the temporal expression of a lack of movement through space. Hence the lack of narrative. There is no going beyond the moment because, in anything but the technical sense – one 250th of a second or whatever – the moment does not exist. Cameras provide the option of focusing on a distance given as infinity. The equivalent shutter speed would, I suppose, be eternity. Each of Ghirri's pictures offers us a specific moment of eternity. By offering themselves entirely, in an instant, they make us feel that we could stand and gaze into them, not just for a long time but on the threshold of forever.

2020

Formigine, 1985, by Luigi Ghirri

© Eredi di Luigi Ghirri

Peter Mitchell's Scarecrows

A photograph is not the same as the thing photographed. But sometimes photographs make you conscious of that thing in a way that the thing itself never quite did. More precisely, they make you aware of things – stuff – about that thing of which you were either barely conscious or entirely oblivious. Whether photographing a pepper or a toilet bowl, Edward Weston repeatedly insisted that the camera was uniquely equipped 'for rendering the very substance and quintessence of the *thing itself*.[1] Back then the potential of the camera was still in the process of being explored and established, was inevitably drawing attention to itself. In the case of Peter Mitchell's pictures of scarecrows it is as if the photographs do not exist, as if we just chanced upon these creatures in the course of walks we've taken hundreds of times before. So how did we miss them?

Well, partly because Mitchell was only recently persuaded that pictures taken over a forty-year period, from 1974 to 2015, might be of interest to anyone beside himself. Which is strange, given that he has long been regarded as one of the most important British photographers working in colour. In his seventies now, he was included in Martin Parr's *Colour Before Color*, a 2007 exhibition in New York that sought to challenge the standard account whereby colour photography only got going with William Eggleston's show at MoMA in 1976. A number of American photographers were using colour before then but, as that extra 'u' in the title hinted, Parr extended the catchment area to include British and European photographers such as the quiet visionary Luigi Ghirri.

If Mitchell has worked obsessively close to his home in Leeds, this should not be confused with parochial appeal or limited ambition. His 1979 exhibition

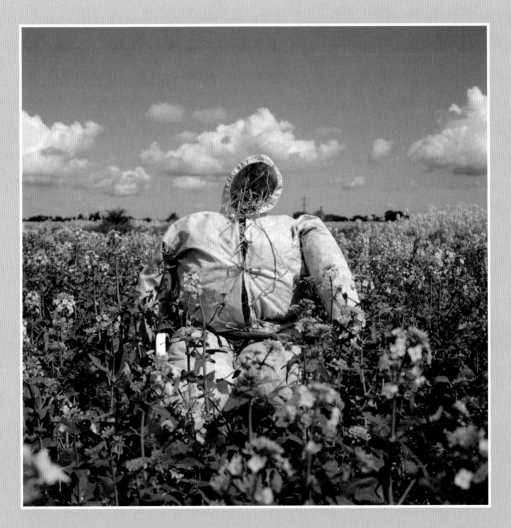

From *Some Thing means Everything to Somebody* by Peter Mitchell

By kind permission of Peter Mitchell and RRB Photobooks

A New Refutation of the Viking 4 Space Mission presented the city as it might appear to visitors from Mars. Unwavering in his commitment to the specificity of the universal, Mitchell insists in his book *Some Thing means Everything to Somebody* (RRB Photobooks, 2015), that the scarecrows 'are essentially Yorkshire'.[2] Further research is needed to discover the regional variations and consistencies in scarecrow design and construction but, to me, they are . . . essentially Gloucestershire, where I grew up. They take me back to afternoons spent on my dad's allotment with these strange creatures in silently dilapidated attendance. I mean that literally; they waited in a state of transient permanence. They were, I see now, signposts from the past in that they seemed always to have been there. Looking back on his childhood in 'Nottingham and the Mining Country', D.H. Lawrence writes that he was conscious, as a boy, of 'Robin Hood and his merry men' not as a memory but as a felt presence in the landscape. In both cases we are talking less about history – which is necessarily concerned with dates – than the pre-existent. While for archaeologists the past has to be dug up and uncovered, Mitchell enables us to see that it's there before our eyes.

Mitchell goes on to say that his scarecrows 'could be Walter De La Mare's "host of phantom listeners stood thronging the moonlit air, listening to the world of men" or the various tribes of farmers or anybody. But to me they're friends.'[3] Asked why he 'liked' scarecrows he responded:

> They are temporary
> They have character
> They are not neutral
> They have a job to do
> They are between heaven and earth
> They symbolise and remind us of things
> I could go on and on and on[4]

Since he didn't, I will. We have to start with the fact that they are nearly human. In a sense, they are homeless – rough sleepers – in that they're out

in all weathers. They tend, consequently, to be wrapped up warmly whatever the temperature on the grounds that while being overdressed for the heat is uncomfortable it is not as life-threatening (in England) as the cold can be. So even in a field of sunflowers, in mid-summer, they dress as if for a February blizzard in the Alps.

I said that they are homeless, that they are rough sleepers, but only statues or trees are more firmly attached to a particular place. One appears to be walking, as if the photograph rather than the ontological limit of existence has frozen him in his tracks. To that extent they're entirely at home – in themselves. And they never actually sleep. Eternal vigilance is their motto and *modus vivendi*. If they nod off, even for a moment, then their effectiveness as a deterrent will be compromised. They have a consciousness, that is obvious (because everything in a photograph is obvious). This consciousness is of the kind usually achieved through deep meditation. Devoid of ego, they are at one with the earth and the sky and, by extension, all of creation. Including, um . . . *crows*?

After all the years in which the relationship of scarecrow to bird was one of hostility and repulsion, could it be that the scarer longs to shake off the limiting function for which he was intended? If only there were a photograph of a crow perched on the shoulder of the thing designed to instil fear. That would offer proof, on the one hand, that it was not fit for purpose; on the other it would be a lovely reconciliation. A pipe dream, clearly: the scarecrow nation still waits for its Francis of Assisi.

I am torn between the urge to generalise and the need to recognise diversity. Each scarecrow has its own personality. Some wear waterproofs (always a good idea in rainy Yorkshire). One looks like a cross between a melting ice cream and a giant condom hung out to dry. Which seems a good moment to raise the issue of pronouns. It's easy to speak in the plural of 'they' and 'them'. But given that each scarecrow is singular, should we speak of 'it', 'he' or 'she'? Most seem masculine, none more so than the lewd character slumped in a chair and red in the face – well, what do you expect when you're caught jerking

off in the middle of a winter field? The reason for this chilly expediency is that women are so hard to come by.

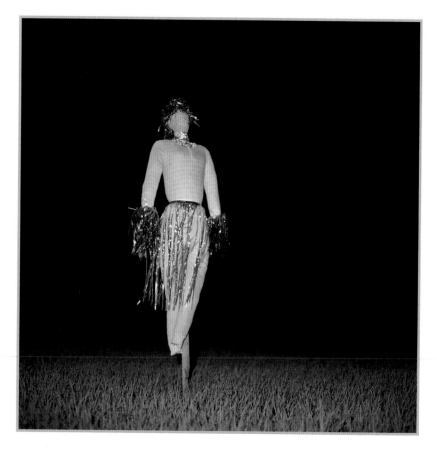

From *Some Thing means Everything to Somebody* by Peter Mitchell

By kind permission of Peter Mitchell and RRB Photobooks

As far as I can make out there's only one real looker, decked out in a pink body stocking, revealing sparkly grass skirt and green wig, the whole ensemble glamorously polished off with silver necklace and pink pompoms. Talk about all dressed up and nowhere to go! The (doomed) party atmosphere is heightened by the way that this is one of only a couple of pictures taken at night. Which begs the question: while fundamentally solitary and averse to

get-togethers, do these outcastes – these palpable untouchables – communi-cate with each other? Are they, in fact, a *system* of communication? If so, with whom are they communicating? An anthropologist from Mars would have no doubt: they are communicating with the gods on our behalf. Which gods? Well, this is where the anthropologist might get it wrong, might conclude, by reference to Kierkegaard (who observed that 'even the remote resemblance a scarecrow has to a human being is sufficient to inspire respect'[5]), that they are erected by the crows or, more broadly, by the non-human mass of nature as tributes to *us*.

Kierkegaard's countryman, the photographer Henrik Saxgren, published a se-ries of photographs called *Unintended Sculptures* featuring structures which, viewed in a certain light, from a given angle, might be considered works of art. The scarecrows could be regarded as folk art, but this ignores an impor-tant dimension of their being. For their aesthetic and practical value seems inseparable from some ritual or religious purpose, as if they are leftovers from seasonal rites that have been forgotten. Looking at Mitchell's pictures, I am reminded of the guys – also made from discarded clothes bulked out with straw or waste paper – we used to wheel around in old prams or trolleys in the weeks leading up to Bonfire Night, when they were burned. T.S. Eli-ot's poem 'The Hollow Men' is preceded by a line slightly misquoting what we used call out: 'A penny for the old guy.' We never said 'old'. Had we got it wrong – inconceivable – or had Eliot? Conscious only of wanting money, we were mouthpieces or conduits of larger forces (what Eliot would have called tradition) that continue to find explosive expression every 5 November.

Like these effigies – and unlike statues – the scarecrows are not permanent, let alone immortal. So it is appropriate that Mitchell's photographic record does not aspire to the rigorous taxonomies associated with Bernd and Hilla Becher. It's more like a bunch of street portraits, done slowly, in fields. Time, in its physical manifestations – rain, wind and sun – takes its toll. Not having

access to the actuarial data, I don't know the average life expectancy of a scare-crow. Is it just a season (as in the world of fashion) or a year? Either way the snowsuit becomes smeared in blood, as if it has barely survived some frosty and atrociously extended ordeal. A bloody wound suggests that crows have begun to peck away at its Promethean liver. Eventually the clothes rot away so that the scarecrows acquire a Lear-on-the-heath air of tragedy: 'Off, off, you lendings!' The difference is that whereas Lear discovers that beneath the clothes are 'poor naked wretches' these guys *are* their clothes. Patched together not from stolen body parts but lent clothes there is, nevertheless, a Franken-steinian quality to them: they are, by definition, *scary*.

As the scarecrows collapse in on themselves it's as if they end up consum-ing their own body fat just to stay alive – if that is the word, which clearly it is not. One photograph resembles a police view of a crime scene in which a scarecrow ends up flat on its back, decomposing like the remains of a murder victim. Another looks like he's been lynched. This sacrificial quality becomes more pronounced as the skeletal structure is laid bare by time. Eventually all that's left is a wooden cross with a few tatters blowing in the wind.

2016

Nicholas Nixon: The Brown Sisters

From the most modest beginning in July 1975 – a single picture of his wife, Bebe, and her three sisters – Nicholas Nixon has created a profound and ongoing exploration of what it is to be human – which is, uniquely among animals, to live in time. Since then they've gathered each year for a photo shoot with the sisters always lined up in the same order, from left to right: Heather (twenty-three in 1975), Mimi (fifteen), Bebe (twenty-five) and Laurie (twenty-one). From each shoot a single image is chosen to stand as a permanent record of that year.

Aside from the fact that they are Nixon's wife and sisters-in-law, all we know about the Browns is what the pictures show. While in many other photographs there is an abundance of information about clothes and fashion – in the restlessly crowded world of Garry Winogrand, for example – in these it's minimal. Compared to the fascination exerted by their skin and faces, the sisters' clothes are pretty uninteresting. To that extent they are as naked as clothed people are ever likely to appear.

Over time their fortunes and circumstances (about which, to repeat, we know absolutely nothing) will have fluctuated. In any given year, I'm guessing, things will have gone particularly well for one or more of the sisters while for one or more of the others adversities and setbacks will have been either succumbed to or overcome. Pick a year from the 1990s. This will be a year when one has married, divorced, had a child, started a new job, lost her job, moved into a new house, fallen in love, had an affair, travelled to some exotic country, been audited by the Internal Revenue Service, been inconvenienced by a cancelled flight and – just the day before the shoot! – had to cancel her credit card

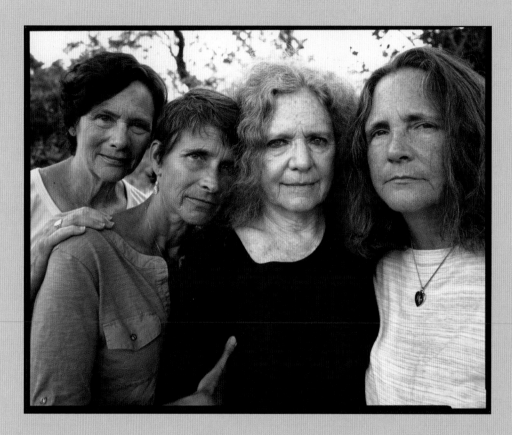

From *The Brown Sisters* by Nicholas Nixon

because it had been stolen, except it hadn't been stolen, it had been handed in at the supermarket by an honest fellow citizen. All of this data is there in that open but immensely complex book of the human face. Presumably, in the course of a given year, one or more of the sisters has quarrelled with another member or members of the group. Various narratives can be implied from or imposed on the stilled evidence of gestures – who's embracing who, who's standing alone, arms folded and isolated within the collective – but nothing can be independently verified. In addition, the photograph chosen to represent a given year was not the only one taken at a given shoot. Any conclusions we come to on the basis of the chosen image might well be contradicted by the others that have not seen the light of day. (Though it could be argued that the process of selection – a joint enterprise, apparently, between photographer and subjects – is itself telling.)

Variants of almost all of the things that have happened to the sisters over the long unfolding of the project will happen to everyone. In addition to routine hindrances and joys there were probably more serious matters to contend with: a miscarriage, a bout of depression, an unexpected financial catastrophe (in 2008 or 2009, presumably?). Obviously anything that directly affects one sister – an illness, say – also has an impact on the others. Perhaps one of these pictures shows something they shared equally: the death of one or more of their parents. Nixon is an only child: he must be conscious of an existential feeling of alone-ness – not loneliness, which is quite different – that the sisters can never share. (I'm presuming that this was part of his motivation and fascination with them as subject matter.) Again, one scrutinises the pictures with questions and possibilities they neither deny nor affirm. Faces and gestures say everything and nothing.

Photographers from Bill Brandt to Richard Avedon to Diane Arbus have claimed that photography can serve as a kind of prophecy, that a photograph of someone at a particular moment in their life can tell everything about what life has in store. Arbus, for example, said of Ernest Hemingway and Mari-

lyn Monroe that suicide was there in their faces, that their fate could be seen. It's an attractive idea precisely because it's not true. The only way you can see the future is to wait for it to come around and record the results so that, in retrospect, it appears obvious and irrefutable. Meanwhile, we live the years. Or, more accurately, the years live us. That's what makes this series so absorbing and, in a way, so awful. The revelation of the inexorable is as powerful here as it is in a Greek tragedy. Especially since whereas the photo sessions used to come around just once a year, now they are coming round . . . well, still once a year in calendar terms but, as sisters and photographer grow older, so the felt duration of each year – the interval between shoots – shrinks as time accelerates. If they continue for a decade or more the sessions will start to seem like different images from a single shoot. So, with every passing year, the series of static photographs gains momentum. With the project ongoing, we wait for each new picture – each stilled episode, as it were – with easily contained impatience. What will it reveal? In a sense, not much. The difference from one year to the next is not that great, but from one decade to the next it is unmistakable. From year one to year forty it's almost terrifying.

In her book *Teaching a Stone to Talk* Annie Dillard likens being born to opening up a summer cottage. The similarity comes from the fact that at the moment you are born or enter the cottage 'you have all the time you are ever going to have'.[1] After a certain age, typically from fifty onwards or from when your parents die, one of your main experiences is of time running out, or running away with *you*. In addition, more and more things start to go wrong with your body. Joints ache. Teeth need fixing. Hair greys. Skin loses its glow. Things begin to sag. Beauty fades. Features coarsen.

Time achieves its effects in many ways but, after a certain point, as these photographs make plain, it's doing one thing and one thing only and that thing is, so to speak, staring us in the face. It is tugging these women towards death. Or, let's allow a little leeway or ambiguity: it is preparing them – and us – for death. The photographs may not have been about death when

the project started but with every year it becomes apparent that that's what it's about – and was about all the time, even if no one knew it at the time.

Not to acknowledge this is, effectively, to avert one's gaze, to look elsewhere. Earlier I said that the series had gained momentum: more accurately, it is gaining a terminal momentum. In a thoughtful essay about the project, novelist Susan Minot points out that in 1981, 1983 and 1984 the photographer's shadow appears in the frame. She sees this as evidence of his desire – the desire of every only child – to belong. This is an optimistic reading. I see the shadow more ominously. Especially since it's not just Nixon's shadow but the shadow of the camera – of photography itself – that is encroaching, making its presence felt, like a revealed mass in an X-ray. Earlier I wondered about the various things that may or may not have happened to the sisters in a given year, but Philip Larkin's poem 'Aubade' – in which the poet contemplates his own death – renders all such speculation futile. 'Most things may never happen,' he concludes, 'this one will.'[2]

One year there will be not four sisters but three. That's assuming that Nixon will go on with the project after the death of one of the sisters. A string quartet might continue as a trio but more commonly will recruit a new violinist. No replacement is possible here. So the decision will be taken either to call a halt once the quartet is no longer available or to continue to the end – a scaled-down, photographic equivalent of Haydn's 'Farewell' Symphony – when there will just be one sister left. The conclusion then will be that ultimately there are *only* only children.

There is, of course, a concealed assumption in the preceding paragraph. Namely that the photographer outlives his subjects. It could come to an end because he predeceases the sisters. There is also a third possibility: that whatever happens, I will no longer be around to see it.

2015

Lynn Saville and the Archaeology of Overnight

Towards the end of her life Diane Arbus said that she had come to 'love what I can't see in a photograph. In Brassai, in Bill Brandt, there is the element of actual physical darkness and it's very thrilling to see darkness again.'[1] Thrilling but risky. Responding somewhat dismissively to William Gedney's proposed series 'The Night', John Szarkowski commented, 'Photography is about what you can see – this is what you can't see.'[2] The dilemma is as simple as it is complex: to allow us to see that which cannot be seen. Hence the attraction of twilight or dusk, when the seen is poised to disappear into the unseen, when the daylight world of facts begins subtly to slide into the realm of dreams. While the overall mood will always be tinged with romance, the atmosphere of a given picture depends on *how* dark it is, on the balance between memory – of the day that has gone – and the promise of what the night will bring. At dawn the dreams of night give way to the facts of day, when you are able to see what was previously hidden.

Lynn Saville has wandered purposefully through every phase of the nocturnal world, from dusk through deep night to dawn. As a photographer, daylight seems to hold roughly the same attraction for her that it does for a vampire. It is as if, in developing such finely calibrated night vision, the capacity for seeing in broad daylight has been correspondingly diminished.

Between twilight or daybreak lie the variously extended vacancies between places falling into disuse (and out of sight) and being re-fitted and re-seen (with the shared word, shutter, uniting premises and camera). Throughout *Dark City* (2015), in other words, we see the economic equivalent of the diurnal cycle of night and day, light and dark. Much economic planning is dedicated to breaking

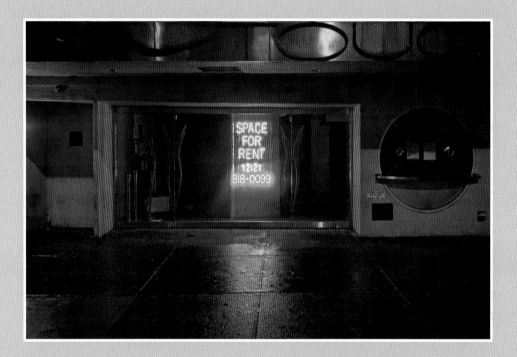

Space for Rent, from *Dark City* (Damiani, Bologna, 2015) by Lynn Saville

the pattern whereby bust follows boom as surely as night follows day. Unapologetic advocates of the free market claim that each bust creates the conditions for a more splendid boom. Either way, on a daily or nightly basis, in cities all over the world, we witness this sequence of closing down and opening up: the seasonal shifts of capital as places go out of business because of rent hikes (during times of prosperity) or bankruptcy (during a recession) before falling into disuse for a while (brief in periods of prosperity, extended in a recession) before being reborn either as cafés, pop-ups or (less happily) as 'Everything for a Dollar' stores. In reality, it's all more complicated than that, of course. Some streets undergo such a boom that there are always empty premises because rents are rising so quickly that fashionable new businesses succumb to the same fate as the quaintly outmoded ones they have displaced. So the boom is adorned and littered with evidence of bust. Residents view these periods of transition with the vested interest of people anxiously awaiting news of a family member who is in hospital: will the outcome be recovery or further decline? In the hopeful meantime a vacated site becomes a place of intense employment as architects, construction workers, designers and fitters prepare for its new life . . . as a café, a restaurant, or whatever it's going to be. And so the empty site becomes pregnant with meaning.

While the same forces – economic, planetary – converge on many images and places in this book, they are observed formally rather than didactically. Saville is fascinated by conflicting colours, reflections and forms of illumination (street lamps, neon, fluorescent strips) and how they interact and react, not so much to being seen, but to being filmed.

There is something lovely about the Fall, when twilight coincides with people coming out of offices, as the working day gives way to the leisure and romance, the carousing and boozing, of evening. And then there are those extended summer days when twilight falls shortly before people head home to sleep. Saville is relatively uninterested in these interludes of heavy foot traffic. Part of the appeal of the night, for her, is that densely populated areas become

largely unpeopled. At night a reclamation seems to take place. It's not that the city becomes uninhabited; more that it is inhabited by itself, by premises and windows, walls and doors, all of which seem to exist for their own sakes, not as conduits to or components of social interaction. This is signalled by the very first picture in the book, of a blank billboard on a road in Baltimore: a lyrical declaration that the journey to be undertaken in these pages is to a city or destination stripped of many of its usual attractions and functions. The neon 'SPACE FOR RENT' sign on West 51st Street in New York advertises its own emptiness so effectively that it seems a shame to convert it to any other use. A string of lights takes on the appearance of an after-hours art installation at the opposite of a gallery opening – a *closing*. Sometimes there is evidence of what might be called the archaeology of overnight: resting tools, tired steps, dreaming brooms, sleeping shadows. The occasional human presence serves not to diminish but enhance the sense of emptiness, to bear witness to sites of vacant self-sufficiency without disturbing or intruding on them.

With our attention fixed on what is before our eyes – no urge to look behind, over our shoulders – these nights, these places, are entirely without fear. They give us a sense of being invisible. And so a strange inversion takes place. The night becomes visible as *we* fade from sight. We are represented either by token figures, their reflections, or by a shadow (the photographer's own), deepening the impression that it is the buildings, the doors and windows – the lighted night itself – doing the looking. This is Neighbourhood Watch in pure, unthreatened form.

The clarity of seeing also makes us conscious of the silence – which is absolute. There is no rumble of traffic or of the subterranean bass from nightclubs, no dawn chorus, even. The pristine silence, the lack of motion in these very still photographs create the sense of a world that has dropped out of time – and therefore out of the cycle of transactions. Stripped of contemporary merchandise and telltale signage, empty premises become difficult to date so that they seem sometimes to have dropped not only out of time but out of *history*. And

yet, at the same time, so to speak, we are conscious in many of them that this is a transitory or fleeting phenomenon. Instead of a world that has dropped out of time, then, we should more accurately speak of *instants* that have dropped out of time. Hence the tension in images in which there is a conspicuous lack of drama or tension. The vacancy is both spatial and temporal – and *Dark City* is full of it.

2015

Philip-Lorca diCorcia's Magic

You know that thing that can happen when you're about to take a friend's picture in front of some world-historic site – a muscle-bound statue, say, or the Colosseum – and, just as you press the button, a passer-by or dog strays into the frame? Nine times out of ten the picture's ruined, but occasionally it's improved, the intrusion throwing into ironic relief or bringing out an unnoticed aspect of the person or the world-historic whatever he's posing in front of. That's pretty much what happened here. I was all set up and ready to focus on Philip-Lorca diCorcia, when who should wander into the shot but Diane Arbus, saying, over her shoulder, that if you've got a camera then 'you're carrying some slight magic'.[1]

If the camera's a form of magic then I guess the resulting image is a kind of trick: in the case of certain photographs, a perfectly executed one. Does this leave the critic in the role of killjoy and know-all, doggedly telling everyone how the trick's been done – which, although it's what we want to know, turns out to be the *last* thing in the world we want to know? You really want to trade in all that wonder for a handful of explanatory beads about whichever dodges (to use an old darkroom term) were employed? Of course not, and you don't have to because Arbus – the most gnomically articulate of all photographers – offered, in passing, an alternative: namely 'the trick of explaining a trick by a further trick, which is the supremest kind of eloquence'.[2]

That got me wondering if, instead of explaining how diCorcia set up his lights like a baited trap on the street, or paid his Hollywood hustlers what they'd get for – well, for turning tricks, as it happens . . . If, instead of all that stuff (which most of the good people reading this know plenty about anyway), we could just

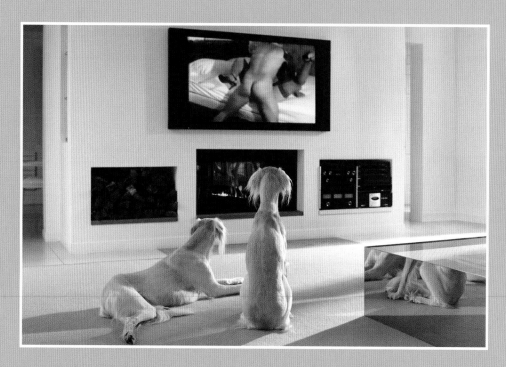

The Hamptons, 2008, from the series *East of Eden* by Philip-Lorca diCorcia

By kind permission of the artist

look at the pictures, maybe describe the tricks, convey what we feel both as they are enacted before our eyes and later, in the wondering afterglow of the experience (which turns out to be part of the experience).

This, after all, is what the works themselves often urge us to do. Take diCorcia's weird book *A Storybook Life*. Seventy-five pictures with no introduction or afterword and no captions, just a list at the end stating vaguely, with a minimum of specificity, where and when each of them was taken: 'Los Angeles, 1980', 'Hartford, 1978' and so on. The main effect of this list is to confirm what you had suspected: that no geographical or chronological order is at work.

A Storybook Life is a sort of camouflaged retrospective that also declares its autonomy and independence. The title is both umbrella and section heading, simultaneously asserting – that there *is* an order, that it *is* a coherent body of work – and querying that assertion: is it really? The pictures are positively charged – to greater and lesser degrees of intensity – with insignificance. 'The one thing is that it is always a banal situation,' diCorcia told an interviewer. 'There's nothing going on.'[3] Each variant of this default situation, each picture, demands that we think intensely: why *this* moment, *this* place? (In the case of pictures by Henri Cartier-Bresson that's always exquisitely and subtly – though not always instantly – obvious; Robert Frank was the first to introduce these doubts and questions as necessary components of appreciation.) Wouldn't another moment have served just as well? Well, funny you should ask, the *Storybook* replies, because here, on the next page – or, in a gallery setting, a few metres along the wall – is another asking the same thing in a slightly different way. Out of this deferral a non-story of constantly confounded expectation gradually emerges. The more you look the more pronounced it becomes, this simmering sense of uncontained sealed-in-ness. Or, putting it the other way round, the *Storybook* is like a hermetically sealed system with a steady leak that is unlocatable because it – the leak – is everywhere. Another word for an omnipresent leak is, I suppose, a flow. (At which point I confess that it took me a while to learn where the various bits of Philip-Lorca diCorcia's almost-

rhyming name began and ended: the syllables just flowed rhythmically together.)

Moving beyond the *Storybook*, the enhanced sense of the ordinary in diCorcia's pictures is often the product of a combination of natural and artificial light. The atmosphere is dreamlike but without the usual oneiric blurring or ghosting, which are visual symptoms or results of movement. There's no sense of hurry or urgency anywhere in the considerable expanse of diCorcia-land, only of suspended agency. What Mark Strand said about people in Edward Hopper's paintings – they find 'a resting place within a moment that is wholly transitional'[4] – goes for the folk in diCorcia's photographs too. Actions, however simple, rarely look like they'll be completed. A woman ironing clothes is making such slow progress that she could be posing for Vermeer. Gazing into the fridge in 1978 in diCorcia's first famous picture, Mario will be contemplating its contents – revealed in a frosty POV shot from *A Storybook Life,* in Hartford in 1980? – until the coming of the next Ice Age. Smoked in a suburban window at night, a cigarette burns like a little handheld version of the eternal flame. DiCorcia's chairs and beds look only a bit easier to get up from or out of than the coffin that brings the *Storybook* to a close. People remain stuck at the level of noun without recourse to the appropriate verb. A woman has a *knife* but seems unable *to chop.* Another is locked in a nocturnal trance, suspended in the midst of a two-step sleepwalk from gas pump to car. It's not that time has stopped; it's just nowhere to be seen.

And yet diCorcia's characters usually seem in partial possession of some form of motivation – if only they could remember what it was or, more accurately, what it meant to act on it. *Act* is the operative word in these scenarios, some of them so painstakingly conceived and constructed you could be forgiven for thinking that the guy who's taken a tumble in New York in 1984 – losing his spectacles and dropping his newspaper in the process – had bumped into a Jeff Wall. Fortunately, Arbus, before she fled the scene, alerted us to what's going on. 'The world,' she discovered in 1961, 'is full of fictional characters looking for their stories.'[5] It's just that, in diCorcia's world, people rarely look like they're

going to find them – or, for that matter, get wherever it is they're trying to go. (By the same token – and at the risk of sounding absurd – even the grass in diCorcia's lawns and parks can't seem to find the time to grow.) The emblematic shot in this regard was made in Paris, 1998. It shows an architectural void in which the only evidence of life is a human figure, black on a white background, surrounded by a red circle: a sign that seems intended both to warn that pedestrians might be in the vicinity and to remind them – pedestrians – that their presence is forbidden. Like that diagrammatic figure, diCorcia's people are stranded in the somnolent clarity – a kind of super-unconscious – of a moment that seems oddly like others which, for whatever reasons, have not been preserved. At their most extreme they're just isolated heads, lost in and surrounded by unfathomable space.

I know I said I wasn't going to explain away the magic, but it has to be mentioned that the visual language of advertising, the model diCorcia often uses and to which his pictures constantly appeal, plays a part in this effect. On the basis of its insistent lure – buy this product and you'll be transformed, from how you are to how you want to be – Raymond Williams called advertising 'the magic system': 'The attempt is made, by magic, to associate this consumption with human desires to which it has no real reference.'[6] In diCorcia's pictures, of course, nothing is being sold (except, if you want to get really autotelic and meta about it, the pictures themselves!), so that what we are faced with is a kind of advert for the satisfactions of – and disappointments yielded by – existence itself. Advertising depends on the promise that before will be transformed by after (the purchase). In diCorcia's pictures they're just different parts of a set-up so thorough that they end up being indistinguishable from each other. Which is just as well, since the temporal equivalent of that lack of movement mentioned earlier means you can't actually get from the former state (desire) to satisfied consumption anyway. Unless, that is, you're operating on the level of the hustlers turning those twenty- and thirty-dollar tricks which, I'm guessing, is not quite what you or the magic system were hoping for.

In England there's an expression for the sense of disappointment – or, as Johnny Rotten put it at the end of the Sex Pistols' last gig in San Francisco, 'the feeling that you've been cheated' – that comes over you after being persuaded to fork out for something not worth having. We talk about *being sold a pup*.

Now, it so happens that puppies and dogs crop up quite a bit in diCorcia's pictures. They're on sofas, waiting on steps, surveying a street at night (front paw resting on a buckled can of Bud), peeking out from behind chairs, burrowing into the earth while a pair of seated card players study the hands they've been dealt (while, incidentally, never looking like they'll ever *play* a card). Mainly what these dogs are doing is *looking*, either at the photographer or at the scene and people he's photographing. (A picture from the *East of Eden* series shows a neat pair of dogs entranced by an on-screen porn film, hoping, presumably, that these humans will eventually go at it doggy style.) In a poem by Billy Collins called 'The Revenant' a dog comes back from the dead to regale his former master with certain fundamental, supremely eloquent truths. Possessed of a near-photographic memory, the dog recalls 'the absurdity of your lawn', 'the way you would sit in a chair to eat,/a napkin on your lap, knife in your hand', and how 'While you slept, I watched you breathe/as the moon rose in the sky.'[7] Looking at diCorcia's dogs, I suspect that they have similar powers of cognition, recollection, revelation and explication. They're our embedded and ideal representatives, these dogs, always looking, and never – as another English phrase has it – missing a trick.

2013

Alex Webb

Alex Webb has described his work as 'a highly interpretive presentation of the world'.[1] The chronological survey offered by his 2011 monograph *The Suffering of Light* tilts the balance away from the second half of that description towards the first half, from the content of the pictures ('the subject matter out there') to the photographer's vision. What are its essential characteristics? How has his vision changed? What has remained the same? Which things are unique to Istanbul, say, or Haiti, and which are universal (in the sense of unique to Webb)?

Where do we come from?

In *Tristes Tropiques* Claude Lévi-Strauss recounts how, on arriving in Calcutta, he discovers that 'the word tension has no meaning. Nothing is tense, since everything that might have been in a state of tension snapped long ago.' A different way of looking at the same situation results in a slightly amended assessment: 'Everything is in a state of such acute tension that no kind of equilibrium is possible.'[2]

Could these two ostensibly contradictory remarks be applied to the tradition of street photography inherited by Alex Webb when he made his first forays to the tropics?

The rules of visual rhyme and harmony established by Lévi-Strauss's exact contemporary, Henri Cartier-Bresson, were stretched by Robert Frank to the point where they seemed – the pun is irresistible – to have been snapped. Almost as soon as we had got used to this apparent slackness, we were asked to get our heads around a quite impossible notion: just because things had been

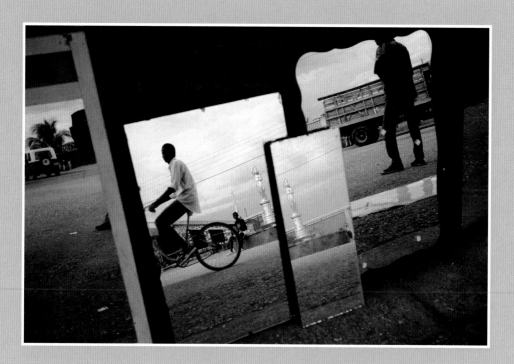

Cap Haitien, Haiti, 1987, by Alex Webb

Courtesy of the artist

stretched beyond breaking point didn't mean they couldn't be stretched further. Something, naturally, had to give. As a result there is plenty of tension but little equilibrium in the work of Garry Winogrand. 'Every photograph is a contention between form and content; one is always threatening to overwhelm the other,' he said. 'I like to work in that area where content almost overwhelms form':[3] an area where everything is pulling everything else out of whack (and thereby holding it together so that some kind of wonky equilibrium is re-established).

Webb is similarly addicted to testing to the limit the load-bearing ability of his pictures: 'It's not just that *that* and *that* exists. It's that that, that, that, and that all exist in the same frame. I'm always looking for something more. You take in too much, perhaps it becomes total chaos. I'm always playing along that line: adding something more, yet keeping it short of chaos.' This was in 2003; since then he has found ways of piling on still more *that*s, especially in *Istanbul* and *Violet Isle* (photographs of Cuba, made in collaboration with his wife, Rebecca Norris Webb).

Where are we?

'What could a bunch of complicated photographs of Haiti in this trying time [1986–8] possibly mean?' asks Webb in *Under a Grudging Sun*.[4] Some of Lee Friedlander's black-and-white photographs are even more complex in terms of composition and tension, but Webb felt compelled to take on a massive additional complication. His influences were the photographers mentioned above (Cartier-Bresson, Frank, Winogrand, Friedlander), and when he first worked on the Mexico–US border in 1975, he dutifully photographed in black and white – even as the terrain cried out to be shot in colour. The reasons for this appeal were aesthetic, cultural and political, none of which could be separated from each other – or from Webb's way of seeing the world. Politically and morally an appropriate aesthetic response was demanded. 'The world is a complex place and there are great dangers when you start looking at everything in terms purely of black and white.'

So you start looking at it in colour.

The result: complicated pictures of complicated situations. *Increasingly* complicated pictures, in fact, but there is a consistency to the underlying rationale: if the pictures made in Istanbul are especially complicated, that is not just because, in his maturity, Webb has been technically able to deal with greater visual complexity; it's also because the place itself demands a complex response.

Where are we going?

Part of the second wave of American photographers working in colour, Webb made his essential contribution by asking the simplest of questions: if you are interested in colour, doesn't it make sense to go where the colour is? In this way he was following the same logic as Van Gogh and Gauguin, in painting, when they decamped to the blazing yellows of Arles. Gauguin, of course, went further, to the tropics of Martinique and Polynesia. (I wonder: is Webb's photograph of pilgrims bathing in the waterfalls at Saut-d'Eau in Haiti a kind of documentary composite of – and homage to – Gauguin's Tahitian masterpieces?)

In a 2003 interview with Webb, Max Kozloff comments on 'a kind of electrifying enigma' in the photographer's approach, 'not necessarily a contradiction in terms, but an order of dissimilar things put together in a surprising way'. It's an observation that recalls Samuel Johnson's line about the defining quality of the work of John Donne and the metaphysical poets: 'The most heterogeneous ideas are yoked by violence together.' This raises the suggestion – if such a thing is not itself a contradiction in terms – of Alex Webb as *metaphysical* photographer. (The work of de Chirico, especially the so-called metaphysical paintings with their turquoise twilights and drastically elongated shadows, made a great impression on the young Webb.)

There's a lovely moment, in the essay at the close of *Violet Isle*, when Pico Iyer calls Webb 'a shadow sociologist'.[5] He is indeed a sociologist – and catcher –

of shadows, sharing D.H. Lawrence's belief that in hot sunny places life lurks in the shadows (Lawrence was writing specifically about Italy, but the point has a broader resonance). Digitally remove the shadows from the work of Cartier-Bresson and the pictures would remain almost entirely intact. Take them away from Webb and great hunks would be chomped out of the pictures. Actually, that, in a sense, is exactly what the shadows are in Webb: areas of such intense darkness that they seem almost to have been snipped out of the picture frame, leaving it as jagged as the black centre of the smashed window photographed by Brett Weston, in San Francisco, in 1937. For Kozloff, these shadows act like a chorus of 'unseen witnesses', looking in on the actors and action in the light. But the distinction between actors and shadows, participants and witnesses, is fluid, shifting. Dark-skinned to begin with, silhouetted against the light, underexposed and, in one case, ingeniously distorted, the guys in the first picture in *Under a Grudging Sun* are, as it were, shadows of themselves.

Elsewhere, too, figures in the photographs' shadow choreography are insubstantial, spectral. It's not that we can see through them, exactly, but they are not absolute barriers to what is going on behind them, are not entirely separate from the background (in so far as it makes sense to use that word in connection with a photographer who consistently does away with the distinction between foreground and background). Either the building they are passing has taken on some of their colour or they have absorbed some of the building's. It is as if parts of the walls have detached themselves and become briefly perambulatory. This tendency is less pronounced in the later work, in Cuba and Istanbul, where the individuals depicted are more substantial and the photographs, consequently, more psychologically dense.

'At the end of the small hours: this town, flat, displayed . . .'[6]

(Aimé Césaire, *Return to My Native Land*)

A man in Bangalore who, in the morning, makes an offering to his god

before going to the job where he is employed as a software engineer seems to live in several worlds or several centuries simultaneously. Webb frequently photographs harmonious dislocations of this kind.

In a city such as Varanasi in India, the Western visitor is conscious that while he or she is seeing the same ostensible reality (buildings, signs, temples) as the residents and pilgrims, they are also seeing – and are part of – another belief-dependent reality. Webb has the knack of recording both realities simultaneously (again that abolition of the distinction between foreground and background is important).

His cities are palimpsests in which one world is constantly peeking into or giving way to another through windows, doors, posters, fading layers of paint. (As Iyer puts it, Webb catches 'what has been pushed down below the surface or is just around the corner'.[7]) The slowish shutter speeds sometimes miss the traditionally decisive moments, but they detect people in the process of flickering back and forth between one world and another *without leaving either.*

Wherever he goes, Webb always ends up in a Bermuda-shaped triangle where the distinctions between photojournalism, documentary and art blur and disappear. *Under a Grudging Sun* is the most time-specific or photojournalistic of his books but, even there, when he is most evidently 'a witness to history', Webb is forced to recognise 'the pattern of my futile efforts at news photography . . . I had missed the February "revolution" and the fall of Duvalier; now, in April, I arrived to calm . . .'.[8] The most newsworthy pictures are offset by others which suggest that what we are seeing is, as it were, old as well as news. (To make the same point the opposite way: perhaps Ezra Pound's definition of literature – 'news that stays news'[9] – also holds good for great documentary photography.) Sometimes this temporal double standard exists within a single image. On one side of the picture is human time and violence; on the other, the animal time of the dog, sniffing around. W.H. Auden's claim

about the way daily life goes on while a catastrophe unfolds nearby has been documented in the field by many photographers. Webb depicts suffering or news not just as it is experienced by humans but as it is apprehended by animals, by the dogs going about 'their doggy life.'[10]

There is another, still larger, non-human dimension to these pictures: the abiding consciousness or sentience of the place itself. A single picture states both *The body is lying in the street* and *One day the body will not be here, but the street will remain*. A given picture shows clearly how a scene looked in the instant it was taken. But it also suggests how the scene will look in an hour when the people in it have moved on. Or in a year, when the particular political upheaval or story has run its course. Or thirty years hence, when the only thing still there will be whatever is not subject to change. This, in a word, is the light.

Webb is drawn to borders – most obviously in the book *Crossings* – so it comes as no surprise to discover that the borders of the pictures, the edges, are central to his work. Literally. In this respect he is the photographic equivalent of Berlin (the divided city, as it used to be called) after the Wall came down, when what had been the edges became the centre. Webb's signature way of dividing up the picture is by some kind of pole or tree, or the edge of a wall. On either side of the divide are two potentially quite distinct worlds or two near-mirror images of each other.

OK, that's simple enough. As are the triptychs where a single image is made up of three quite distinct elements or frames. Further multiplication is achieved – the clever maths of photography: division is a way of multiplying! – by a glimpsed mural or poster, by views through a doorway, or window or mirror (or a car door or rear-view mirror). Sometimes a mirror is glimpsed through a door or a hole on a wall – or vice versa – so that we end up with the flattened, visual equivalent of a Russian doll. Within the frame there are multiple alternative frames: phone booths, windows (which double up as half-hearted mirrors), televisions and – of course! – *photographs* . . . You start

to wonder: just how many pictures are there in a typical Webb picture? Which picture holds the record for most pictures?

Further contradictions: mirrors are constantly reflecting on what they see going on around them; the shadows are looking in on and leering at the main action. All of this contributes to the feeling of claustrophobia, that the places photographed by Webb are all somewhat turned in upon themselves.

But the doors, windows and holes in the walls also provide views of a world beyond, a way out. Hence the contrary feeling of expanded – or even exploded – awareness. 'If the doors of perception were cleansed everything would appear to man as it is – infinite':[11] proposed by William Blake, seconded by Aldous Huxley and Jim Morrison. In Webb's case the doors are partially cleansed, often only ajar. And what looks like a door is actually just the reflection of one (in a window or mirror). Still, isn't that the defining characteristic of infinity: a little goes a long way?

Often the disparity between the various elements in a photograph is so extreme it can seem as if two or more images have been joined invisibly together, as collage or montage. How does this fit – how does it square with – the job of documentary reporting?

In *The Shadow of the Sun* Ryszard Kapuściński tells of a time, in Uganda, when he met a poor man called Apollo wearing a much-repaired shirt. This shirt has had its holes patched so many times, has had so many extra bits of fabric sewn on, that it is no longer possible to work out where the original material of the primary, ancestral shirt begins or ends. 'To describe it one must resort to the vocabulary of art critics, capricious postmodernists, scholars of suprematism, of abstract expressionism. It is a masterpiece of patchwork, of collage and pop art . . .'[12]

Perhaps, then, there is a closer connection than might be supposed between Webb's complex, highly advanced aesthetic and the half-made worlds he

photographs. Webb's opting to go where the colour was (to the tropics) might be only half the story, half the picture: perhaps these places were not just naturally but *culturally* predisposed towards the kind of work he ended up making.

I once wrote of Winogrand's pictures that a form of horizontal vertigo holds sway. The same is true of Webb – only more so.

He has said of Mexico and Haiti that these are places 'where colour is somehow deeply part of the culture, on an almost spiritual level'. That's as maybe, but his is a world where certain instruments and tools – a spirit level, for example – do not make sense (the Bermuda syndrome again!). It's not just the laws of perception, altered laws of *physics* seem to pertain. Within Webb's pictures gravity is rarely more than optional. There are often people's feet dangling from the top of the frame as if it's a branch they're perched on. Or else they're hanging in mid-air like cartoon characters in the blissfully oblivious seconds after they've walked off a cliff. Or floating upside down and sideways, weightless as astronauts. One way or another, there's a lot of *suspense* in these pictures.

Photography is a medium of exceptions. And so, inevitably, one of Webb's pictures is a precise refutation of the above. It's the one of a guy lying on a blanket – crashed out on it, as they say, like the man who fell to earth. I think of this as a photograph of an *anti*-parachute.

On the one hand . . . sometimes so much is going on within these pictures (in which – often – not much is going on) that it's difficult for people to make their way from one side to the other. There's too much stuff in the way – to say nothing of those life-devouring shadows. The picture planes are too congested. Viewed in a certain way even empty space can assume the complexity of a multidimensional maze.

On the other . . . we often see people strolling across the picture, exiting the frame, crossing (though this is only implied) from one photograph to another. More generally, persons (not the same person, but variants of the same person)

migrate from one series to another. The pictures' borders are porous. Thus we have Haitian workers in Florida, real-estate salesmen from the US tied to posts in the Amazon, and so on. Also, ironically, Webb took his great zombie picture – a hand reaching out of the grave – not in Haiti but in Florida.

It's a witty, spur-of-the-moment type picture, not the kind of thing we usually associate with Webb – and a reminder that the best photographers all make work that lies outside the received idea of what their work looks like. We have a pretty good idea of what a Cartier-Bresson picture looks like. Or an Edward Weston. But they are not reducible to their Cartier-Bresson-ness, their Weston-ness. In the case of Cartier-Bresson a virtual album of other photographers' work can be constructed from his non-Cartier-Bressonish work. Alex Webb has an instantly recognisable style, but he is not just Alex Webb; there are Webbs that don't look like Webbs. In *Hot Light*, to take just one example, there's a classic Martin Parr picture from *Small Worlds*: a couple of white tourists looking excruciatingly conspicuous – she's topless – on a beach on the Ivory Coast while three black guys go about their business (which is looking for business).

And then there are the photographers who are working, both in terms of content and style, in adjacent or neighbouring states to Webb: Magnum colleagues such as David Alan Harvey, Harry Gruyaert . . . It's not always possible to tell if certain pictures are by Gruyaert, Harvey or Webb. The borders of photographic identity are naturally – notoriously – porous too.

Perhaps that's why – as a way of trademarking their work, retaining image rights, as it were – photographers sometimes include their own representative in their pictures: a person who, in the words of Dorothea Lange, is part of the scene, 'though only watching and watching'.[13] I can never find Webb's representative in his pictures. There are the pensive solitary men like the one on the boat in the mauve twilight in the final image from *Istanbul*, but he doesn't – they don't – quite fit the bill in the way that those solitary overcoat-

ed figures correspond precisely with our impression of André Kertész. Nor do any of the other recurring figures or types.

This absence, this lack of representation, is its own kind of answer. It's often difficult, sometimes even impossible – because there are so many reflections, perspectival distortions, dislocations and flattenings and so on – to work out where Webb is in relation to what we are seeing. The pictures are full of people looking, staring – representatives of our own bewilderment or disorientation: where is he, what's he up to? Which, if you think about it, is an entirely appropriate response to a photographer who is, in his own words, 'trying to ask questions'.

But there's something else as well. For Kapuściński the near-universal aspect of life in the developing world was the number of people just sitting and staring, staring into space, at whatever came by. The world over, from the Yukon to the Philippines, from the Andes to Jamaica or Djakarta, people are 'sitting idly, without motion, and are looking at who knows what?'[14]

Prop this passage alongside Jane Jacobs's famous admonition – 'there must be eyes upon the street'[15] – and you see that the answer to that question about Webb's representative has been staring you in the face all along. Webb's streets are *all eyes*. (Jacobs again: 'Even more fundamental than the action and necessary to the action, is the watching itself.'[16]) And there is, inevitably, a photograph to prove it, in the middle of his first book, but as overt in its intention and meaning as the studio at the start of Walker Evans's *American Photographs*. Hanging above a shadow-divided street in India, so flat they could almost be pasted on: a pair of painted, unblinking eyes.

2011

Postscript: Further reflections

The first technical thing I understood about any visual medium was the use of narrative – the movement across space in time – in superhero comics. (I associate this technique with the great Jim Steranko, but it is possible that he was not the first artist to deploy it.) A panoramic view of a street is spread across the page: a single view or shot but divided into four panels. In the first frame a figure is in the distance, on the left, at one end of the street. Then he makes his way across the page – across the frames, down the street, through time – until, in the last frame, he can be seen in close-up.

Something similar seems to be going on in the picture on p. 138, taken in Haiti in 1987, as these figures make their way from mirror to mirror, from frame to frame. It's an illusion, of course, but some amount of time appears to be passing – even though it can't be – between the mirror on the right (with the guy in the red shirt) and the one on the far left (with just a foot stepping into it). The only actual figure to recur, to appear in more than one frame, is also the only one that *can't* move – the silver statue – but the suggestion of movement is reinforced by the bicycle, which can remain upright only when it is in motion. In this way the picture combines the sequential, the simultaneous and the static.

Actually, it's more complicated than that. From right to left we see a number of different figures: one standing, one sitting, one riding a bike, and a fourth – as metonymically glimpsed by the foot – walking. So the sequence is disrupted in three ways. 1: The action proceeds in reverse convention, as it were, from right to left. 2: The second mirror or panel from the left contains two figures. 3: Whereas a Muybridgean analysis might be expected to reveal a gradual transition from sitting to standing to riding (or walking), here the chronology of motion is shuffled. In keeping with Jean-Luc Godard's claim that a story should have a beginning, a middle and an end, but not necessarily in that order, these mirrors appear to have been moved around or edited. In a further overlap of vocabulary the mirrors create an effect of serial transparencies.

One of the mirrors in this picture – originally a transparency – of mirrors

contains a mirror. What looks at first like a strangely geometrical puddle is actually a horizontal mirror – or at least a man-made piece of highly reflective material – in which can be seen a muddled reflection of part of what can be seen (the guy's legs) in the larger mirror of which it's a part.

All of these components add up to a complex instance of the kind of collage also enjoyed (usually in gentler, more lyrical form) by Luigi Ghirri. A montage that is not manufactured after the fact but discovered, lying in wait ('*walking* in wait' would be a better phrase) in the actual world, it is constructed in the act of being seen, through the fact of being photographed.

2018

Vegas Dreamtime: Fred Sigman's Motels

It's to be expected. You take photographs in order to document things and these documents then acquire a quality of elegy. What is extraordinary is the speed with which this happens, the brevity of the 'then'. As soon as the images emerge in the developing tray – even, conceivably, the moment the shutter is clicked – they are imbued with how they will be seen *in the future*. (Now, of course, the process itself has an elegiac quality too.)

The photographs in Fred Sigman's book *Motel Vegas* (2019) were commissioned in the mid-1990s in order to record the signage of once-thriving motels on Fremont Street in Las Vegas. Frame and brief were later expanded to include the motels themselves, many of which had fallen on – or were in the process of falling into – hard times. The pictures were exhibited in 1997, but the twenty-two years – almost a quarter-century's worth of future – between that show and the publication of this book have lent a neo-archaeological dimension to the undertaking. It's consistent with the larger tendency whereby components of modernism become a source of lament.

The first motel opened in California in 1925, but the heyday of these hotels for motorists coincided with the post-war period of American prosperity. In the 1960s especially, the motel became an architectural extension of something that appears almost inconceivable except in retrospect: Las Vegas glamour. Vegas was a wonderland, and the faithful who flocked to it needed accommodation. Motel signs were a way of reconciling the humdrum necessity of providing shelter without breaking the neon spell of the magically boozy kingdom of the Rat Pack. The essential element in this was neon: the light of pure promise

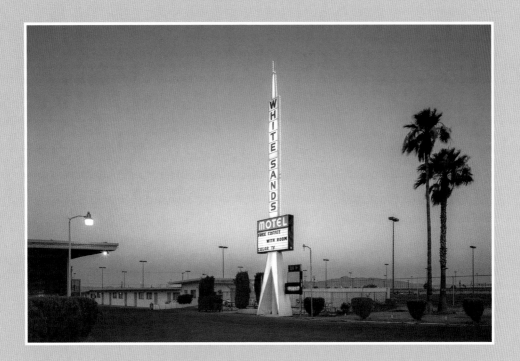

White Sands Motel by Fred Sigman

By kind permission of the artist

('VACANCY') that, if all else failed, could be filled or underwritten by naked guarantee ('STRIPPERS').

We still believe. If you are walking down a street in any city after dark, the sight of neon suggests nightlife even if, up close, it turns out to be a sign for a cobbler's. This holds good in the tropical nights of Costa Rica, specifically at the Key Largo, 'the infamous supper club where you can't get supper', according to Denis Johnson in *The Stars at Noon*. 'It's set back from the street, only a few doors down from the Hotel Amstel, in its own small misty jungle, with the lone- liest green neon sign on Earth clutching the corner of the building.'[1] And then there's the smeary poetry of neon in the rain, as captured in Saul Leiter's lyrical images of New York. All that is solid melts into a humid blur of puddly reds and foggy greens. If nothing is lovelier in the rain than neon, this does not mean that neon is never lovelier than in the rain. In Vegas, in the parched south-west, the neon blazes sharp and dry as bone. Back in the 1950s and 1960s the angular fever dream and curvaceous swirl of motel/casino names brought together an explosion of technological possibility – rocketry, atomic power – with a range of cultural allusion that extended from the home-grown Wild West (Bonanza Lodge, Apache, Purple Sage) to the exotic lure of the Orient: Sahara, Dunes. The landscape on which these illusions perched lent itself perfectly to the Vegas dream. The city is as flat as the highway you drive along to approach it. In the 1960s the car you were piloting may well have been adorned with the tail fins of a jet or a low-flying spacecraft. At night that space is not the obscure article of faith that lurks, sight unseen, above our cloud-shrouded island. Drive out of town for a couple of miles at night and there it is, in all its astronomical and star-spangled splendour, light years away but apparently within touching dis- tance of the desert floor. Motels like the Starlite, Desert Moon or Star View typ- ically consisted of one or two storeys but in the larger story of Vegas, the sky's the limit. In economic terms this means that the cost of staying at the Jackpot or Par-A-Dice was not just within reach; it was irrelevant compared with the fortunes aching to be made at the tables and wheels.

The allure and status of neon has been subtly changed, possibly even enhanced, by the advent and spread of LEDs. It so happens that the greatest light show on earth also takes place in Nevada, a couple of hours north of Reno, the state's other gambling mecca. The lights of Black Rock City, home of the annual Burning Man festival, are overwhelmingly LEDs these days. They're utterly stupendous but, here and there, you spot a few ghostly vestiges of neon, palely loitering, bathing the desert twilight in a calm and quiet glow. Neon, in this context of cutting-edge technological illumination, feels like a refuge: a source of quiet contemplation.

Back in the fallen world of motels such as the Blue Angel, meanwhile, it's tempting to go parodically semiotic and rush into the realm of pure sign, floating free from its signifier! Maybe it was different half a century ago, but the motel fruit seemed pretty stale when I got round to tasting it at about the time these pictures were made. Romance shrivelled the moment you entered the room. The smell, overwhelmingly, was of masking: scented cleaning products designed to hide other smells, though there usually lurked a kind of mildewy under-odour that seemed connected to the icy rattle of the AC. (Back in the golden age the cover-up must have required even more chemical-industrial might in the diurnal struggle to start afresh by erasing the dreadful linger of cigarettes.) If the nose was quick to adjust, the eye took longer to come to terms with the bedcover, the moulded sink, the downtrodden carpet – all in merciless view by virtue of lighting that was the opposite of neon. Tom Wolfe pointed out that the defining architectural feature of the motel – no need 'to go through a public lobby to get to your room' – 'did more than *the pill* to encourage what would later be rather primly called "the sexual revolution"'.[2] But the lighting in those rooms was so functional as to be at odds with the explicit goal of the revolution: recreational or non-functional fornication. If anything, the rooms, with their minimal soundproofing, seemed designed for overhearing other people going at it. All of which left one with a profound indifference to the promises and possibilities alluringly displayed by the neon outside. The

experience ended up being so life-denying that, if you heard someone being murdered in the room next door, your first impulse would be to complain about the noise. The second would be to kill yourself instead – ideally, like Nicolas Cage in *Leaving Las Vegas*, by drinking yourself to death.

Obliged, then, to speak of the broken promise of motel neon, it makes perfect sense that many of the signs in Sigman's photographs have since gone belly-up. Daylit shadows of their former selves, they were condemned to a boneyard of dead light where they could be plundered for parts used to bring other ailing signs flickering back to life. In a real sign of the times Vegas now boasts a museum of neon, a glowing cross between the V&A in London and the V of K (Valley of the Kings) in Luxor – the place in Egypt, I mean, not the casino-hotel. It's well worth a visit, and it's good to know that a place of displayed rest in the afterlife has been found, in the darkness on the edge of town.

2019

The Undeniable Struth

Not to be confused with his near-contemporary Thomas Ruff, Thomas Struth is one of that small band of artists – Francis Bacon and Canaletto are others – whose work seems to be an emanation of their names. A generalised expression of astonishment, 'Struth!' started out as an oath: 'God's truth!' Certainly, there is an impersonal, almost omniscient quality to the truth conveyed by Struth's best photographs, among them a series devoted to 'Places of Worship' in which the camera exults in its ability to capture what he calls 'monumental emotional packages of overwhelming experience'.[1] This begs an obvious question: do these epic photographs *deliver* that which they capture? What is the nature of the aesthetic relationship – to frame the question more tightly – between a partial self-portrait of the photographer (identified only by the anonymous blur of his blue jacket) and the Christ-like self-portrait of Dürer he is contemplating in that modern, secular place of worship, the art gallery?

These questions, it needs emphasising, are ones posed not by a doubting critic but by Thomas himself. For Struth the photograph – 'the undeniable truth of what is in front of you' – is the product of 'an intellectual process of understanding people or cities and their historical and phenomenological connections. At that point the photo is almost made, and all that remains is the mechanical process'.[2] The photographs, in these terms, are relics of the wholly cerebral process by which they came into existence. And yet some of them seem as mysterious as miracles.

Struth himself came into existence in the routine way, in Geldern, Germany, in 1954. He began studying at the Kunstakademie Düsseldorf in 1973, first with Gerhard Richter and then with the newly appointed professor of

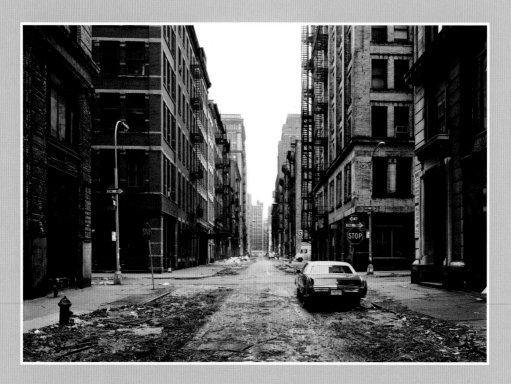

Crosby Street, Soho, New York, 1978, by Thomas Struth

photography, Bernd Becher. If Richter was interested in photography primarily as a goad to painting, Becher and his wife Hilla were devoted, with a glacial fixity of purpose, to the art of photography in its documentary essence – a commitment that could be traced back to August Sander and the Neue Sachlichkeit (New Objectivity) in the Weimar Republic. Partly through the Bechers' own work – rigidly objective surveys of architectural forms – and later through the spreading reputations of their protégés (Candida Höfer, Andreas Gursky, Struth and Ruff) the Düsseldorf school became a kind of International Style in the realm of photography. Its rise coincided with and was marked by a double inflation: in the scale of the works produced and the prices they fetched.

Modest in size, black and white, the works of Struth's early maturity – made in the late 1970s – display many of the features that will define the later, bigger and better-known colour works. The passage of time may also reveal them to be among his very best works, or at least the work in which his best qualities are found in most concentrated form. This is appropriate, for these views of deserted streets – first in Düsseldorf, then New York, later in Rome, Edinburgh and beyond – came to be preoccupied by the attempt to document locations where the meaning of a given city was most 'condensed or compacted'.[3] The tramlines and overhead cables stretching down the receding and empty streets emphasised Struth's preference for central perspective (which, as John Berger had explained earlier in the decade, causes the visible world to converge on the eye of the spectator 'as the universe was once thought to be arranged for God'[4]).

Less grandly, there were echoes (especially in the picture of Campo de' Fiori in Rome) of Atget's detached yet instantly recognisable inventory of Paris. Working in America in the 1930s, Walker Evans shared Atget's fondness for using the receding vista as a way of suggesting the view through 'a stack of decades'[5]; in Struth's case the views are often blocked by buildings of more recent or older provenance. And even when we are permitted to gaze, unimpeded, towards some kind of vanishing point, the scenes evoke not a vista of years but,

as it were, a present of *unusually extended duration*. As a consequence there is no narrative potential in these pictures.

It's not just that the streets are deserted (i.e. that everyone's indoors, tucked up in bed); the buildings look uninhabited too. There is no sense – in spite of all the windows – that there might be someone looking out, that our gaze is in any way reciprocated. In mood these photographs are reminiscent of the opening scenes of *Night Work* by the Austrian novelist Thomas Glavinic, in which a man in Vienna, Jonas, wakes up to discover that he is the last person on earth:

> He kept an eye open for signs of life, or at least for some indication of what might have happened here, but all he saw were abandoned cars neatly parked . . . He looked in all directions. Stood still and listened. Walked the few metres back to the intersection and peered down the adjoining streets. Parked cars, nothing else . . . He noticed nothing out of the ordinary.[6]

Jonas's wanderings – his investigation of this strange extinction of narrative – force him to conclude that 'some catastrophe was to blame'. The nature of that catastrophe is not made clear, but in some of Struth's pictures there is the pervasive if never explicit suggestion of the Third Reich and the Second World War. For someone of Struth's generation, as he has said, this confrontation 'with Germany's past' was unavoidable. Whether photographing streets or making the 'Family Portraits' (another important series), 'the question of what your family did under fascism was never far away . . . The traces of structures, social and psychological, are legible.'[7] The empty cityscapes seem devoid of memory – while all the time suggesting that this lack might itself *be* a memory. (This sense has deepened over the years as the photographs have become subtly ingrained with *our* memories: of other times when we have seen them, in books and earlier exhibitions.) Inverting the claim of Dresden-born Durs Grünbein that 'Memory has no real estate' (in his poem 'Europe After the Last Rains'), Struth asks if this is what the world would look like if memory were

purely physical, tangible, if it resided not in people's heads but only in structures, in the buildings and streets they had created.

The legacy of Nazism is specific to the German pictures, but versions of his mission question – 'Why do cities look the way they do?'[8] – are asked in New York and elsewhere. Needless to say, they are never answered – that would establish a narrative. Instead there is the conviction that the photographer, in the words of art critic Peter Schjeldahl, 'had a Geiger counter for meaning, whose meter happened to go crazy at this location.'[9]

We are here approaching the 'optical unconscious' discovered, according to Walter Benjamin, by photography. Another of Benjamin's ideas informs – and is tested by – the photographs Struth has made of people looking at paintings in museums (and, in a few instances, of the way these people might appear to the paintings they are looking at). The reciprocal choreography whereby viewers accidentally echo poses depicted in the paintings was a rich source of visual quips for the Magnum photographer Elliott Erwitt, but for Struth this was just the starting point. What interested him was the chance to bring together 'the time of the picture and the time of the viewer'.[10] And not only that. In Benjamin's famous formulation the aura of the work of art was lost by frequent reproduction (as the aura of his idea has itself been bleached out by incessant re-quotation). With this in mind, Benjamin's account can usefully be balanced by another famous passage, from Don DeLillo's *White Noise,* where the narrator, Jack, and his friend Murray visit 'The Most Photographed Barn in America'. 'We're not here to capture an image, we're here to maintain one,' Murray explains. 'Can you feel it, Jack? An accumulation of nameless energies.'[11]

What kind of accumulation and convergence occurs when we come face to face with the most frequently reproduced items in a museum? This is the question Struth asks of Géricault's *Raft of the* Medusa – and of the people who make the daily pilgrimage to see it. The most spectacular work in the series is probably the supersize photograph of Delacroix's *Liberty Leading the People,* taken while it was on loan to the National Museum of Art in Tokyo. The paint-

ing is hung behind bulletproof glass, making it look like a cinema screen on which an epic costume drama is being projected, watched by an audience of silhouetted Japanese who, exactly as described by DeLillo, are 'part of the aura'.

Taking advantage of the new-found ability to make photographs on the scale of history paintings, Struth made visible the compound phenomenon that might be termed *the aura of nameless energies*. The project reached a logical apotheosis in 2007 when photographs from the series were exhibited in the Prado, some in proximity to the paintings depicted in them, like magnets with their silent powers of mutual attraction and negation simultaneously heightened and held in check.

Along with the various overlapping museum series Struth continued to photograph the world's cities, in colour predominantly and – especially in China and Japan – with people now permitted walk- and cycle-on parts in the kind of scenes from which they had been conspicuously absent in the West. He also undertook expeditions to photograph forests and jungles where the tropical foliage was often so dense and lush as to resist the scrutiny the images compelled. They were powerful, these 'New Pictures from Paradise', but perhaps they also signalled a lurking danger: how fertility and abundance can become self-obstructing, how the overgrown might turn into the overblown.

As early as 1978 Struth had expressed his interest in 'photographs that have no personal signature'.[12] Which inevitably *became* his signature. Through repetition and familiarity our expression of appreciation and recognition – 'Struth!' – acquired (how else to put it?) a nominal quality. His truth was in danger of becoming a matter of visual rote. It is difficult not to see some of the recent work – tangles of flex and wire, the manufactured equivalent of all that perspective-less, Pollock-esque vegetation – as evidence of a lack of direction or purpose. Make no mistake, Struth's best works earn their size, but the big recent pictures of very big things such as the construction of the Space Shuttle at Cape Canaveral – bigger than a snooker table: how's that for size! –

emphasise the scale of the emptiness and raise further doubts about where he might be headed. The accomplishments are undeniable, but one is reminded (by Nietzsche) of 'God's boredom on the seventh day of creation'.[13]

2011

Andreas Gursky

It's the Walker Evans question. Did Evans take pictures of things – sagging shacks, abandoned cars, vernacular signage – whose attractions had been obvious for years before he photographed them? Or did the act of photographing this stuff imbue it with an aesthetic dimension to which we had hitherto been somehow oblivious? Either way, from 1938 onwards, when *American Photographs* was published and exhibited at MoMA in New York, this was how America came to look – and what we looked for in America. Documentation doubled as creation. Not just the creation of an observed world but of the terms and criterion by which the results would be judged. And the look was not simply aesthetic; despite Evans's famous claim to the contrary – 'NO POLITICS whatever'[1] – it framed, described and reflected larger ideological, economic and political forces that had created the Depression.

With a little adjustment and the odd inversion – for Depression read Boom – much of the above can be transferred directly to Andreas Gursky. These days we routinely find ourselves walking or driving through a Gursky world. That world may have been there – logically, must have been there – before he photographed it but I, for one, was not conscious that it looked like this. Which seems surprising, given how readily his ability to visually articulate the world around us was *recognised*, and how frequent the experience of stepping inside or inhabiting a Gursky turns out to be. Naturally, you don't have to be in the exact same places that Gursky has photographed in order to have this experience. In fact, you don't even need to have seen an *actual* Gursky. A way of seeing has become so widespread as to float free of the person

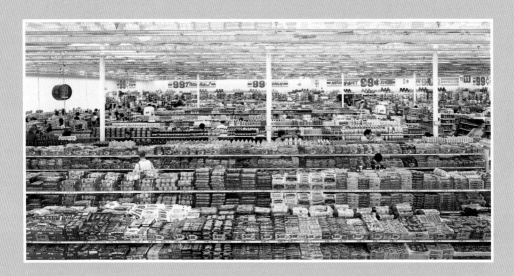

99 Cent, 1999, by Andreas Gursky

Chromogenic print mounted on Plexiglas in artist's frame, 81½ x 132⅝in. (207.01 x 336.87cm). The Broad Art Foundation © Andreas Gursky/Courtesy Sprüth Magers Artists Rights Society (ARS), New York

who configured and calibrated it. As part of what George Steiner called 'the general landscape of awareness',[2] Gursky, these days, is just one person among many doing Gurskys: a result, paradoxically, of having a style that is readily identifiable. Of course, curators and critics insist that the imitators are serving up sub-Gurskys, trotting out work that might be termed *scuola di* Gursky, but it's not as simple as that. Nor is it a situation unique to photography. A decade ago the critic James Wood wondered if it was possible for a writer to dissolve entirely into influence. Do all Gurskys achieve the quality and condition – of Gurskyhood – to which their authenticity testifies and lays claim?

Even if not, we consistently find ourselves in circumstances or environments in which the mode of perception or style of response most appropriate to such places is the one determined and recorded by Gursky. I say places but it's often 'non-places' of the kind described by Marc Augé that come to mind. The original English translation of his book *Non-Places: An Introduction to Supermodernity* featured one of Garry Winogrand's airport pictures on the cover, but the text itself offers extended captions of classic Gursky zones, which comprise 'two complementary but distinct realities: spaces formed in relation to certain ends (transport, transit, commerce, leisure), and the relations that individuals have with these spaces'.[3] This is where Gursky's world view announces and displays itself most graphically. In one famous instance the flight-indicator screens at Frankfurt airport show city destinations in other parts of the world, destinations which, on arrival, look pretty much like the place you've just flown from.

Gursky is drawn – and draws our attention to – endlessly reiterated units of the same thing. These units can be brightly wrapped sweets and drinks in a 99 Cent store (in a picture made in 1999, neatly enough), offices, apartments or people – it's all the same. (As a consequence it is almost inconceivable that Gursky could do a full-facial portrait of an individual.) In a globalised world, nothing lends itself to homogenisation as spectacularly as variety on an unprecedented scale.

Speaking of nothing, remember Cordelia's response when asked by her father, King Lear, what she will say to gain a share of his kingdom 'more opulent' than that of her sisters: 'Nothing.' Which is precisely what is on display and for sale on the opulently vacant shelves of *Prada II*. Prada, according to certain barometers of taste, is a definitive site of quality, worth and value. But only a few days ago a neighbour of mine observed, despairingly, that the street near where we live was 'only one or two iterations away from hosting a branch of Prada'. From that point on – now, here! – the street would effectively be nowhere, the non-site of a store offering nothing that we wanted (valued), selling non-sense.

And speaking of scale, Gursky's prints are, of course, very large (too big to fail, as is sometimes said of financial institutions). They have to be since they are, quite often, *about* size. More than a few depict interiors so massive as to turn previous ideas of the interior inside out, as it were. (Don DeLillo, in *The Names*, calls a similarly vast space 'a container for emptiness'.[4]) You become aware of a related sensation in venues designed to host bands and acts – Madonna, for example – that have outgrown and gone beyond the confines suggested by what was once quaintly termed stadium rock. These spaces are larger than the human capacity to comprehend their scale. The architectural seed of such design is, presumably, that everyone should have a reasonable view irrespective of where they're sitting or standing. By definition this means doing away with perspective (an ambition that I was going to say 'brings us close to Gursky's achievement', but for reasons that will soon become clear that is not appropriate). As a result of this abolition it is sometimes difficult, in such venues, to tell whether you're far away from the stage or – compared to others who are even further away – quite near. And then, after a brief cognitive struggle, you realise that you'll never be able to compute the matter in these terms because there is actually no such thing as near here. (Hence the inappropriateness of 'close to'.)

The subtle amendment or cancellation of perspective in some of Gursky's

work – technically the result of merging multiple shots into a single image – creates the impression, as Frederik Stjernfelt has remarked of the 1993 picture of an apartment block in Montparnasse, of a building 'seen from nowhere'.[5] Clearly the most suitable place for observing a non-space, this view from no-where has the effect of immersing us within the experience depicted (which perhaps explains why the feeling of inhabiting a Gurskyeque world is oddly familiar). It also means that a picture in which conventional perspective is maintained has an allure that is almost nostalgic, even if it is a night-time view of Los Angeles (1998), the paradigmatic city without a past. Taking things a stage further, the early pictures of a football match in Liège or of a road scene in Ratingen (both from 1984, before Gursky began digitally manipulating his images) have the homeliness and intimacy, relatively speaking, of family snaps. They also serve as mementoes, reminding us that what Gursky lost in the process of becoming the poster boy of a certain kind of poster-sized pho-tography should also be factored in to any consideration of what he gained. What has been lost – though the hyper-clarity of Gursky's pictures blurs our awareness of this – is the old and trusted compact between a photograph and whatever-it-is and wherever-it-is-in-the-world that the photograph depicts. The price of omniscience, despite claims made by HSBC to the contrary ('The World's Local Bank'), turns out to be the near-extinction of local knowledge (cognitive closeness). The 1985 view of 'Sunday Walkers' at Düsseldorf air-port is, in this light, prophetic: a 'straight' photograph showing the documen-tary edge or barrier beyond which curious viewers might no longer be able to enjoy unrestricted and uncomplicated access.

If distorted perspective is a common but not constant feature of Gursky's work, the extreme depth of field – in which everything is as sharply defined as everything else, irrespective of how near or far it is – is ever-present. Com-bined with the scale of the photographs, the result, as Stjernfelt nicely phrases it, gives us 'the strange experience of an excess of recorded detail far beyond the point where the viewer's attention is focused at any single moment'.[6] The

effect is a kind of disoriented stasis, a tranced attentiveness so complete that the possibility of movement – of being elsewhere – is entirely absent. This is particularly striking in the picture of the departure boards at Frankfurt airport: an image full of named elsewhere. Barely visible, almost lost amid the hustle and bustle of activity around his high-speed car – a scene where every second counts – is the helmet of racing driver Michael Schumacher, who will end up in a coma, paralysed, stranded in non-time.

There is, more broadly, an important temporal dimension and consequence to the spatial effects routinely achieved by Gursky. The corollary of Anthony Lane's suggestion about perspective in Atget – 'a matter not only of space but of time' – is that the absence of perspective in Gursky leaves you stranded in a universal present: something akin to the unhistoried – and, at the risk of tautology, perspective-less – art of the Middle Ages. This seems a daft comparison (and one at odds with the suggestion of some kind of congruence between ideology and style in Evans's work) until we remember that for a while in the late twentieth century it was widely believed that we had come to the end of history. That may have been an idea, ironically, whose time came and went (the end of history turned out to be subject to history after all) but it defined the era in which Gursky and the so-called Düsseldorf school achieved such critical and commercial dominance as to have generated a new international or globalised style. A distinctive feature of this style (as we have seen) is the sense of time and history not as force but as state or condition. In an era when the pace of change has accelerated unimaginably – when the period with which it is most frequently compared is the 1930s, to which Evans bore such eloquent witness – the consolations afforded by such views are as valuable as they are immense.

2015

Thomas Ruff

In the mid-1960s, when Philip Larkin saw a couple of kids and guessed he was fucking her and she was taking pills or wearing a diaphragm, he knew this was the paradise everyone old had dreamed of all their lives. A paradise that turned out – isn't that the way with any paradise? – to be transitory, from which we were expelled with the advent of AIDS and the return of the presumed-obsolete condom. Then a substitute paradise came along, one in which the idea of expulsion and exclusion was not imminent but immanent: online porn.

I didn't see porn of any kind until I was thirty-four, when I stumbled across it by accident – and for free – on TV in a hotel in Belgrade. I'd been told that porn equals woman-hatred, but it didn't seem hateful or hate-filled. What it looked like was people having sex. Camerawork and lighting were devoid of subtlety, but the fact that the film showed people actually having sex rather than resorting to cloying visual euphemisms and discreet elisions gave it the quality of a revelation. I know, I know (I mean I know now), it wasn't people really having sex, it was people having sex on a film set, for money, surrounded by a camera crew and equipment, but it was real in the sense that things were really going in and out of other things. I'd never seen anything like it. Despite the aesthetic shortcomings, it was a glimpse of crudely illuminated bliss. This was in 1992; nowadays it is almost inconceivable that anyone could reach the ripe old age of thirty-four without having encountered porn via its latest on-line mode of distribution and consumption.

Porn can be all things to all people. Whatever one's desires, porn will already be alert to them, will pander to them – and, by pandering, shape, mould

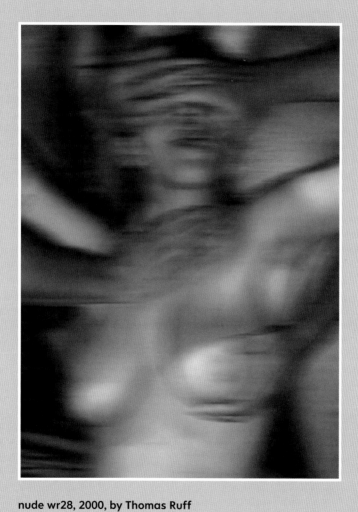

nude wr28, 2000, by Thomas Ruff

135 x 100 cm, chromogenic print. By kind permission of the artist

and form them. In some ways it is better than real life – an essential characteristic of any kind of paradise. In a well-known essay Martin Amis asks John Stagliano, a pornographer, about 'the truly incredible emphasis on anal sex' in his work. Good question – the key question, in fact, since in some ways anal sex can be seen as a metonym of porn itself. (Friends who are art collectors have a blurrily explicit greyish painting – of a woman being fucked from behind – by John Currin in their bedroom. What makes this art rather than pornography? Simple: if it was porn, he'd be in her ass.) Stagliano's answer to Amis is that whereas with straightforward vaginal sex the experienced viewer, far from sharing the astonishment I felt in Belgrade, is asking himself, 'Is this for real?' With anal, on the other hand, there's no doubt about it: the actress is obliged to produce 'a different order of response'.[1]

One takes the point, but there's a simpler and more persuasive answer: namely, that anal sex looks better or – at the very least – involves less hassle in porn than it does in real life. (Didn't Amis's friend, the late Christopher Hitchens include anal sex – along with champagne and something else I can no longer recall – among life's three most overrated pleasures?)

At the risk of sounding like a killjoy, it bears emphasising that the anus is designed primarily for shitting. Not that you would ever guess this from porn. Although there are doubtless a few hideous recesses of the internet that would refute this claim, the asshole, in the overwhelming mass of pornography, is hairless, odourless and shitless. All comers are invited to look at it, fuck it and lick it. And whereas D.H. Lawrence famously took exception to Swift's appalled realisation about Celia – 'Oh Celia, Celia, Celia *shits*' – porn takes the modern Swift as its ideal client and delivers numerous and gorgeous anti-Celias who don't shit . . . but love to take it up the ass! In similar fashion, male teenagers today, whose sexual expectations have been formed by the waxed, depilated and shaved horny angels of porn, might turn out to be as devastated as John Ruskin by the discovery that actually existing women have pubic hair. Or do they? If increasing numbers of young women *are* hairless, shaved,

waxed and so forth, that is partly because porn does not just respond to the world, it shapes it; creates demand in the process of satisfying desire; doesn't just read our brains but washes them too.

Except as a spurious and implausible inducement or plot device, the idea of shame is anathema to porn. In *The Unbearable Lightness of Being* Milan Kundera considers the theological debate as to whether Adam and Eve had sexual intercourse or defecated in Paradise. He concludes that without shit (and the attendant sense of shame) there would be no excitement and 'no sexual love',[2] that the three things – shit, shame and sex – were all products of the Fall. That might be true in the real world – but not in the shame- and shitless (and loveless?) free-for-all that is porno-paradise regained.

People in porno-land do the things they do, in the demanding positions they assume, for one reason only: so that we can see what they're up to. Even as we acknowledge that shadows and glimpses, the unseen and unseeable, are key components of any erotic narrative, that narrative is propelled, in part, by the desire to see more and more: with less shadow, in closer close-up, in sharper focus, in HD. At some point, however, it can all get *too* close and clear, whereupon, as Slavoj Žižek points out, 'erotic fascination turns into disgust at the Real of the bare flesh'.[3] (Swift comes to mind again, when Gulliver is exposed to the gigantic blackheads and gaping pores of women's bodies in Brobdingnag.)

Lifted from porn sites, Thomas Ruff's ongoing series of *Nudes* thwarts the urge to see more and more – and by so doing brings us back to our senses. I mean that literally – to the blurry imprecision of the senses. Several contradictory things go on, depending on which photographs you are looking at (or even while looking at the same picture). Porn takes the universal desire to have sex and delivers it and improves on it: perfect bodies, no disease or impotence (as suffered by the porn-addicted Michael Fassbender in Steve McQueen's film *Shame*), no heartbreak, no regrets, no *consequences*. But by blurring these images Ruff improves them in the opposite direction, as it were. They acquire the uncertainty of memory, the imprecision of unenacted fantasy, the unfocusable

swirl of the unconscious, of dreams. Or nightmares in which the idyll becomes either leeringly horrible or ludicrous and laughable. Arranged with only one thing in mind, the original lighting is coaxed into gorgeous subtleties; colours become nuanced, achingly delicate – or expressionistically garish. Acts and actors become more intimate than – and more remote from – the way they appeared on screen. The photographs impart a lyricism to the source material (though the originals are themselves rarely devoid of romance; even hardcore action usually starts, as the song has it, with a kiss), or, particularly in the re-cent work, they lay bare the ghastliness and vulgarity of an industry that aims to service desire so thoroughly, so instantly. Hence the hilarious poignancy of the moment in Amis's novel *Money* when John Self wonders why, with all the hookers and porn available, he still feels the compulsion to jerk off. It's because, he concludes, he needs the human touch.

When I was a teenager masturbation was always and only a substitute for sex *with* someone. Porn aims to make us forget this, to convince us that mas-turbation *is* sex. In the past withdrawing prior to ejaculation was an inefficient and entirely frustrating form of birth control. Now withdrawing and coming over the woman's face – stemming, again, from the pornographic obligation for everything to be on view – is the climactic part of the sex act. A few years back the *Guardian* columnist Marina Hyde observed that some young men do this – without so much as a by-your-leave – because they think this is how sex is supposed to end. Even the most basic biological urges, it turns out, are extraordinarily susceptible to cultural modification. The line between what is considered natural and what is condemned as abnormal behaviour is con-stantly shifting and changing.

I am ignorant of the process by which Ruff makes his *Nudes*, but more than a few of them – particularly older ones from the series – are reminis-cent of paintings Gerhard Richter derived from photographs. Given the shared smudge and smear and a similarly slurred palette, this is hardly surprising. What was surprising, as I looked at some of these *Nudes,* was that I found my-

self thinking not just of Richter's pictures of people but of his *landscapes*. And then I remembered reading of Alberto Moravia's suggestion that a woman's body might be all that modern man any longer possesses of nature.[4] (Perhaps there is a link here with Flaubert's astonished observation about 'the horror of nature' in Sade: 'There isn't a single tree in Sade, or a single animal.'[5]) Ruff's pictures seem both to endorse Moravia's idea and to take it a step further: what if the woman's body is itself so divorced from nature (from shit) that it becomes entirely non-corporeal and untouchable, nothing but image?

Ruff's decision to call these pictures *Nudes* encourages us to see them as part of – conceivably as culmination of and commentary on – a major tradition and genre of Western art which has cloaked itself in any number of religious, mythological, aesthetic and moral disguises. As John Berger pointed out in *Ways of Seeing* in 1972, you paint a naked woman looking in a mirror so that you can see her tits and ass – and then you call it 'Vanity'. So, from a feminist perspective, these pictures are a final insult and injury, which perhaps has the redeeming virtue of honesty. On the other hand, let's not forget that when Berger left school and went to art college he was possessed by a single idea: 'I wanted to draw naked women. All day long.'[6] In this light, the long history of the changing pictorial conventions of the representation of the nude expresses an unchangeable desire of men to look at naked woman and – extrapolating from there – to have sex with them. Berger is looking back to what he felt as a teenager, but as you get older and wiser you know that the times when these desires were realised were among the very best moments in your life. Ruff's *Nudes* show part of the process by which these most intimate moments – longed-for, remembered or imagined – are preserved and warped. But it's more complicated than that. Remember the scene in *Blade Runner* when Rachael the replicant shows Deckard her little collection of snaps which authenticate her memories and prove that she's human? They're not your memories, Deckard tells her. They're just . . . implants. Something similar happens here. These are not *our* memories; either that or they are entirely impersonal ones,

as it were. And at some level – one inscribed in the process of their creation – these images are not Ruff's either. That's what makes them instantly recognisable as his, and his alone.

The same could be said of the other half of the exhibition: photographs derived from data beamed back from Mars. And there is perhaps another connection between images of flesh and shots of the surface of another planet. I remember an episode from the sci-fi series *UFO*, back in the 1970s, when an unmanned probe sent back images of the planet from which the alien threat was thought to emanate. These images provided vital information in unprecedented detail. But an oversight meant that there was no scale and this, a technician claimed, rendered them useless. To illustrate his point, he projected a picture of what seemed to be a horizon. Except when he zoomed outwards it was revealed that this planet was in fact the gentle curve of a young woman's thigh. So could these views of whorls, craters and meteorite-pocked surface actually be extreme, Gulliveresque close-ups of skin, flesh? Either way, the challenge of these photographs is that we don't know quite what we are looking at – or for.

The history of painting seems to move logically and inevitably towards abstraction; with photography there is, at the very least, something counterintuitive or even illogical about abstraction. But another world – Mars in this instance – represents the possibility of *indexical abstraction*. As such these pictures depict radically new topography: a new and distant frontier in landscape photography, broadening our idea of what to expect – what to look for – in photographs. In 1830 the astronomer John Herschel advised someone who was unable to decipher the solar images projected through his prism that a distinction should be made between 'not knowing how to see' things and 'any deficit in the organ of vision'. In this regard Ruff is offering training of a kind similar to that of Herschel when he reassured his frustrated companion that he could 'instruct you how to see them'.[7]

Another connection between the two halves of this exhibition is, of course, that Mars has long been the default site of sci-fi fantasy. Our ideas, desires and hopes for what another life-supporting planet might be like have been projected on to Mars, the red planet which, in these false-colour images tends to be anything but red. (What could be more *human*, after all, than the very idea of the Martian – who, in Craig Raine's paradigmatic sequence of poems, 'sends a postcard home'?) Seen in this way Ruff, in these pictures, seems to be setting Mars free from a long history of earthly extrapolation. There are echoes and suggestions of some of the more inhospitable realms of our own planet – Siberia? Sahara? South Pole? – but perhaps the pictures' success is measured by the extent to which their serene, translucent and milky beauty manages to distance itself from earthly notions of the sublime and beautiful.

Easier said than done, especially given the long history of assimilating that which appears inassimilable by any established ideas of beauty. Up until the twentieth century the deserts of the American West were seen – more exactly *un*seen – as expanses of entirely repellent desolation. It was only with the publication of John C. Van Dyke's *The Desert* in 1901 that this very desolation came to be viewed as a manifestation of the sublime and beautiful. So complete has been the change that some of the most spectacularly beautiful sights our planet has to offer – the only planet of which most of us have any experience – are those that are termed unearthly or otherworldly. So perhaps our reactions to Ruff's Mars pictures demand a similar kind of response, a vocabulary uniquely suited to images that at their best are – to their and Ruff's credit – unphotographly, or otherphotographly.

2012

Prabuddha Dasgupta's *Longing*

Longing is not always future-oriented. It can as easily and frequently be retrospective. You can long for what you have already experienced. Sexual fantasies, for example, are memories (sometimes slightly improved on) as often as they are inventions, albeit memories that are in danger of fading even as they are summoned. Conversely, memories cannot always be relied on, may themselves have elements of invention.

Nor should it be assumed that longing is person- or object-specific. You can be in a state of generalised longing without knowing quite what it is that you long for. This might be the purest form of longing, the most difficult to assuage, the least susceptible to being brought to an end, the kind capable of lasting *longest* – so much so that it can become all but indistinguishable from a generalised condition of existence. The similarity here to Kierkegaard's observation that one can be in despair without knowing it suggests that longing might be both the flip side of – and prelude to – despair. A symptom of despair is an absolute lack of longing: not just the inability to look forward to something but the inability to remember what doing so is like.

Combine these two aspects of longing – the non-specific and the retrospective – and you realise that longing can exist entirely for its own sake, with no object in mind, as a kind of intensified nostalgia or eroticised elegy.

In Prabuddha Dasgupta's *Longing* there is a powerful suggestion of travel, of journeys that have merged into a single journey. There is evidence of arrival and departure, but the main sense is of being in transit. Of looking back on what has been left, or forward to what is to come. The photographs are rarely *in* the moment. The present tense flickers and is gone.

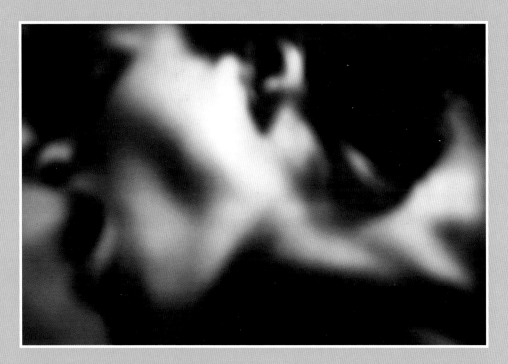

From *Longing* by Prabuddha Dasgupta

With its core images of sexual bliss, the series suggests the all-powerful role of the erotic (minus the Freudian mumbo-jumbo with which this idea became widely linked). Sometimes this is blurrily explicit (not in the way that porn is explicit but in the sense that what is depicted is actual physical sex). Sometimes it is oblique: bed linen, underwear, towels, clothes or hairpins on the floor or on a table. Sometimes it is present only implicitly. There is much that is mundane or circumstantial (lights left on in windows, hotels, streets): stuff that has nothing to do with sex or even pleasure, but which takes on a tint of the erotic by association and adjacency. It is a reminder that even in the most passionate affairs or romances – the kind, let's say, where two people have only an occasional weekend together – lovers do not spend all their time in bed. They go for walks, buy things in shops, stroll by the sea, eat dinner in a restaurant. Then they separate and, in some way, the view from the train window reflects back not just a face (intermingled, darkly, with the shifting landscape beyond) but memories – intensely sexual – of what has gone on in the previous days and nights. Sometimes such weekends can be part of or prelude to a shared life together. Sometimes they can be reflected on, remembered and reconjured – longed for – for the reminder of a lifetime that is defined, in every other aspect, by their lack.

In 2009 I published a novel that circles around some of these ideas. The following year I was engaged in a low-intensity dispute with my British publisher about the cover of the mass-market paperback of the book. Indifferent to the designers' proposals, I had no clear notion of what I wanted – except that I liked the idea of using a photograph. As to which photograph, by whom, I was entirely flexible, but when asked to come up with suggestions I sent a link to pictures by Prabuddha Dasgupta. They liked his photographs generally and, after a certain amount of to-ing and fro-ing, we agreed on a particular image. Roughly the same thing happened with the US and Australian publishers: they all liked Prabuddha's work, but each publisher chose to use a different image. This seemed to suggest that the photographs in *Longing* – intimate,

personal – tapped into something universal in a highly individual way.

I remember this process of image selection and nationally specific choices quite clearly, but what I have no recollection of – and this is something I can usually recall precisely even when my memory of the work itself has grown a little hazy – is how I first came across Prabuddha's work, who introduced me to it, or even when or where I first saw it. Logically, I suppose, this means that I can't remember a time when I did not know Prabuddha's work! Well, I know I did not know it ten years ago, but I can't remember the circumstances or the moment *since then*, as it were, when I first encountered it. To repeat, this, for me (and, since we are dealing with personal manifestations of universal themes, perhaps for most other people too), is highly unusual. It is a little like having a lover but being unable to recall how you met. As we all know, the more you strain to remember a lost name or the details of a dream, the smaller the chance of their coming back to you. Then, invariably, you think or talk of something else and the forgotten name and the lost flecks of dream float back unbidden into your head. I've tried this – that is, I've tried not to try – with the lost origins of my first encounter with Prabuddha's work, but it doesn't work. I just can't remember. At the risk of sounding like a drunk refusing to accept responsibility for his actions, who blames the drink rather than his consumption of it, I take this not as a personal failing but as an accurate reflection of – or at least a response to – something inherent in the work. It's the photographer's fault, not mine! In some way this work – which seems so much about remembering – is indelibly associated, in my mind, with forgetting, with the inability to remember. Could this be why there is a sadness about it? Why – amidst scenes that are a source of celebration, happiness and joy – even of bliss – there is also a suggestion of elegy and loss?

Shortly after the US paperback was published I received an email from the photographer Adam Bartos, who admired the image on the cover. 'When I first saw it,' he wrote, 'it took me a few moments to realise that the beautiful face submerged on the cover belongs to my friend, the actress, Sarita Choudhury, who I met when Mira [Nair] was making *Mississippi Masala*. We went

out together for a time . . . The photograph was probably taken in Khajuraho on the set of *Kama Sutra*.'

Well, well, what a small world! I forwarded the email to Prabbudha who, as expected, was amused to hear of this coincidence – though not for the reason I expected. Adam had not been out with the woman in the picture for the simple reason that she was not the person he thought it was. She was actually Prabuddha's long-time girlfriend, Lakshmi, and the picture was taken in a 'natural pool in Alibagh, near Bombay'.

A more general lesson can be drawn from this anecdote. Prabuddha's pictures disorient the person looking at them. They attach themselves deeply to you while simultaneously floating free of your conscious life and memories, refusing to become part of the documentary or circumstantial record. As evidence they are entirely unreliable and inadmissible. We are in the realm of dreams, and memories – exactly whose is never clear.

Books by neuroscientists or the famous case studies of Oliver Sacks frequently cite examples of patients who, due to some kind of brain damage – the result of a stroke or head injury – have variously impaired memories. In some cases this can mean that they are incapable of forming new memories, but there are others whose conditions are less straightforward. I am uncertain of the medical facts, but I imagine that there are patients for whom memories *are* lodged, somewhere, in their injured brains; it's just that they are arranged so chaotically and haphazardly – and, as a result, come so fleetingly to the surface – that any individual recollection immediately fades into and is overlain by others that cancel out, blur, or at the very least reconfigure the previous ones. Or perhaps the jumble and chaos – the sheer abundance of memories – is such that no individual memory can attach itself to the circumstance in which it had its origin. In other cases perhaps there is some kind of problem with space or time: the memories cannot be arranged chronologically or spatially. (The photographic equivalent would be a stash of photographs in which the captions are muddled

or entirely missing; or a sequence that suggests an order that can never be definitively established, which evaporates in the process of becoming apparent.) In such cases a person could remember incidents and moments but not where or when they occurred, and, as a consequence, would have no understanding of the consequences of what was depicted. Narrative would then give way to . . . to what? To something akin to what we see here. The degree of torment caused by any of these conditions must be dependent on the extent to which the sufferer is conscious of his or her impairment. In a psychological scale of reckoning it might go from bliss – absolutely no idea – to longing, to sadness, to frustration, to despair. In any given photograph, however, these distinctions dissolve; it is hard to tell one state from another, however powerfully one longs to do so.

Coda

In 2010 I agreed, very happily, to contribute an essay to accompany a book of Prabuddha's pictures from the series *Longing*. I wrote the piece, we met for dinner in London, he gave me a couple of beautiful prints. Everything about the collaboration was a pleasure. *The Paris Review* ran a portfolio of photographs and a slightly edited version of the essay. Prabuddha worked on making a definite selection of pictures for the book. Then, just a few days after he had emailed to say that *ArtVarta* magazine also wished to publish some of the pictures with my text, our mutual friend Dayanita Singh wrote to tell me that he had died.

Re-reading the essay after his death, I was surprised to find that I had used the word 'elegy'; that, sadly, is what the piece has become. When I wrote it I had not read Maggie Nelson's *Bluets* but a line from her book seems, now, to provide a perfect epitaph: 'When I was alive, I aimed to be a student not of longing but of light.'[1]

2012

Photojournalism and History Painting:
Gary Knight

Susan Sontag's book *Regarding the Pain of Others* concludes with a discussion of Jeff Wall's huge photograph *Dead Troops Talk (A Vision after an Ambush of a Red Army Patrol, near Moqor, Afghanistan, Winter 1986)*. 'Exemplary in its thoughtfulness and power', this image of a 'made-up event' was constructed in Wall's studio. 'The antithesis of a document',[1] the picture's effectiveness derives, in other words, from the fact that it is a fiction.

But what effect does this have, in turn, on combat photographs that *are* documents? Are they diminished or enhanced by comparison with Wall's mock-up?

Consider, for example, Peter van Agtmael's well-known photograph of a line of US troops sheltering from the downdraft of a helicopter in a rocky grey landscape in Nuristan, Afghanistan, in 2007.

Its compositional resemblance to Wall's image suggests that the fictive can set a standard of *artistic* authenticity to which the real is obliged to aspire – and can still, accidentally, achieve. At the same time, its similarity to W. Eugene Smith's shot of marines sheltering from an explosion on Iwo Jima in 1945 testifies to its place in the heroic tradition of documentary photography.

It reminds us, also, that George Bernard Shaw's appeal to photographic proof still holds good, in a battered and shop-worn (as opposed to Photoshopped) sort of way, despite the challenge of digital. Shaw said that he would willingly exchange every painting of the crucified Christ for a single snapshot of Him on the Cross. '*That*,' as Magnum photographer Philip Jones Griffiths insisted, 'is what photography has got going for it.'[2]

Or is this to miss an important point about Wall's work, namely its relationship not to photography as traditionally conceived – as a kind of visual

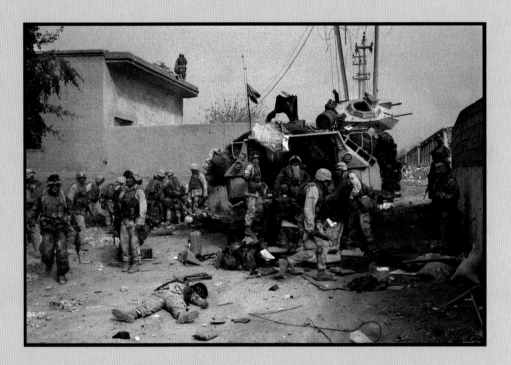

**US Marines attend to their dead and wounded after a 130mm artillery shell
entered the top hatch of an amphibious vehicle and exploded during their assault on
Dyala Bridge during the invasion of Iraq on 7 April 2003 by Gary Knight**

By kind permission of Gary Knight/VII

stenography – but to the imaginative ambition and reach of history painting? Sontag herself describes Wall's intentions as 'the imagining of war's horrors (he cites Goya as an inspiration), as in nineteenth-century history painting and other forms of history-as-spectacle'.

If van Agtmael's photograph falls short of the epic scale of this ambition then we can turn to a picture taken by Gary Knight in Iraq in April 2003. The photograph is actually part of a sequence recording the battle for Diyala Bridge. All of the pictures have the kind of immediacy we associate with photojournalism from Robert Capa and W. Eugene Smith in the Second World War, to Larry Burrows and Don McCullin in Vietnam. Taken together they make up a visual narrative of combat and its aftermath with which we have become wrenchingly familiar. At its heart, however, is a single photograph that contains the larger story of which it is part.

Knight himself has provided a vivid account of the terrifying context in which the picture was made:

> This was at the start of the invasion. We were at the Diyala Bridge, which had to be taken by the marines so they could get into Baghdad. They were the lead battalion, the ones who went on to pull down the statue of Saddam. The opposition were shelling us. It was terrifying – both the actual shelling, and the anticipation of it. It comes in waves so you can see it moving in your direction. One had exploded in the tank. If it had landed on top or a couple of feet over, I would have died.[3]

In the dead centre of the picture a soldier is pointing – directing our attention – to the corpse that everyone else, with the possible exception of the soldier advancing towards the camera on the extreme left, seems determined to ignore. Understandably: in situational terms he is the least important figure there; in every other way, he is the most important figure in the picture, its unavoidable focus.

The dead man is also the epicentre of the remarkable *stillness* of the picture,

a stillness that emanates from and converges on him. (The slight blurring of the leg and foot of the soldier walking across the scene shows that a relatively slow shutter speed was enough to capture everyone else with near-perfect clarity.) There is a lot of activity – a lot going on and a lot to be done – but there is almost no movement. There is thus a kind of double stillness: the stunned stillness that comes after a battle and the stillness of an oil painting, a stillness that does not stop time (as happens in fast-shutter-speed photography) but contains it. Oil paintings imaginatively recreate the swirl of action and battle with the steadiness of observation the painter would bring to bear on a still life (a bowl of fruit, say, or flowers). Photography can record actual combat but only with the kind of urgency and blur of Capa's famous picture of a Republican soldier being killed in the Spanish Civil War or – for disputed reasons – his shots of the D-Day landings. Only in the aftermath of extreme violence can the twin strengths of photograph and oil painting be combined in this single extended moment.

It is not at all unusual for news photographs to echo the paintings of the past, either deliberately or accidentally. In 1967 John Berger famously pointed out the similarities between the photograph of the corpse of Che Guevara and Rembrandt's painting of *The Anatomy Lesson of Professor Tulip*. A year later Joseph Louw photographed Martin Luther King's friends and associates on the balcony of the Lorraine Motel in Memphis, after he had been shot.

It's a picture of instantaneous journalistic and historic importance, but the way three arms are raised, pointing in the direction of the presumed assassin – not, as in Knight's Diyala Bridge picture, at the victim – mirrors the three brothers in Jacques-Louis David's *Oath of the Horatii* (1784).

This, surely, was not in Louw's mind at the time he took the picture. The parallels, however, are not merely visual. As art historian Hugh Honour writes in *Neo-Classicism*, David chose to depict 'a moment not mentioned by any historian . . . in which the highest Roman virtues were crystallised in their

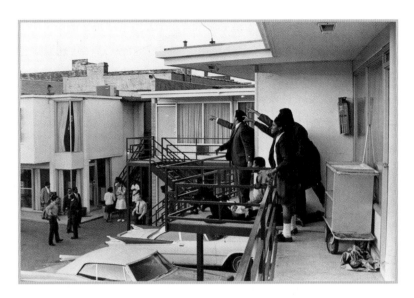

Assassination of Dr Martin Luther King, Jr, 1968, by Joseph Louw

Joseph Louw/Getty Images

The Oath of the Horatii, 1784, by Jacques-Louis David

finest and purest form. This was the moment of the oath when the three youths selflessly resolved to sacrifice their lives for their country.'[4] Or, as King had put it in a speech the night before his assassination, 'Like anybody, I would like to live a long life. Longevity has its place. But I'm not concerned about that now. I just want to do God's will.'

While the Louw picture instantly recalls David's, Knight's suggests a generalised memory of several paintings without quite superimposing itself on any one in particular. (The overall colour of the picture – a sandy, dusty, light brown that extends to and dulls the glow of the sky – is like the default hue of any number of paintings of atrocities, battles and assorted barbarisms in the Middle East: the Orient, as Delacroix and his contemporaries conceived it.)

The centre foreground of *Napoléon on the Battlefield of Eylau* (1808) by David's pupil Antoine-Jean Gros is dominated by a heap of corpses, around which the rest of the figures are arranged, but the fit is far from exact. Paintings of various scenes and battles from the American Civil War – Charles Prosper Sainton's *Pickett's Charge, Battle of Gettysburg* (1863), say – provide only rough templates. Knight's Diyala Bridge photograph quotes from an actual event but not from an identifiable painting. It combines the documentary immediacy and evidential power of the best photojournalism with the epic grandeur of history painting.

2013

Pavel Maria Smejkal's *Fatescapes*

Occasionally, even now, you still come across places where a little piece of graffiti quaintly explains that on this day, on this spot, nothing happened. That's the claim made by the images in Pavel Maria Smejkal's series *Fatescapes*. By doing so they insist, simultaneously, that something momentous happened here. Poetry, W.H. Auden claimed, makes nothing happen. But can photography make things *un*happen?

Smejkal's strategy is audacious in its simplicity: take some of the best-known news images of the last 150-odd years – Joe Rosenthal's shot of marines raising the Stars and Stripes on Iwo Jima; Robert Capa's photographs of the Spanish Republican soldier getting shot, and of an American soldier wading ashore on D-Day; a hooded Black September terrorist at the Munich Olympics in 1972 – and digitally remove everything except the background so it looks like nothing happened. Same with Vietnam in 1968 and 1972 respectively: just the street and the houses where the chief of police shot a Vietcong prisoner in the head, or the long road down which the naked girl was running, her skin raw from napalm. Painted white arrows on an urban highway point us towards the exact spot in Beijing where, in Stuart Franklin's photograph from 5 June 1989, a single protester blocked the path of a column of tanks. More arrows urge us *away* from the same spot – quite reasonably, since there is nothing now, not even traffic, to detain us.

A number of technical precedents spring immediately to mind. American photographer Kathy Grove removed the women from some famous photographs and paintings so that in Brassaï's picture of a couple kissing in a bar, for example, the man is left gazing, empty-handed, at himself in the mirror of the

From the series *Fatescapes* by Pavel Maria Smejkal, from an original photograph by Stuart Franklin, 5 June 1989

By kind permission of Stuart Franklin

booth. In his series 'Absence of Subject', Michael Somoroff took August Sander's portraits and digitally removed the featured subjects, leaving only the chairs they were sitting on and the countryside or architecture that framed them (i.e. the social landscape that formed them). Dutch artist Martijn Hendriks got rid of the birds from Hitchcock's *The Birds* so that the film becomes a parable of pure paranoia – unfounded were it not for the face with its eyes pecked out by some invisibly malevolent force. And Smejkal himself has ventured into this kind of territory before, stitching his own face into the photographed past (in the series *The Family of Man)* so that he is the one pulling the trigger in that street in Saigon or wading towards Omaha Beach. Unfortunately the questions Smejkal intended the work to raise – 'How would I act under certain historical circumstances, or how would I have to act?' – were somewhat undermined by the inevitable association with an earlier bit of face-grafting: Woody Allen's *Zelig*.

In *Fatescapes* the past is not amended but erased. And yet, in most cases, we 'recognise' or reconstitute places, people and events instantly, even when – as in the case of a shot from Dallas, 1963 – there is a only a blur and shimmer of green. It's the visual equivalent of the way the grassy knoll has itself become a verbal metonym of the assassination of JFK. Only the ghostly turbulence of tide stops another picture becoming a serenely Sugimoto-esque void – but that is enough to identify it as one of the surviving shots from Capa's D-Day. Memories and knowledge whoosh in to fill the visual vacuum. How profoundly the original images must be embedded in our brains for us to be able to reconstruct them, unthinkingly, from the unnoticed background. The extent to which our memories and knowledge reach beyond this, to an understanding of the events photographed rather than just familiarity with the pictures themselves, is a different question entirely.

Smejkal was born in 1957, in what was then Czechoslovakia. Nine years earlier, as Milan Kundera reminds us in the famous opening of *The Book of Laughter and Forgetting*, Communist leader Klement Gottwald was photographed as he stepped out on the balcony of a Baroque palace in Prague. 'It

was a crucial moment in Czech history – a fateful moment of the kind that occurs once or twice in a millennium.' Four years after that he was charged with treason, the picture was altered and Gottwald was 'airbrushed . . . out of history and, obviously, out of all the photographs as well'.[1]

Smejkal's absolute, totalitarian erasure – not of events but of history itself? – is sometimes applied to images that have been altered in this way, that have a prior history of amendment. All that survives in his version of John Paul Filo's picture of the 1970 massacre at Kent State are three poles sticking from a grass verge. As published in *Life* magazine and elsewhere, one of these poles was removed because it was protruding, in an aesthetically unpleasing way, from the head of the distraught woman kneeling by the body of the dead student.

Sometimes the photographic evidence was questionable even before it was tampered with. Didn't Capa fake the Republican soldier's death? Wasn't the Iwo Jima flag-raising restaged? Typically we are aware of such rumours and allegations but are unsure of exactly what happened. In the case of Alexander Gardner's photo of a dead rebel sharpshooter, Gettysburg, 1863, we know that Gardner moved the corpse some distance, propped its head on a knapsack (so that it faced the camera) and leaned a rifle (not the dead man's, but one Gardner carried as a prop) against a stone wall for enhanced dramatic effect. By removing the dead man and his gun, then, Smejkal has removed an *un*truth.

His version of Roger Fenton's picture of a rock- and cannonball-strewn road from the Crimea in 1855 is particularly loaded, since the original is itself, as Susan Sontag puts it, 'a portrait of absence, of death without the dead'.[2] What Smejkal has done is get rid of the things – the cannonballs – that were themselves intended as signifiers of absence. But the story does not stop there. Fenton's picture was perceived as a kind of visual tribute to the Light Brigade's charge down the Valley of Death, even though – Sontag again – 'it was *not* across this landscape that the Light Brigade made its doomed charge'.[3] At the level of literal or geographical truth, in other words, the landscape itself – the only thing that remains in Smejkal's rendering – is absent from the original.

As for the cannonballs, Mark Haworth-Booth, former curator of photography at the Victoria & Albert Museum, noticed that they were scattered differently, more abundantly in a second version of Fenton's original picture – because they had been rearranged by Fenton or his assistants? When he pointed this out to John Szarkowski, the director of photography at MoMA in New York responded, 'You're right, the second picture has more balls.' The discrepancies and differences between the two pictures – and the history of previous attempts to explain them – have been examined in forensic detail by Errol Morris in his book *Believing Is Seeing*. Smejkal, meanwhile, wipes the slate clean and, in the process, paradoxically creates a palimpsest: a year-zero approach that preserves photographic history in the process of obliterating it – but only if you are conscious of that history in the first place.

There remains the question of how interesting these pictures are as photographs in their own right. It's hard to imagine anyone forking out to hang one on a living room wall. And it's equally difficult to believe that they'd look significantly better there than they do on-screen. In short, is there much to look at – in pictures devoid of the very things we were intended to look at – after we've got the point, solved the puzzle?

Well, that presupposes – to jump back to the end of the preceding paragraph – that we *have* solved it. Surprisingly – but logically – the most intriguing pictures in the series are probably the ones we fail to recognise, even with the help of captions identifying location and date. The absence in these pictures reflects our own lack of knowledge, leaving us with a vision of our own ignorance. A low building, grey fields in Iran – what happened there? That question makes us go back to the other pictures, to the ones we do 'get'. What is the single characteristic that they all share? To put it as simply as possible: these were places where famous photographs were taken. Hence the awful corollary that is implicit throughout the series: if an event was not photographed then, in a sense, it didn't happen at all.

2011

Chris Dorley-Brown's Corners

There's something not quite right about the photographs in Chris Dorley-Brown's book *The Corners* (Hoxton Mini Press, 2018). The scenes are ordinary enough – intersections in east London with people going about their normal business – but there's a tranced stillness about them: a feeling of being in some kind of fugue state. I'm referring not only to the people *in* the pictures; I'm also describing the effect induced in us, the people looking at them. And when I said there was something not right about them, maybe I meant the exact opposite: something *too* right, eerily ordinary.

The strange thing about this strangeness is that, to anyone who knows London, these pubs, post offices and people all look so familiar. If the familiarity is photographic as well as geographic that might be partly because Dorley-Brown has also assembled and edited the colour slides of an earlier photographer, David Granick, in another book: *The East End in Colour 1960–1980* (also from Hoxton Mini Press). This was the era from the pre-Swinging Sixties to the punk revolution of the late 1970s but, as Dorley-Brown notes in his introduction, the wartime trauma of the Blitz infuses 'the mood of this tired landscape . . . with a melancholic determination to remain in the past'.[1] Architecturally, parts of the East End may still look weary, battered, hungover, but in recent years Hackney and its hipster environs have significantly tilted the axis of London life. The eastward migration has left 'fashionable' areas such as Notting Hill on the other side of town contemplating a future as affluent cultural wastelands.

In *The Corners* Dorley-Brown is updating Granick's work in two senses: recording the changes and continuities of the areas he had photographed and

Sandringham Road & Kingsland Road, 15 June 2009, 10.42 a.m.–11.37 a.m., by Chris Dorley-Brown

By kind permission of the artist

doing so in a way that employs the changed technologies of the moment. Each photograph is actually made up of 'a matrix of smaller pictures' of parts of the same scene that are later 'composited on a screen'. A typical background is made up of eighteen to twenty-one images, with a further selection of details added to create 'a montage of time compression covering up to an hour of action'.[2] (We'll come back to that word 'action' later.)

The results are full of legible evidence confirming the practice whereby the photographic moment is extended and the documentary record adjusted. A shot of Truman's Road and Stoke Newington Road – featuring a man in a blue sweater talking on a cell phone while another contemplates the scene of which he is a part – was taken between '12.01 p.m.–12.34 p.m., 18th June 2009'. A traffic sign enlarges the frame of temporal reference still further – 'Mon–Sun 7 a.m.–7 p.m.' – only to be outlasted by an off licence that is 'Open 24 hours'. A dry-cleaner's, meanwhile, offers 'Repairs and Alterations'. More generally, a sign in another picture alerts us to the fact that, having left the documentary free-for-all of traditional street photography, we are entering a 'Controlled ZONE'.

In some of Granick's views from 1960–80 Dorley-Brown observes that hints of the hipster future can be seen 'in a distant haze, just around the corner'. In *The Corners* the past can be seen emerging from a slight haze, just down the road. That haze can sometimes be more than slight: in the very last image in the book – and in another series of works, *The Fogs* – there lurks a linger of mist that can trace its ancestry back to the aptly named 'London particulars' of *Bleak House* in the nineteenth century, and the murky dawn of photographic light. The long exposure times of early photographs emptied those bustling Victorian streets of all moving people and horse-drawn traffic except for the occasional blur of almost stationary ghosts. The individual images within the large time frames of *The Corners* are taken at shutter speeds sufficiently fast to suspend people in the act of walking. People in photographs by Garry Winogrand or Helen Levitt always look as if they are capable of crossing the

frame and, in a second or two, passing beyond it. No such egress is possible within the oneiric zone of Dorley-Brown's control. His daylight somnambulists are rooted to the ground by the effort of ostensibly traversing it, as oddly static as the figures in Edward Hopper's paintings. So the pictures look like records of a fully immersive street installation which, for those lucky enough to obtain tickets, offers the experience of being able to wander through a world in which time is stalled, isolating everyone else mid-stride, mid-phone call, mid-life.

The sensed absence of time – the result, paradoxically, of an unusual amount of it being accumulated within each picture – is accentuated by another lack, which deepens the enveloping aura of emptiness and, as a consequence, emphasises the connection with the photographic past: no traffic, no congestion. In this world lacking vehicular transit – a result of shooting traffic-less interludes rather than having cars towed away after the fact, in post-production – the 'Chapel of Rest' on the corner of Vernon Road and High Road is a conveniently located destination and terminus. The figure loitering across from it looks like one of the living dead: the ghost of long exposures past, summoned into full tangibility. What's he going to do? The question makes no sense. He doesn't have the time.

Cathy Lomax, in a brief introduction to the book, writes that there is 'something happening in every frame', but it is hard to imagine how less could be going on without the pictures being digitally purged of people. In the background of the frontispiece a building is being demolished, in another a police van blocks a road cordoned off by police tape. The sky is more turbulent in this picture than any others, but the two cops on view are chatting, relaxed, doubly happy, in this context, to be on *overtime*. The 'action' of the pictures is, in other words, almost entirely photographic. Visual detectives investigating 'Kingsland Road/St Peter's Way' have identified as a person of interest the aged lady in purple top, lugging a matching shopping bag, who, between the hours of 12.11 p.m. and 12.36 p.m. on 25 June 2010, somehow found herself wandering in from a Katy Grannan photograph. How could this have happened, given the

inability of people to make meaningful progress across the page? The clue is the street sign just behind her head: 'Zone ENDS'. Dorley-Brown manipulates his scenes not to manufacture drama or to bunch people into near-collisions but to create a 'truthful' picture that 'must match the memory of a moment that never occurred'. He does not specify *whose* memories, but they have the potential to join and alter (remember that sign in the dry-cleaner's) our own.

There is abundant information in each photograph – in the form of street signs and shop names – about exactly where we are but, as we have seen, the frame of temporal reference is necessarily hazy. On these corners the intersection of time and space is consistently angled towards the latter. Dorley-Brown's admission that he doesn't have 'a journalistic bone in [his] body'[3] fits nicely with Rebecca West's suggestion that 'sometimes it is necessary for us to know where we are in eternity as well as in time'.[4]

Not that that's much help to the fellow in the first plate in the book. He's gazing in the direction of the street name – Sandringham Road – while, behind his back, the film showing at the Rio Cinema implies, in the captioning way of such things, that he might also be *Looking for Eric*. (Ideally the cinema would be screening *From Here to Eternity*, but that would perhaps be too good to be true and Dorley-Brown's alterations do not permit the addition of any details that were not actually present. Within their own enlarged conception of the words, the pictures are accurate and authentic.) Nowadays we try to arrive at a movie at the time advertised, but how can you do that when you're stranded in the East End dreamtime? In an essay on Edward Hopper, 'The Nothing That Is Not There', Leonard Michaels writes, 'It wasn't important, in Hopper's day, to see a movie from the beginning. People often arrived in the middle, which led to an expression we no longer hear, "This is where I came in."'[5] Not *when* but 'where'. That, give or take half an hour in each picture, is where and what we're seeing here.

2018

Dayanita Singh: Now We Can See

Arriving at Delhi airport in 2006, I was confronted by an unusually impressive advertisement. It featured a big and grainy black-and-white photograph of the tabla player Zakir Hussain and his dad, Ustad Alla Rakha, in concert sometime in the mid-1980s, I guessed. Zakir's dad is reaching over and patting his son's head, ruffling his hair as if to congratulate the puppy on having barked with such enthusiastic promise. But with this loving gesture the pre-eminent tabla player of one generation – in the famous Concert for Bangladesh it's the grinning Alla Rakha we see accompanying Ravi Shankar on sitar and Ali Akbar Khan on sarod – is also passing on the musical baton to the man Bill Laswell will later describe as 'the greatest rhythm player that this planet has ever produced'.[1]

The picture turned out to be by Dayanita Singh, who, in one of the small home-made-looking photographic journals from the boxed set *Sent a Letter*, has constructed a tribute to her mum: a passing-back of something that was never quite a baton. The other six books in the set take their names from places in India – Calcutta, Bombay and so on – whereas this one, with its slightly darker cover, is named after Dayanita's mother, Nony Singh. It's made up either of pictures Nony took or of ones she found in her husband's cupboard. There are quite a few pictures of a little girl with a determined little pout or frowning smile who is clearly Dayanita.

Is that smile-pout a precocious sign of ambition? When the eighteen-year-old Dayanita first went to photograph Zakir at a concert, the organisers prevented her and she tripped and fell. Embarrassed but undeterred she called out, 'Mr Hussain, I am a young student today, but someday I will be an

Ustad Alla Rakha and his son Zakir Hussain by Dayanita Singh

© Dayanita Singh

important photographer, and then we will see.'[2] Mr Hussain liked this spirited response and allowed the student to travel with him and his fellow musicians, to document his life on the road and at home. The result of this was Dayanita's first book, *Zakir Hussain* (1987), which included the picture I saw, almost twenty years later, at Delhi airport.

Now that her injured boast has been made good, another kind of continuity can be seen. It too can be illustrated musically. Many of the greatest living female singers of the Karnatic and Hindustani classical traditions are in their sixties or seventies. As they take slowly to the stage they look magisterial, imposing, grand, conscious of the immensity of their reputations. It can take them a while to get seated, cross-legged, but when these ladies start to sing the years fall away to reveal a lovely girlishness. A part of time has been stopped. Their voices are light-footed and graceful as the *gopi*s spied upon by Krishna – but with the knowledge, wisdom and often sadness of age. Now look again at that set of diaries, *Sent a Letter*: in its high-art, homespun way, it's not unlike the kind of thing you might have tried to make as a kid in art classes – and it's as far removed from an Andreas Gursky or an Anselm Kiefer as one could get. *Go Away Closer* looks like a school exercise book. The book of *Dream Villa* photographs – many of them printed quite large for exhibitions – seems intended to pass itself off as a pocket diary. This last, in my view, is a perverse decision and major aesthetic mistake – what is the gain in having the double-page full-bleed spreads dominated by the gutter? – but the general point stands: playfulness, pleasure in the possibilities of the modest and the miniature are not at odds with seriousness; they are part of what enabled Dayanita to become 'an important photographer'.

While it was perfectly natural for Zakir to become a tabla player, there were numerous obstacles to be overcome if the young student was to turn her mum's hobby into a vocation and profession. These were obstacles born of expectation: what was expected of young women in India and what was expected from Indian photographers and photographs of India generally. With Dayan-

ita's work there is a subtle but clear break from the teeming streets of Raghu Rai and the crowd of colours associated with Raghubir Singh in favour of a photography that is quiet, intimate, private, withdrawn: an art, increasingly, of absence.

In one of the pictures by her mum the baby Dayanita is barely visible; in a couple of others she is entirely overlooked in favour of the splendid surroundings of a hotel room. The grown-up daughter has followed suit: her pictures are full of empty rooms, empty beds and what Billy Collins calls 'the chairs that no one sits in': 'where no one/is resting a glass or placing a book facedown.'[3] The poet is here thinking of permanently empty – rather than briefly vacated – chairs, but in photography, of course, even the momentary becomes permanent.

About half of the pictures in *Privacy* are portraits of people in their opulent homes, spacious rooms crowded with wealth and flesh. The effect of these is to make the other half, the empty interiors, seem . . . even emptier! And then there are the museum rooms of Anand Bhavan, the former Nehru residence in Allahabad where we get a redoubled, much-multiplied emptiness: unworn clothes hanging on the unopened doors of empty rooms. The glaring absence in these pictures, these rooms, is of the present (as symbolised by the stilled ceiling fan). This is what time looks like after history has moved on and left it for dead.

Referring to his own photographs of empty interiors, Walker Evans once said, 'I do like to suggest people sometimes by their absence. I like to make you feel that an interior is *almost* inhabited by somebody.'[4] The dominant suggestion in Dayanita's rooms is not the absence of people so much as the *lack* of their absence: the idea of people, I mean, doesn't rush in to fill the vacancy. The wide-awake daybed and the books wanting nothing more than to curl up with a good read are perfectly content with the prospect of an evening on their own, undisturbed by human intrusion.

What Dayanita shares with Evans is the ability to suggest another rarer absence: that of the photographer. Making it seem that the room itself had done

the photographing was Evans's paradoxical and signature gift. In this he both expressed an ideal – of the photographer disappearing into his photographs – and harked back to the dawn of the medium, to William Henry Fox Talbot's claim about an image made in 1835: 'This building I believe to be the first that was ever yet known *to have drawn its own picture*.'[5]

The silent atmosphere of places surveying themselves pervades Dayanita's rooms, corridors and halls. It's at its most extreme in a picture of – so extreme it seems more appropriate to write 'picture *by*' – the library in Anand Bhavan. There *are* people in this photograph – visitors peering in through the glass that preserves and isolates the room – but the sense of latent sentience is so strong that a kind of role reversal occurs: as if the room itself is regarding a vitrine displaying these time-frozen specimens of life-sized humanity.

Elsewhere this atmosphere of self-surveillance is enhanced and signalled by the way that the rooms so often contain other photographs, either actual ones – hanging on walls, propped on shelves – or, less tangibly, in the form of reflections: in shining floors and polished furnishings, in windows and mirrors. (It's often impossible, in photographs, to tell the difference between a mirror and a photo. In a photo, in fact, a mirror is automatically transformed *into* a photo. A photo, let's say, is a mirror with the time taken out it.) The effect of these layers of self-seeing – inanimate, passive and abiding – is a cumulative laying bare of essence: the stillness of still photography. That's one way of seeing and putting it. Another, by a visitor to the 2007 exhibition of the *Go Away Closer* photographs at the Kriti Gallery in Varanasi, was to copy into the visitors' book some lines in Urdu from a *ghazal* by Faiz called 'Hum Dekhenge' ('We Will See'):

> All that will remain is Allah's name,
> He who is absent but present too,
> He who is the seer as well as the seen.

Light stares whitely through the windows. These windows reflect on the interiors – as we have seen – and provide visual access to the world outside. What happens when we gaze through them? What do we see?

To answer this we first have to re-familiarise ourselves with the terrain, get an overview of how the documentary impulse in early work such as *I Am As I Am* and *Myself Mona Ahmed* gradually softens to something anchored less directly in place and time. Bear in mind, also, that the divisions between projects and books have never been absolute. A picture from *Go Away Closer* is also in *Sent a Letter* and in *Privacy,* and so on. The piles and shelves of documents in the recent *File Room* are prefigured by the libraries and piled-up books and lockers of *Privacy*. Effectively, then, the pictures are all the time overlooking each other, glancing over each other's shoulders. You can, in other words, glance out of the windows of a tower in Devigarh and gaze down at Padmanabhapuram. Until recently you could be fairly certain that the place you looked out from – and at – was somewhere in India, but that's no longer the case. Come to think of it, a place might not even be a place: just a wall that's nowhere in particular with the image of a photographer drawn on it.

You can tell by the face of the woman in this sort-of mural – the photographic equivalent, surely, of Dayanita's tag – that this revealed and self-observing world is constantly surprising itself. Dayanita's work seems to advance by a series of rhythmic astonishments – '*Ooh, I wasn't expecting that!*' – so calmly accepted that they appear almost to have been intended.

This is most noticeable in the shift to colour. Colour photography only gained institutional recognition in the West in the 1970s. For his part, Raghubir Singh wrote that if photography had been invented in India there would have been no need for all the theoretical hand-wringing and attendant claims of heresy.[6] Dayanita, on the other hand, dutifully worked through black and white – from documentary and reportage to the more elliptical style of *Go Away Closer* – before lurching accidentally into colour. *The Blue Book* was the result of running out of black-and-white film on a shoot. No problem, she

thought, just turn it into black and white later. Except this was daylight film, it was after sunset, and so the contacts came out blue. This blue period was short-lived, of stark if limited aesthetic usefulness, but the miscalibrated rainbow beckoned and soon she was in the midst of exactly the kind of 'spontaneous colour experience' proclaimed by László Moholy-Nagy.[7] Having tumbled into colour as people stumble into darkness – *now we shall see!* – she glided into the gorgeous nocturnes of *Dream Villa*.

This move was both unexpected and unsurprising in equal measure. The very last words quoted by the tabla genius in *Zakir Hussain* look ahead to the colour-trance of Dayanita's tropical oneiric. 'Maybe it's a dream world, maybe it's make-believe, but it's beautiful.'[8]

So what makes a Dream Villa? How does Dayanita know she's found one? The answer, surely, is that she doesn't, or, more accurately, that the question *is* the answer. The pictures are all uncaptioned because the places in them don't exist. Yes, they're out there in the world somewhere and she photographs them in that interrogative way of photographers, but it's only later, when they've stopped being places and become photographs, that it's possible to see if what was once reality – or a piece of real estate, at any rate – has acquired the ideal and elusive aura of the dream image.

The image that illustrates this most vividly is of a thin tree – more twig than tree – bathed in deep red light (see p. 207). Michael Ackerman's first book of photographs, *End Time City*, was very obviously about an actual place: Varanasi. But in his next book, *Fiction*, Ackerman decided he 'no longer wanted to see any information in [his] pictures'.[9] That's what we have here: a picture in which there is almost no information. Just night, red light and trees. No before and no after; the opposite, in a way, of an Edward Hopper painting. Wim Wenders said that Hoppers always prompt us to construct little stories or movies, before-and-after scenarios: 'A car will drive up to a filling station, and the driver will have a bullet in his belly.'[10] It's not just that the *Dream Villa* pictures do not provoke a response of this kind; they make it seem entirely inappropriate. The

red is presumably from a car's tail- or brake-lights, but that's the full extent of the story. It does not make us curious about what the car is doing there, though it does suggest that the way to understand this picture is by reversing into it, as it were, by the *opposite* of storytelling; that our curiosity will not be satisfied in narrative terms. There's not even the potential mystery of the crime that may or may not be illusory in the photographs in Antonioni's *Blow-Up* (although the red glow of the ground is reminiscent of the safety light in David Hemmings's darkroom), a mystery that will be revealed if we scrutinise the picture closely enough. If there is intrigue here, it is in the incidental cluster of lights in the distance and over to the right: *what's going on over there*? There is mystery in the foreground – there is nothing *but* mystery – but not the kind that seeks an answer beyond itself. This is mysteriousness not as a goad to solving and thereby bringing the mystery to an end, but mystery as a condition in which to reside (another reason for the lack of desire *to move on*). So it's not just stylistic clumsiness on my part that has led to this infestation of 'nots'; what we see here is a demonstration of photography's ability to depict a state of negative capability.

The red light makes the earth, or this little patch of it at any rate, seem as mysterious as Mars at night. But there's nothing threatening here, no murders of the kind Wenders saw lurking in Hopper, just the light that dyes the tree – the necessary leafless tree – and the corpesless, deathless ground red.

So you look at this picture without any irritable straining after truth, content in the permanence of the fleeting mystery depicted. And when you do this you realise that there *is* something there, in the middle of the picture. The ghost of a figure of some kind? Another tree? A mini-tornado touching harmlessly down? Just a trace of something, no more substantial than a smudge of smoke. So perhaps that mention of the darkroom in *Blow-Up* was not as parenthetical as it seemed. What we share here is the essential mystery – in danger of post-digital extinction – and excitement of the photographer watching an image emerge in the red glow of the darkroom. A different kind of negative capability: one that might even be a synonym for photography itself.

The colourful dissolution of the external in the *Dream Villa* series was followed by what cries out to be described as Dayanita's most *substantial* body of black-and-white work, *The File Room*: a documentary record of documents! There's no room for emptiness here: sacks, cupboards, archives and cabinets are crammed full of books, papers and folders that have the weight and permanence of geological strata – minus, it goes without saying, the weight and permanence. That was an illusion: they're just pictures, after all, but how easily matters of fact become the stuff of fiction! So maybe it's not too deluded to think that if you pulled open enough drawers in one of the rooms, you would find, neatly preserved and archived in some Borgesian way, *Go Away Closer, Zakir Hussain, House of Love* and all the earlier books, along with the prints and contact sheets. Certainly it seems safe to say that this, for the moment, is where she has ended up.

2013

Dream Villa 44 by Dayanita Singh

© Dayanita Singh

Oliver Curtis: *Volte-face*

A simple idea that raises interesting questions and leads to aesthetically successful results: show up at some of the world's most visited – and therefore photographed – monuments and sites, turn your back on the very thing you have come to see, and record the view that no one else is interested in. It's not the same as photographing a famous site from an unexpected angle – from behind the HOLLYWOOD sign, as Robert Frank did in the 1950s – in order to reveal its local or grubby underside. Often, in Oliver Curtis's *Volte-face*, the monuments do not even get a look in. What we get, instead, is an idea of what they look *at*.

In films a character's point of view is often conveyed by showing that character from behind while looking over his or her shoulder. Without this bodily reminder we would see without knowing who was doing the seeing. Once the viewpoint has been fixed – once we have entered the mind of the looker – these glimpses of the consciousness-bearing body can be dispensed with as the film unfolds over time. But what of a photograph that isolates and is stuck in a single instant of time? A picture by the Danish photographer Per Bak Jensen shows a statue, seen from behind and slightly to one side. But it also conveys what it is like to *be* that statue, to be confronted with the same view, day after day, year after year. Without the statue the picture would offer a relatively uninteresting view of landscape. By framing the picture as he does, Jensen introduces the idea – or, even better, induces the feeling – of unsentient or dormant consciousness.

If we saw a single, uncaptioned picture from *Volte-face* it could appear quite meaningless or pointless. Once we've seen a few, with the locations

Taj Mahal, Agra, India, 2014, from *Volte-face* by Oliver Curtis

indicated, we begin to understand what we are looking for in each new picture, even if we don't know exactly what we are looking at. Even without recourse to the identifying captions we can try to get our bearings and, if we have visited the place in question, might be able to work out where we are in spite of the absence of the very thing that *is* where we are. It depends on the place, though. Some of the most spectacular places in the world provide a fully immersive experience in that they offer abundant views of themselves *from* themselves. Angkor Wat, for example, is a superb place from which to see Angkor Wat. Perhaps that's why, in these pages, it is nowhere to be seen. Sometimes the site offers a view of somewhere less famous, less historically freighted with meaning, but still quite pleasing, as happens in the view from Piazza San Marco in Venice. Elsewhere we are confronted, in exalted form, with what might be called the non-reciprocity of real estate. A house is on the market for a price well in excess of two million pounds: a fabulous place with gorgeous rooms, perfectly designed and maintained exterior, and enormous windows. These windows afford unobstructed views of the building opposite: a social housing block, covered in satellite dishes, entirely functional, done on the cheap and devoid of any visually pleasing features. The rooms are small and the ceilings low, but it has one great thing going for it: the windows, though small, are filled with the sight of the splendid house opposite. With their views from – but not of – sites of world-heritage splendour, these photographs take the side of the large house described in that vernacular dilemma or relationship. That they are *about* looking is slyly suggested by the way that quite a few of them seem to contain a symbolic eye or pair of eyes that returns our gaze. Once we notice the staring floodlights under the grating at the Statue of Liberty gazing at us, wide-eyed, then the circles formed by other technological or architectural features double as a discreet chorus of passively inquisitive eyes. Consider that cartoonish fire hydrant (if that is indeed what it is) with eyes *and* ears cheekily eavesdropping on the Wailing Wall from its perch by the steel fence. Then

there are all those windows – etymologically 'wind-eyes' – offering their own form of blank surveillance. But mainly, of course, it's *people* who are looking.

In their way the destinations in *Volte-face* are monumental equivalents of Sylvia Plath's 'Mirror' which spends most of its time meditating 'on the opposite wall',[1] but instead of a solitary viewer occasionally coming into view, they are each day treated to an international cast of thousands turning up to relieve the long monotony of time. Often the view includes a road leading out of shot, back into the city from which these pilgrims and visitors have trudged and swarmed. They come to see, to pay their respects and to make and take souvenirs of their seeing in the form of photographs. Magnificent in themselves and, for many centuries, content to bask in the sunlight and rain of their mythic renown, these monuments have in the last century and a half become increasingly dependent on the tributes paid to them in the form and currency of photographs. (If Martin Parr, in his book *Small World,* showed this economy in action, then in a perfect world – a perfect small world, as it were – one of Curtis's pictures would show Parr in the process of snapping a grinning group of Chinese or a couple of earnest Scandinavians. That would circle the photographic square, so to speak.) Without the daily and annual testimony of photographs, monuments would crumble in the sense that they would disappear from tourists' itineraries – how could a place be worth visiting if no one had bothered photographing it? Effectively, it would cease to exist. And so, in a sense, views of rubble- and garbage-strewn emptiness at Giza or Hollywood are prophetic glimpses of what such places – sites of eroded or vacated meaning – might look like when that has come to pass. In this light they are photographs showing a world in which there is no reason to go somewhere and nothing to see when you get there. In such a world there are only photographs and – Look, behind you! – people looking at them.

2016

Tom Hunter: The Persistence of Elegy

How often Tom Hunter seems to have photographed the end of something. That it is not always or immediately clear exactly what has – or is about to – come to an end is part of the works' fascination, one of the things that detains us, that stops our experience of a particular image coming to an end.

It might be just a day (dusk, twilight, the final blaze of light before darkness falls), the dazed aftermath of a party, or – in a signature reworking of Vermeer – the knowledge that one has a roof over one's head. It might be a phase of someone's life or, extrapolating from that, the end of a way of life. Or a headline-derived, artistically staged 'Naked Death Plunge'. It may not be all over Europe that the lights are going out, but the curtain has come down at the Rio cinema in Dalston. The urinals in London Fields and Hackney Downs have almost nothing in common with the gleaming modernist promise of the toilet photographed by Edward Weston in Mexico in 1925; they stand, instead, as blank memorials of what is left when we have, as the saying goes, pissed it all away.

So many pictures are, to borrow the title of a series and a picture within that series, swansongs that it seems, in retrospect, as if the 2012 Olympics and all the attendant plans for redevelopment hung over east London like some invisibly brooding apocalypse – *before* the host city was announced.

Even when Hunter photographs beginnings something shifts our attention back to what came before, to what had to make way for this new start. (Perhaps that's the purpose of the black-and-white pictures of Brick Lane at the beginning of the retrospective book *The Way Home*). In the empty rooms

The After Party, from the series *Life and Death in Hackney*, 2000, by Tom Hunter

Cibachrome print, 5ft x 4ft, Museum of Modern Art, New York Collection. Courtesy of the artist

of the *Holly Street Voids* the sense is rarely of what is going to happen next or who is going to fill the vacancy; invariably it is of what *has* happened, of who was there before and no longer is.

This predilection makes it almost inconceivable that Hunter could be anything other than British. The sun does not set on America (to say nothing of Japan or China) in the way that it has managed to go on setting for so long – to sink so low while still retaining some angled knack for creative illumination – in and on the island kingdom of Ukania.

Another word for this is, I suppose, tradition. In Hunter's case it is a tradition traceable back at least to the Pre-Raphaelites and their Arcadian response – an aesthetic reaction and invention that was also a tacit admission of defeat – to the regimens of industrial society. But there's a stubbornness in that impulse too: a refusal to submit that has continued to manifest itself in unexpected ways, with certain aesthetic elements remaining more or less intact, even if they've had to go underground in order to do so. That, I think, is what Hunter celebrates: the idea of alternative lifestyles – the residue of a once-widespread counterculture – as bedraggled representatives of a seldom-recognised strand of what is best about Britain. (Any updated list of 'Great Britons' should include Helen Steel and David Morris, the so-called McLibel Two.) This is not to romanticise; it is, as Hunter's photographs lyrically insist, to acknowledge. Without being backward-looking, they remind us of the persistence of elegy, of the idea of transience as survival strategy.

Unlike the utopian communities in America documented by Joel Sternfeld in his book *Sweet Earth*, the places photographed by Hunter are – with the obvious exception of the *Places of Prayer* series – less principled and planned, more provisional. Similarly, the squatters and other *Persons Unknown* who inhabit them have often drifted into ways of living on the fringes of – and adjacent to – mainstream society. As such they are under constant threat from the combined interests of the state and private finance; they are also vulnerable from within, courtesy of drugs, alcohol or people just moving on and out.

Given Hunter's interest in things coming to an end, it seems inevitable that he has also been drawn to the spatial equivalent of temporal endings: the coast (in the *Dublin Bay* series), the edge. As itemised by Paul Farley and Michael Symmons Roberts in their book *Edgelands,* these edges also crop up in the middle of Britain, in the gaps between the developed urban and the as-yet-untouched rural, between decaying industrial and rebranded start-up or retail park. Whereas the coast is permanent (it will always be there, even if bits of it crumble in to the sea each year) these internal edges are accidental and temporary, characterised by their in-between-ness in space and time. Places that thrived in the wake of something prior – nineteenth-century factories, the canals and railway lines supplying them with raw materials and distributing their products – are themselves subject to change and erasure, thereby creating a kind of double vacancy.

Hence, perhaps, the increasingly dreamlike quality of Hunter's pictures, especially in the recent series of *Unheralded Stories.* There is a distinct sense that these stories are not unfolding but *suspended* within an interior or psychic landscape as figures wander or float through the frame. Like many of the *Persons Unknown,* they may have come from the art-historical past – as if they have crawled in from an Andrew Wyeth painting, for example – but they look like they're here to stay. Sometimes the mood is sinister, with a nightmarish suggestion of being trapped. Other scenes are characterised by a freedom from any desire to move on, a somnambulant lack of volition. Either way, the distinctive quality of these dreams is the absence of time. That is why the stories are suspended rather than unfolding; stories can unfold only in time, after all. After all.

2012

Fernando Maquieira and the Maja at Night

We've all had the experience of going to a blockbuster art show or a major museum and been frustrated by the way that, with so many other visitors, we couldn't get a decent view of the paintings. But then – call it the self-incriminating logic of the traffic jam – we realise that we are part of the problem, that if they'd not allowed so many people in, if they'd decided to keep the numbers down so that those who were admitted had a better view, we might not have been there at all. If you have connections with the museum there are sometimes special early-morning tours when, together with a small group of other well-connected or influential people, you can have a more private experience. Basically, the less convenient the time, the better the chances of having the place – the paintings – to yourself.

Over the years there has developed a distinguished mini-tradition of photographs of museum-goers looking at artworks. The gestural reciprocity of viewers accidentally echoing poses in paintings or sculptures was a rich source of delight for Elliott Erwitt. Whereas Walter Benjamin had argued that the aura of the original work of art was lost through reproduction, Thomas Struth's magisterial, large-scale photographs tried to show how a different kind of aura was generated by the encounter between much-reproduced works of art and people seeing them in the flesh.

But what happens to works of art during the non-time when museums are closed? How wonderful it would be to see these pictures then, when there was no one around to see them (not even oneself!): to catch them just hanging out with each other. Consider it in these terms. You go out to a lavish and glamorously crowded art opening. You come home, change out of your fancy

Museo Nacional del Prado, Madrid, 10-2-2011/23:37h., *Naked Maja*, **Francisco de Goya,
from the series** *Night Guide Museums* **by Fernando Maquieira**

Reproduced by kind permission of the artist

clothes and watch a bit of late-night TV on the sofa. No one else sees you like this. Is there an equivalent of this scenario for paintings you had been looking at earlier in the evening? When they are not doing that for which they were created – i.e. being seen – do they too, at some imperceptible level, slip into something more comfortable?

Using, I'm guessing, very long exposure times, Fernando Maquieira grants us exactly this kind of privileged access and insight: the ultimate private view, which enables us to eavesdrop on masterpieces in silent conversations with each other. In some works from the series *Night Guide Museums*, one painting is reflected in the protective glass of another so that they mingle like the museum-goers who, a few hours earlier, had crowded around them. In some cases it is almost too dark to make out anything, so that we see our own rather brutishly intruding reflections: the equivalent of meeting artists we admire and then, instead of listening to what they have to say, bombarding them with anecdotes about ourselves. As a result, in this darkness, the paintings sink further back in to themselves, retreating from view (and, in so doing, further exposing their dimly revealed interiority). In the case of Goya's portrait of Gaspar Melchor de Jovellanos – painted, incidentally, without the wig that he would tend to have worn in public – the subject is able to immerse himself more deeply in thought than he is able to in the day while nudged and jostled by the questioning looks of thousands of visitors.

It is probably another Goya, *The Maja Undressed,* that demonstrates most clearly the processes at work in the series. The pair of paintings *The Maja Dressed* and *The Maja Undressed* represent a blatant exercise in exposure – a strip so complete and sudden it is devoid of any hint of tease. Having gone from the Maja Dressed in one painting to the Maja Undressed in another, she is further and subtly unclothed by Maquieira's photograph: not clothed in the gaze of all who are looking at her but intimately naked. As a result, the painting regains an erotic charge that has been steadily wiped clean by centuries of being seen so publicly. Whereas in the day we are invited to stare, here it is as

if we are spying on her while she sleeps. Or, more precisely, spying on her at the exact moment when we see – look, her eyes are open! – that she is only pretending to sleep.

2015

Spirit and Flesh in Naples

'I wasn't, but I could have been,

A god I was living in.'

Frederick Seidel, 'Hymn to Aphrodite'

I first saw . . . No, that's not the right word at all. I first *experienced* Elisa Sighi-celli's work at the Villa Pignatelli in Naples in July 2019: photographs of bits and pieces of antiquity from, among other places, the city's Archaeological Museum. Walking through that museum after seeing the exhibition, it was difficult to discover the original objects from which Sighicelli's samples were taken. One instance, a tight crop of fingers pressing into a calf (see p.225), is from a highly elaborate, much-restored and augmented sculpture with so much going on – a naked swirl of bodies, a rearing horse, a sympathetic doggy – it's hard to imagine how she found it in the first place. From the midst of this limby extravaganza the resulting image is as tactile as a close-up of a physio massaging the muscled calf of an injured footballer.

Even when you have located the original, it is tricky, sometimes, to work out how the picture might have been coaxed from it. Taking the photograph must have involved a kind of archaeological excavation in its own right – a visual dig – in the course of which the original works are not just photographed but transformed. Tightly framed, the goddess Aphrodite's midriff and hip have a slinky stillness – a form of naked display enhanced by concealing folds of stone drapery – that embodies the erotic force of millennia.

These images are printed on the same materials from which the original objects were made – marble, travertine – so that there is a symbiosis between what is depicted and the way it is shown. We associate photography with a mo-ment, but the main feeling induced by these entirely flat images is of temporal and sculptural depth, of deep permanence. The photographs simultaneously

Untitled (9038), 2019, by Elisa Sighicelli

UV print on marble, 100 x 80 x 4cm. By courtesy of the Ministero per i Beni e le Attività Culturali
– Museo Archeologico Nazionale di Napoli

remove the object from and return it to its source. The new stone becomes imprinted with an achieved vision of itself, of what it had become. (It's like a version, in a way, of that miraculously faked relic, the Turin Shroud.) The veins in the marble remind us that the statues are themselves idealised renderings of what might be called the ultimate original, without which there would never have been any art (or gods, for that matter, if you are of a Nietzschean bent): the veiny human body. Blotches in the processing or flaws in the marble are symptomatic of the defects and wounds to which the flesh will always be heir – including the flesh of gods.

Photography is all about surface – 'the surface is all you've got',[1] as Richard Avedon insisted. Looking at the two muscular male torsos of the Tirannicidi, however, it's impossible not to think of how the 'Archaic Torso of Apollo' scrutinised by Rilke was 'still suffused with brilliance from inside'. And whereas Christianity brought about an agonised separation of the spirit from the body, here there is a powerful affirmation that the spirit dwells in – is part of – the flesh. With their combination of purity and sensual power, these isolated body parts kept bringing me back to Jack Kerouac's observation about Neal Cassady, the model for Dean Moriarty in *On the Road*: 'a man who can sweat fantastically for the flesh is also capable of sweating fantastically for the spirit'.[2]

The following day I went to the Museo Cappella Sansevero to see Giuseppi Sanmartino's sculpture of the *Veiled Christ* (1753). It's justly famous for the way that hard marble has been transformed so that we see the dead Christ, stretched out on a tomb, through a diaphanous veil of the thinnest fabric. The almost-immaterial has rarely been better achieved by stone. And yet, great though it obviously is, I found myself wondering, blasphemously, if the *trompe l'oeil* quality of see-through stone might not be slightly stronger in the numerous photographs of the work that had made me want to come and see it in the first place.

Downstairs, the two so-called 'anatomical machines' from the 1760s are the opposite of veiled. Housed in glass cases, these 'machines' consist of the upright skeletons of a man and a woman with their arteriovenous systems preserved

almost intact. So intricate is the web of large and tiny veins that, from a distance, it looks like the skeletons have donned ghastly, close-fitting fur coats in an attempt to preserve a measure of modesty in the face of the chill stare of eternity. Up close they are laid bare by what appears to cover them. So they stand there, these two specimens, simultaneously the flayed descendants of Adam and Eve, and the rather shabby, mid-eighteenth-century ancestors of the slick exhibits in Gunther von Hagens' plastinated *Body Worlds*.

It was a relief to leave this weird shit behind, to get outside and back in the world of heat and flesh, of melting ice cream and skimpy clothes. From the Cappella Sansevero I walked, a little self-consciously, through the tight streets and hanging laundry of the Spanish Quarter. I'd been here twice before, many years ago, and on both occasions had exactly the same experience as considerate old ladies warned me that it wasn't safe. Was it really dangerous or a place where people were unusually concerned with one's safety and well-being? Possibly both. This time, keeping hands in pockets and phone in hand, I was left to my own devices. It was twilight; there were no signs of gentrification but plenty of signs of everything else. Lighted street shrines – dedicated to the Virgin, to various saints – had the beauty of magic that has endured so long as to be perfectly ordinary. And then, quite by accident, I came across exactly what I had hoped to find. On the wall of an apartment building was a huge grey mural of what looked, from a distance, like the *Veiled Christ*, in slightly androgynous mode. Getting closer I saw that it was a version of another of these 'veiled' sculptures from the same church, of a woman this time, by Antonio Corradini. In Manhattan this would have been an advert for underwear or for a highly sexualised perfume called Spirit or some such. Here it formed part of a tacit diptych, the other half consisting of a slightly smaller mural, on a nearby wall, of Diego Maradona (to whom a shrine was dedicated beneath the veiled woman). Now, I don't have a spiritual bone in my body, obviously, but I sensed immediately that I was in close proximity to the thing I crave, the main incentive – stronger than the lure of art or the possibility of sexual adventure

Maradona mural and shrine in Naples

Photographs by author

– for going anywhere: the experience of religious power converging on and emanating from a place.

Maradona is not just one of the greatest footballers of all time. Asif Kapadia's documentary tells the story of what happened after Maradona signed for Napoli in 1984 for what was then a world-record transfer fee: how he led the team to their first ever Serie A title in 1986–7, followed by a second two years later. And then? First, betrayal – essential in any Catholic drama – in the form of the penalty he scored for his national team, Argentina, in the 1990 World Cup, against Italy, in the very stadium in Naples where he was worshipped. Second, he fell foul of the Camorra crime syndicate, which had helped feed and satisfy his increasing hunger for hookers and, more disastrously for an athlete, cocaine.

Maradona's tragi-comic story is long and ongoing, but the essential thing about his time in Naples can be stated very simply: in this city a boy who had grown up in the slums of Buenos Aires, who had already risen to heights of unimaginable greatness, *became a god*. That is a subject worthy of a book

by Roberto Calasso but it is, I suspect, unfilmable. Still, the evidence here, at this shrine, is persuasive. A team of pilgrims, all kitted out in Maradona's blue number-10 shirt, came and photographed each other beneath the mural. I took some pictures of them too, with my phone. I wanted to have a permanent record of this fun scene, this sacred site – or a few visual relics, at least.

2019

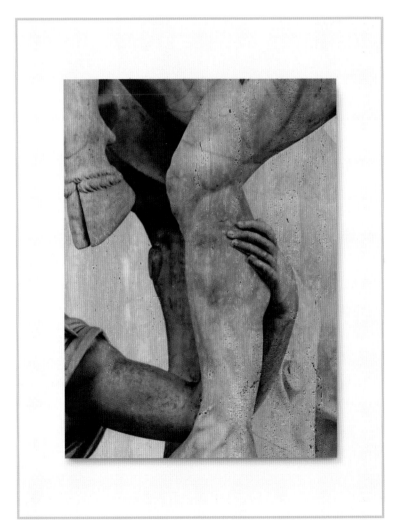

Untitled (8990), 2019, by Elisa Sighicelli

UV print on marble, 100 x 74 x 4cm. By courtesy of the Ministero per i Beni e le Attività Culturali – Museo Archeologico Nazionale di Napoli

Zoe Strauss

I had gone to the International Center of Photography (ICP) in New York to see two exhibitions: photographs by Lewis Hine and photographs of the Kennedy assassination taken by bystanders. What I didn't know was that there was a third show at the ICP, a mid-career retrospective of work by Zoe Strauss. And there I was, suddenly surrounded by a display of powerful individual photographs that also added up to a coherent and important body of work.

The tumble of first impressions went something like this: street photographs. Striking colours. Not that large. In-your-face portraits: faces that looked as worn-out as old rugs, others full of confidence and a beauty rendered more intense by the way that what they were confident of was that the beauty wouldn't last, so that the confidence too was touched by resignation. (A close-up version of this same emotion was of a navel piercing so inflamed it looked well on the way to becoming infected.) Signs and graffiti, the never-ending dialogue between the multiple promises of wealth, cash – 'CASINO' – and redemption – 'SAVE' – and the guarantee that they'll be broken. A sign offering 'EVERYTHING' ends up getting reduced to '– – ER-TH– – G'. Better than nothing? Maybe, but it's not as emphatic as the message sprayed on a wall: 'IF YOU READING THIS FUCK YOU'. Scattered among this richly (in the sense of poorly) peopled and much-written-upon social landscape are oases of pure angles and lines: impeccable grids of concrete and windows. These *almost* always contain some detail – a crack in the concrete, a boarded-up window – to refute the utopian claims of abstraction. But not *always* always: a carpet climbing the stairs in Las Vegas forms horizontal bands of colour so lush and textured they look like manicured red hedges.

Monique Showing Black Eye, Philadelphia, 2006, by Zoe Strauss

By kind permission of the artist

The carpet picture, I later discovered, was used on the cover of Strauss's first book, *America*. By encountering it accidentally I was experiencing Strauss's work in a way that was both like and unlike the way in which it had first been presented to the public. Strauss did not begin seriously photographing until she was thirty, in 2000. In 2001 she installed some of her pictures under Interstate-95, in her hometown of Philadelphia. Hardly anyone had heard of Zoe Strauss – she wasn't Zoe Strauss, the Magnum photographer – back then. So in that respect my experience resembled that of early visitors to what became regular shows beneath I-95. But my experience was *unlike* that of the people in the neighbourhood who knew her, who came along to the shows because they or their friends were among the subjects briefly displayed, like 'WANTED' posters, on the giant pillars supporting I-95. These event-shows – not underground exactly, but certainly under*road* – gradually became well known. They led, eventually, to a retrospective at the Philadelphia Museum of Art that travelled to the ICP, preceded by a bow-wave of press attention I had contrived, somehow, to miss.

It's obvious to anyone who visits this show that Strauss is an artist with a distinctive visual style; and it's equally obvious that this distinction is impossible to separate from the way that so many threads of American photographic history seem to have found their way into the tightly bound forms of her pictures. The tattooed girl – Monique – with a beaten face and a black eye recalls a self-portrait made by Nan Goldin after she'd been battered. There's a lot of Eggleston – most notably a green version of his famous red ceiling – and a lot of Stephen Shore too. And there are traces of Walker Evans – how could there not be? – everywhere. No sooner have these influences – or presences – been registered, however, than one becomes conscious of how Strauss's relationship to photography and to the world adds to or alters them. She never simply 'does' an Evans or an Eggleston. Take Goldin, for example. The pictures in *The Ballad of Sexual Dependency* are frank, intimate, beautiful and profoundly narcissistic. They are advertisements for a life being led: a bohemia that was longing

to be recognised, a bunch of people whose poverty was a form of indulgence, who believed they were artists – even if there was no chance of their ever creating works of art. Except they *were* justified in their belief after all, because they ended up *in* works of art, in museums, in Nan's pictures. It's a very different world here in Strauss's Philadelphia, where the poverty is as matter-of-fact as it is in an Evans photograph of rural Alabama. The difference – from Evans – is that Strauss is not an outsider, is as intimate with the facts as Nan was with her fictions. And Strauss didn't have to insinuate herself into situations as Diane Arbus cunningly did; she was already there, in the midst of the lives depicted. By the time she began ranging further afield – in Vegas, say – she was able to take this home-grown familiarity and confidence with her. As she puts it, rather beautifully, in a Facebook exchange with a friend (included in the catalogue for the Philadelphia/ICP catalogue): 'I just always let everything in and keep everyone who's ever mattered as a part of myself.' To which the friend replies, rightly: 'Wow . . . That is a phenomenal outlook on life.'[1]

The traces and precedents running through Strauss's photographic outlook are mainly American, but not exclusively so. There are some pictures – of a *Blue Building with Grass*, near Limerick, PA, or of city lights at night – which, if they were blown up bigger, could be mistaken for work by a disciple of Gursky. There are even echoes – though I advance this suggestion tentatively – of Luigi Ghirri. I'm thinking of Strauss's very empty, very still scenes, often with reflections in puddles, in which the world looks stranded by an ordinariness in which everything – the 'everything' she lets in – is simultaneously instantly recognisable and almost incomprehensible. It is as if she has pressed not just the shutter but also the mute button on a visual remote.

2014

Matt Stuart: Why He Does This Every Day

For many years, getting around London meant just one thing to me: hurrying. Taking no notice of anything except obstacles that might cause delay, I kept an eye out only for little dodges or shortcuts that had the potential to save a few seconds, which might end up yielding a dividend of minutes at the Tube station or the next set of traffic lights. It was fun in its way, 'skipping round dawdling/or stupidly halted pedestrians'[1] in the style of the protagonist of Christopher Reid's poem *The Song of Lunch*. Then it hardened or intensified into something that was the opposite of fun: not simply not noticing, but shutting out and keeping at bay. My well-being depended on blocking out aural intrusion – that default London soundtrack of f-ing and blinding – and wearing mental blinkers to keep any visual buffeting to a minimum. I wanted to do in my home town what a passport is supposed to allow us to do while abroad: get to wherever I was going – home ideally – without let or hindrance.

I only realised how debilitating this had become after I had – how else to put it? – bumped into Matt Stuart's photographs. Matt's London was as interesting as Winogrand's New York, Cartier-Bresson's Paris, Trent Parke's Sydney – or anyone's anywhere, for that matter. Of course it was. I mean, I knew that all the time, I'd just got into the habit of turning a blind eye to the fact. And despite our shared fondness for hurrying, Reid's protagonist, I saw now, was actually an ally or alter ego of Matt's as he

> allows himself to feel
> pleasure in his own fleetness,
> in not being carried but riding

From *All That Life Can Afford*, Oxford Street, 2009, by Matt Stuart

By kind permission of the photographer

the currents and eddies
of the human torrent.[2]

The lines seem especially apt given that Matt is a former skateboarder. Even so, the idea that one might willingly dawdle where this torrent is at its thickest – so thick that it's not a torrent at all – at Oxford Circus was a revelation. Oxford Street is the street in London where you don't spend a moment longer than you have to – especially now that it's allegedly among the most polluted streets in the world – because you know that you're going to be stuck there for longer than you want to. Everyone feels this, even initially eager tourists, but Matt hung around to prove it, to catch that look of clenched resignation, suppressed rage and barely contained pissed-offness that constitutes the London face, irrespective of where the individual faces started out in life: Dalston, Dorset, Dhaka . . . It's like something from *Koyaanisqatsi*, this picture, minus the movement, the music and the Hopi Indian warning (way of life needing change), so that what we have turns out to be a view of that which is stubbornly resistant to change. Except the effect of seeing it and the others in this book is, precisely, to change us, to become conscious of the fact that, if you are quick on the draw, you can catch Zorro trudging the streets of W1.

Since I did the journey only occasionally and never during rush hour, I always liked seeing the graffiti at Gerrards Cross from the M40 on the way into London, an interrogative reflection of what must have been going through the minds of many of the commuters who read it: 'Why do I do this every day?' Because you're human. Because you have an amazing capacity not just to put up with things but to get used to things. Because the distinctive quality of the intolerable is how readily it becomes tolerable – the proof of which is that so many others are tolerating it (which is what renders it intolerable). Because seeing the question put like that is itself a kind of answer.

But hey, it's not appropriate to get too glum, serious or even stoical. Matt is mischievous, not morose, and this collection of pictures – this revelation and

restoration of all the things I'd been missing, all the things that we all miss as we hurry through our days – is, among other things, an album of brilliant site gags.

There's such a rich vein of humour to be mined from the history of photography that I'm surprised no one has put together an anthology of photographic jokes. Only joking. The problem with funny pictures is three-fold. First, there is the reliance on visual puns, of which Elliott Erwitt is the dryly (the 'd' is often silent) acknowledged master. Second, whereas great photographs demand a second, third or thirtieth look, interest in a funny photograph tends to evaporate as soon as we get the joke. Third, unlike most other kinds of joke, photographic ones rarely make us laugh aloud. Instead, like guests at the Hollywood party attended by Zadie Smith in *Changing My Mind*, we say – or think – to ourselves, 'That's hilarious. That is *so* funny.'³ Combine these three problems and you end up with a fourth: when funny pictures are gathered together in a bunch we don't look at them as we would 'normal' pictures, with properly open minds and eyes; we go to them solely in order to hunt out the lurking joke. From this simple bit of arithmetic it follows that great photographic jokes cannot just be photographed jokes – they must be something else as well. So what else *is* going on in Stuart's streets? What keeps him doing what he does every day?

Henry Wessel called his book *Odd Photos* 'a collection of one-liners,'⁴ but that doesn't quite apply to what's happening in these pages – unless there's such a thing as a paragraph-long one-liner. At their best the jokes overheard – over-*seen* – by Matt on the streets of London document the convergence of several little stories on and in a moment. Except, of course, these stories did not even exist until that moment. They were, in other words, not simply recorded but created by the camera. And not only that. Properly edited and sequenced, the punchline from one image can lead to the story contained in the next. So out of these quick-witted glimpses of daily life a journey or narrative emerges, a parable of sorts. The meaning of this parable? That, funnily enough, there's no such thing as the last laugh; only the next-to-last. That if you let them, the lets and

hindrances might constitute not just the highlights of your journey but its purpose.

Especially since these spots or moments are frequented – haunted – by the ghosts of street photographers past and present. In their way they're like fleeting blue plaques, saluting the fact that while Winogrand, for example, didn't actually stand in a given place, he provides us with a way of understanding what's going on there. A woman crosses what looks like a street but is actually a hoarding with a street printed on it: a demonstration of the way that photographs of streets form a constant backdrop to what's going on here. Clutching her bag, blonde hair tossed by the breeze, she's walking briskly – in her oblivious London way – to a rendezvous with one of Winogrand's wind-tossed women in Manhattan. Oxford Street is, by a similar token, twinned with a street in Sydney photographed by Trent Parke. Matt has somehow even managed to import the ravaging Australian sunlight. And isn't there, in another case, some kind of reflection of Helen Levitt's picture of kids playing with the frame of a mirror on the streets of New York?

More generally – and equally improbably – he has made one of the famously grey capitals of the world into a city of vibrant colour. Not quite the Kodachrome-drenched blues and candyfloss pinks that Alex Webb seeks out in the hot light of the tropics, but chicken yellows, peeled oranges and (especially) bus-y reds. In a working city, these colours are not just decorative; they are obliged, understandably, to do their share of compositional load-bearing and storytelling. The result? An endless blossom of momentary metamorphoses that are turned, in turn, into something permanent. Another name for this – for the skateboarder turned photographer – might be arrested development. 'No Entry' signs (white on red) invite us in. Red routes (no stopping) and yellow lines (no waiting) urge us to do exactly the opposite. And he lets us.

2016

Stay-at-Home Street Photographers:
Michael Wolf, Jon Rafman and Doug Rickard

'All streets in time are visited.'

Philip Larkin, 'Ambulances'

When I was growing up in the pre-computer England of the 1960s, various board games promised 'all the thrills and spills' of Formula 1 or football 'in the privacy of your own home'. There was even a brewing company whose slogan – 'Beer at home means Davenports' – offered the chance to get drunk on draught beer without the irritating conviviality of getting your round in at the local pub. This desire for voluntary house arrest has since been so thoroughly sated by the internet that we now expect to be able to get, do and buy almost everything without having to leave our lairs. But who'd have thought that you could be a stay-at-home street photographer?

I only became aware of this breakthrough when Michael Wolf (born in Germany in 1954) received an Honourable Mention in the 2011 World Press Photo Awards for work made sitting in front of his computer terminal, photographing – and cropping and blowing up – moments from Google's Street View. Ironically, Wolf fell into this way of working when he moved from Hong Kong to one of the great loci of street photography as traditionally understood. Having relocated to Paris when his wife was offered a job there, Wolf discovered that the city had nothing to offer him photographically. Compared to the teeming, constantly changing cityscapes of Asia, Paris was an open-air mausoleum that had remained largely unaltered for over a hundred years. Haussmannisation had radically transformed Paris in the mid- to late nineteenth century, but pockets of the 'old' Paris photographed by Eugène Atget will be familiar to any contemporary visitor. Atget famously made his living by

#82.948842, Detroit, MI (2009), 2010, by Doug Rickard

providing 'documents for artists' and Wolf was alert to the connection between Atget's painstaking survey of the city and the possibility of deploying Street View's comprehensive – if uncomprehending – kerb-crawl for his own artistic ends.

He saw quickly that the indifferent gaze of the Street View camera randomly recorded what he called (in one of the series resulting from this discovery) 'unfortunate events': altercations and accidents, pissings and pukings, fights and fatalities. The Street View cars are like the ambulances in Larkin's poem: 'giving back/None of the glances they absorb'.[1] Actually, it's not just glances: while the cars usually go about their business unnoticed – or at least unheeded – occasionally people respond to their all-seeing presence by giving them the finger (hence the title of another of Wolf's series, *FY*).

A number of amateur websites sort, collate – and direct viewers to – glimpses of naked women in windows and so forth, wherever they have been seen by Street View, and Wolf might have been expected to pursue the easy hyena option, by mopping up this kind of visual carrion. He preferred to stalk his own prey, methodically going down every filmed street in Paris, combing through mile after uneventful mile of boring footage in search of moments that may or may not prove decisive. A quest that seemed destined to prove the accuracy of Michel Houellebecq's verdict – 'anything can happen in life, especially nothing'[2] – turns out to represent not a break but a continuity with Wolf's earlier work.

In *Transparent City* (2008) Wolf had taken telephotoed images of high-rise buildings in Chicago, a project that was itself an extrapolation from his earlier survey of the architecture of density that had fascinated him in the east. The results were heavily flattened patterns of light and line with occasional Hopperesque views of humans stranded in the immensity of urban geometry. Imagine Wolf's delight when he saw that in one of these apartments a large TV was actually showing *Rear Window*! Yes, there was James Stewart with his telephoto lens staring into someone else's apartment, photographed by Wolf with his. (Was this just old-fashioned photographer's luck? Did the

occupant of the apartment have this on permanent freeze-frame as a gener-ous gift and ironic reprimand to anyone who happened to be spying? Or was there an element of Doisneau-esque contrivance involved?) Later, as Wolf was looking at some of the other images through a magnifier, he saw something that had escaped him when making the picture: a resident in one of the win-dows of one of the apartments in a distant building had spotted what he was up to – and was giving him the finger. Pioneers of candid photography – Paul Strand on the street, Walker Evans in the subway – had gone to awkward lengths to work unnoticed. For Wolf in both *Transparent City* and the Street View work, the fact of being recognised and abused – the moment people re-alised that they were being photographed – proved incentive and invitation as much as insult. Having spotted this magnified, pixellated figure, he proceeded to comb through every window in every apartment in the *Transparent City* to see what other intimate details had been unwittingly revealed. He treated the rows of lights like roads, methodically peering in to each. Perhaps film could yield potential images that ordinarily observed reality did not? The re-sults, for the most part, were disappointing and dispiriting: boredom, serial isolation (Hoppers, Hoppers everywhere!) as people watched TV or stared at computer screens. There is also the unremarked possibility that another kind of reciprocity was at work: some of those people concentrating hard on their computer terminals could conceivably be scanning Street View, making their own images.

When Wolf got that Honourable Mention the response was immediate – and overwhelmingly hostile. There was, however, some division within this negative reaction. Moderates claimed that the work was not photojournal-ism, the most aggressive that Wolf was no longer a photographer at all. To the first accusation it could be argued that while the news part of the content might be minimal (crashes, brawls, mishaps) the way of making these pic-tures was itself a newsworthy story and an up-to-the-minute investigation. To the second, Wolf responded happily that he was part of a long history

of artistic appropriation of which his detractors were presumably unaware. (James Joyce famously said that he would happily go down in history as a scissors-and-paste man.) The art in this latest technological manifestation of visual sampling was in the crop, the edit – an edit that could actually enhance or even create a *Blow-Up*-like sense of implied, unresolved and potentially incriminating narrative (feet and limbs disappearing out of shot). There was also a comparable sense of urgency, for it turned out that Google tended to scrub exactly the kind of unfortunate events that fascinated Wolf so that within twenty-four hours a brawl that had broken out on a given road was tacitly disappeared (which means that there was some kind of news dimension to the content after all). Hence the addictive, virtually Winograndian urge to patrol the same streets repeatedly. But whereas David Hemmings in Antonioni's film or Stewart in Hitchcock's were obliged, in their different ways, to confine their attention to one tiny fragment of their respective cities, Wolf had at his disposal a surveillance project of unprecedented magnitude, which, in turn, is just a single strand in the larger network of state and corporate monitoring of daily life. Works of art that seemed, paradoxically, to undermine the role of the artist as an individual creator were predicated on another paradox: the near-extinction of available privacy for citizens whose faces were automatically blurred – whose identities were thereby extinguished – by Street View's software. (As Wolf discovered, the software sometimes failed so that people's faces were visible and they became, in Diane Arbus's phrase, 'anonymously famous'.[3])

Needless to say, Wolf's curiosity soon ranged beyond its local origins. If he grew bored prowling the streets of Paris, he could zoom off to some other city in the world and see what was happening there. While each place tended to be marked by particular kinds of incidents (lots of bicycle accidents in Holland), broadly speaking the same things – glimpsed nudity, violence, sudden faints – break out of the drab uniformity of life wherever one happens to be. In tandem with Wolf's instant pan-global drift, this viewer soon

discovered that there were a number of people doing pretty much the same thing as Wolf.

Almost exactly the same thing, in fact. Jon Rafman's website features crops from some of the same Google source scenes as Wolf's – so whose pictures are they? That, in Rafman's beautiful formulation, is part of the conceptual underpinning of this shared activity. These are 'photographs that no one took and memories that no one has'.

There are, however, broad differences in approach between Wolf and Rafman. Arranged in series, Wolf's work retains something of the systematic nature of his search; while sharing Wolf's fondness for certain things – people flipping the finger, roadside hookers and traffic accidents – the style of the thirty-year-old Rafman seems far more aleatory. One gets the impression not simply that he lacks Wolf's formation as an old-school photographer but that he has, quite possibly, never set foot outdoors, that his knowledge of the world derives entirely from representations of it. Even this is to understate matters somewhat, for while Rafman is apparently based in Montreal, he might as well be gazing at life on earth from a distant space station. And gazing on it longingly. There is something extraordinarily poignant about this apparently haphazard collection of grabbed snaps from everywhere and nowhere in particular. It is as if the technological relay that brings the work into existence gives vent to a nostalgia and homesickness so intense that the longed-for original becomes impossibly intimate, mind-bogglingly remote and – as a consequence – unfathomably strange. Like Wolf, Rafman insists that 'it's the act of framing itself that gives things meaning', but then goes further: 'By reintroducing the human gaze, I reassert the importance, the uniqueness of the individual.' Where does this idea of the individual come from? From photography, of course! Excited by the way images lifted from Street View possessed 'an urgency [he] felt was present in earlier street photography', Rafman mines Google to uncover a parallel history of the medium, in which repeat images from Lartigue (a goggled couple in a speeding vintage car), Winogrand (who, in his last years became a

kind of one-man Street View, driving and photographing in Los Angeles) and other masters mingle indiscriminately with freakishly fascinating snapshots – all yanked free of their original anchoring in time and place.

Via Cassia Cimina, Ronciglione Viterbo, Italia, 2010, from the series *Nine Eyes of Google Street View* by Jon Rafman

Courtesy of the artist

I concede my own old-fashioned middle-agedness. Exciting though they were, I found it unsatisfying and difficult to see Rafman's and Wolf's work only on-screen, as though lured against my will into this virtual and ever-more-mediated vortex. And then I found myself in San Francisco (the actual city, I mean, with real people, buildings and everything) where, quite by chance, I happened upon Doug Rickard's *A New American Picture* at the Stephen Wirtz Gallery. (These Google-derived images had first been shown as part of *Anonymes*, curated by David Campany and Diane Dufour at Le Bal, Paris, in 2010, an exhibition stressing the continuity with earlier work, such as Evans's subway photographs.) Any doubts as to the artistic – rather than ethical or conceptual – merits of this new way of working were definitively settled by Rickard's pictures. Their effect was immediate, intense – and has proved enduring. It was

William Eggleston who coined the phrase 'photographing democratically', but Rickard has used Google's indiscriminate omniscience to radically extend this enterprise – technologically, politically and aesthetically.

The spots chosen by Rickard are in the economically ravaged fringes of cities: the wastelands and desolate roads that form the constant backwash of America's broken promise. These places are populated by stray figures, strays both in the sense that they have wandered into the car's 360-degree view, but also because they have strayed from the path of prosperity – more accurately, the path to prosperity has passed them by. Loping baggily across the road, these forlorn figures look like they will never quite make it to the opposite kerb, as if they have been cut adrift, are stranded perpetually in the limbo of late capitalism (after which, as we all know, comes more capitalism).

The series contains obvious echoes of photographs made by Walker Evans under the auspices of the Farm Security Administration in the 1930s, with the vernacular signage – 'AMERICAN COLLISION', 'SUPER FAIR' – serving a similarly choric function. The shifting spirit of Robert Frank seems also to be lurking somewhere, as if the Google vehicle were an updated incarnation of the car in which he made his mythic mid-1950s road trip. As with these two illustrious predecessors, there is a strange beauty – sad, lyrical, unconsoled – in this latest and virtual instalment of the American photographic safari-odyssey. We end up not with the pristine clarity of an Evans or the hurried, sidelong glance of a Frank, but a shimmer and blur, a defining imprecision or washed-out residue of the painterly. Colours are simultaneously enhanced – especially the green of trees – and drained by whatever processes Rickard has put them through. Sometimes the sky gets rinsed out, other times it has a vestige of the turquoise ache of the Super-8 of old (the very colour of optimism, of economic growth for all). All of which contributes to the sense that we are seeing ghost towns – or ghost streets – in the process of formation. A phrase of Prospero's – the very name contains the root idea of prosperity that fuels the American Dream – from the end of *The Tempest* hovered in the air

of the gallery as I stared at these pictures: 'This insubstantial pageant faded . . .'

One image in particular seemed both hauntingly familiar and to draw these words to it as though they were an accidental caption. It showed a guy – slightly fuzzy due to one of the alchemical quirks and glitches of the various technologies involved, almost *vibrating* – in a wheelchair and wearing a Stetson, gazing up at the camera. (As Campany pointed out in an essay about the work in *Anonymes*, the Google images are 'all from 2.5 metres above the ground, a height that is neither human eye-level nor the dispassionate "overview" we associate with surveillance'.) It took a while to work out *why* it was so familiar – had I actually seen it before in some unremarked context? – and then, just as I moved on to a neighbouring image, it came to me: it reminded me of the slightly blurry pictures of people lining the tracks taken by Paul Fusco from Robert Kennedy's funeral train as it made its way to Washington in 1968 (the year of Rickard's birth). Instead of people gathering along a set route as the body of the dead senator passes by, there are just these randomly taken people, indifferent or surprised, as the little car with its periscope camera goes about its business, covering every street in the land, as inevitable and accidental as death itself: 'the solving emptiness,' in Larkin's words, 'that lies just under all we do'.

2011

#41.779976, Chicago, IL. (2007), 2010, by Doug Rickard

Mike Brodie: *A Period of Juvenile Prosperity*

In her memoir *Just Kids*, Patti Smith explains how, in the late 1960s, she and Robert Mapplethorpe met in New York, where they were both determined to become artists (were pretty convinced, actually, that they already *were* artists) even though they hadn't a clue about the kind of art they might create. Mike Brodie is a guy who, having taken pictures of the kids he was hanging out with, ended up becoming . . . a diesel mechanic! But the pictures made him 'internet famous' and a selection of them has now been published. Dreams can come true, it seems, even a dream you never dreamt of dreaming. We are talking, in this instance, of a specifically American dream: a coherent body of work, fresh as a new pot of paint, which is also part of several traditions that dig deep into the country's sense of its possibilities.

What happened, briefly, is as follows. In Florida in 2002, when he was seventeen, Brodie hopped a train to visit some friends. The train was going in the wrong direction and so, like Sal Paradise making his first stab at hitching west in *On the Road*, he ended up coming right back home. But this abortive excursion encouraged him to set out again and begin his real life on the rails. Over the next five years and 50,000 miles he took a ton of pictures of the people he met and the life he was living. At first he used a Polaroid which, depending on the account you read, was either found behind the seat of a car or given by a friend. When the film was discontinued, 'the Polaroid Kidd' – as he'd become known on websites where he posted his pictures – switched to a 35mm Nikon, the camera he used to take the photographs featured in *A Period of Juvenile Prosperity* (Twin Palms).

From *A Period of Juvenile Prosperity* by Mike Brodie

The pictures have the day-to-day intimacy and immediacy of a journal, but the journey they describe – the shared root helps – has a clear narrative, even if the route is irrelevant.

We start with a kid on a road bridge contemplating the rails below. In the 1960s you were urged to come to San Francisco with a flower in your hair; this guy, more pragmatically, has a rucksack stuffed with life-sustaining vegetables. The rails lead both to future adventures and back into a mythopoetic past. Next, somebody is clambering over a fence into the rail yard; then people are scrambling onto the trains, one with a guitar in his hand, a po-mo hobo ready to do his version of Hard Travelin'.

As with Nan Goldin's *Ballad of Sexual Dependency* – and if ever a book of photographs deserved to be termed a ballad it's this one – Brodie's pictures are entirely from within the world depicted. Goldin always had a knack, according to Luc Sante, of finding beautiful colours and light in 'the most squalid corner of the worst dump'.[1] The light for Brodie and his fellow travellers is a given, filling their lives with lyric and radiant purpose. The land that blossomed once for Dutch sailors' eyes whizzes and blurs past; the light fades and the dark fields of the Republic roll on under the night. But the book is less a record of sights and places seen than of the people doing the seeing. And not only that. We also share the optimism, recklessness and manifest romance of the outlaws' take on destiny.

The lyricism, crucially, is underwritten by squalor. The sense of a promise constantly deferred and refreshed is kept in check – but never broken – by dirt. Without the dirt this could look like a rebel fashion shoot of the kind that got Corinne Day and Kate Moss started. The shirts and cowboy boots are cool, but the clothes are not just ripped and the dirt is not just dirt – it's grime, filth. We're all up for getting dusty at Burning Man for a week, making do with porta-potties and hand sanitiser, but the hands here are as dirty as any photographed by Dorothea Lange in the 1930s.

The places where these travellers end up crashing make Nan's dumps look

like palaces from a Goldin age of bohemia lost. They also lack the impover-
ished homeliness of the squats photographed by Tom Hunter. One of Brodie's
pictures – of a kid in a sleeping bag in a field by the railroad tracks – looks like
the kind of thing Hunter might have done if he'd been photographing in the
American West rather than east London, but any echoes of prior artworks are
accidental. Take, for example, the young woman sprawled on the floor with
her legs open, one hand hiking up her skirt – very much in the style of an
Egon Schiele model – to reveal knickers smudged with the dull blood of her
period. Her other hand is holding up the book she's reading, a rat-nibbled
Flannery O'Connor omnibus that includes, presumably and punningly, *Wise
Blood*. Other images are similarly and slyly self-captioning. Shot from above,
a woman is sitting on the toilet, bent double, next to a poster advertising what
I assume is a band called, in that endearing teenage way, The Assholes. As the
country slips gorgeously by, somebody chalks the word 'SWELL' on the side of
the container she's travelling in.

At times the Brodie bunch look like survivors in a post-apocalyptic
world in which the trains continue to run mysteriously on time. Or like a
ragtag army of non-combatants on a mission behind enemy lines – a mission
that demands they live off the land while carrying out acts of non-specific
sabotage. The danger of getting busted – legally and physically – is ever-present
and there are, inevitably, casualties. Many of them are bandaged up with
recently self-inflicted wounds (aka tattoos), cuts and bruises. Things are no
longer swell but badly swollen, likely to become infected. Ashen-faced, blond,
beautiful as Henry Wallis's painting of *The Death of Chatterton,* an injured
boy is comforted by a woman. She's not his mom, but the picture has the ten-
der purity of a pietà. On the facing page he's lying on a gurney in a neck brace,
rigged up to tubes and drips. Here and there, among these crusties with dirty
faces, are older hobos, down-and-outs for whom this is not just a phase but a
permanent condition of impoverished existence. Maybe some of the kids will
end up that way, but after a while many, like Brodie, will opt out of opting out

and get their lives back on – i.e. off – the rails. Perhaps that's why one of the photos seems to offer a kind of diagram of choice. It's a subdued picture of rail tracks and road, forming a V, photographed by Brodie as he stopped by woods on a snowy evening (or morning or afternoon). Looked at in career terms, Brodie's friends have chosen a road or track less travelled, but similar journeys are a mainstay of American cultural history generally and of photography in particular.

Walker Evans, Robert Frank, Garry Winogrand, Joel Sternfeld and Stephen Shore all went on photographic trips across the US. They travelled by car with the express purpose of taking photographs. Brodie's photographs were done incidentally with no artistic aim in view, just as the journeys were made for their own sake, rather than with the idea of making it to California, say, or MoMA. Formally, the pictures' aesthetic is pretty much in sync with this, as if they just happened to have turned out as they have: often cropped, free-floating and on the wonk. (So what if the sole of a boot looms up in the viewer's face?) Maybe the experience of riding the rails created a rhythm of seeing that took the place of years of sedentary visual training. If the hurtling convergences and diverging geometries – of track and limb – seem accidental, that is a sign of precariously appropriate mastery.

In another representation of youthful adventure, one of the kids in Rob Reiner's *Stand by Me* wonders why, in *Wagon Train,* they're always wagon-training, without ever getting anywhere.* Here too the friends are in perpetual transit, on trains or in cars; in photographs, in the moment. And yet . . . Evans once said that anyone 'who travels by rail over the lesser lines of the USA clangs and shunts straight into his own childhood'.[2] There is none of that old-fashioned nostalgia about these images. No, they're more like a full-blown elegy – the penultimate picture shows a rear-view mirror; the last, someone

* This is the obvious place to mention that Brodie's pictures are heavily present in two recent feature films: as a pervasive aesthetic in Andrea Arnold's *American Honey* (2016), and by explicit quotation in Claire Denis's *High Life* (2019). (Footnote added 2019.)

looking back with magic-hour longing – for the phase of life that they re-
cord, that Brodie was leading: a life of constant leaving that has since been left
behind.

2018

Chloe Dewe Mathews: *Shot at Dawn*

'I stood gazing at the trees lined up in rows like soldiers, contemplating the memories the land must hold, with so much blood, so many dead, and all their dreams, all that failure and defeat. How could it bear to go on producing, with a burden like that?'

Magda Szabó, *The Door*

It's unmissable, the memorial to the Missing of the Somme at Thiepval. It can be seen from a distance, across the rolling fields, and if there were any doubt of the power converging on and emanating from this place a sign reminds visitors that they stand 'on hallowed ground'. The Great War cemeteries in France and Belgium too, even ones with just a dozen graves, exert a hold on the landscape that surrounds them. Places where time has stood its ground, they allow whatever lies outside the low cordon of walls to return to purpose: for fields to be ploughed, fruit to be grown, crops to be farmed, lives to be lived. When no grave or memorial is in view, one still understands – one feels – that this is more than just a conventionally pleasing landscape, even if the particulars of what has happened remain unknown. History has taken root here.

It is very different from the places in America photographed by Joel Sternfeld in *On this Site*: *Landscape in Memoriam* (1996). A parking lot, a bus shelter, a school gate: entirely unremarkable places where, the accompanying text explains, a murder, rape or abduction occurred. Whatever happened in these spots is absolutely site-specific. Move a hundred yards or so and you are beyond the psychic reach of an event whose only memorial is the photograph – or was, until the photograph was taken. Because the photographs are not only about what is photographed; they are also, as Garry Winogrand said of Walker

Soldat Lucien Baleux, Soldat Émile Lherminier, Soldat Félix Louis Milhau, Soldat Paul Regoult, time unknown/23.5.1916, Roucy, Picardie by Chloe Dewe Mathews

Evans, about 'how what is photographed is changed by being photographed'.[1]

The photographs by Chloe Dewe Mathews in *Shot at Dawn* bear a conceptual resemblance to Sternfeld's, but they are taken within the already charged zone of memory that is the Western Front. Each is of a place where something happened, enormous and terrible in itself, but easily, perhaps deliberately, overlooked in the context of the larger cataclysm of the First World War. Specifically, they are all of places where soldiers were executed for cowardice or desertion in the face of the enemy. All were taken as close to the exact time of execution as possible – either at dawn or, in two instances, at dusk – and at pretty much the same time of year. The weather may be different but within the larger, planetary scheme of things the light is as it was.

It's tempting to assume that the point of view in each of the photographs is either that of the firing squad (in a picture taken at Sint-Sixtusabdij it seems we are seeing not only the wall behind the victim, but the bullet holes left in it by the execution) or of the man they were shooting (in which case the photograph effectively removes, almost a hundred years later, the blindfold placed over his eyes in the last minute of life). This might be the case in some instances, but it's impossible to know for sure. Taken in precise locations – a couple are not of the execution sites, but of places nearby where the condemned men spent their last nights – they are pictures of and in the vicinity of death.

With one exception – a wall covered with traces of Twombly-esque graffiti: a palimpsest from which an archaeologist might hope to uncover the last words scrawled in his cell by Lieutenant Eric Skeffington Poole on 10 December 1916 – the photos are devoid of message or inscribed meanings. They cannot be 'read' in the way that the landscape was clearly legible to the Romantics (like the place where a murderer was hanged, his name carved in – and the grass annually cleared from – the spot so that when the young Wordsworth comes across it, years later, the 'letters are all fresh and visible'[2]). Certain patterns or habits of association nevertheless attach themselves to particular pictures.

Those with a road or path curving into shot implicitly suggest the journey of a life coming to an end – in some cases literally a dead-end. Though idyllic, the fields are scattered with faint reminders of the landscape of battle: a steep bank presents hikers with an entirely safe equivalent of going over the top, a wire fence stands in for thousands of miles of barbed wire, a drainage ditch looks like the waterlogged residue of a trench, and so on. There are ominous con-temporary echoes too. Close-ups of trees and undergrowth are reminiscent of terrain in news reports of search parties painstakingly combing woods for a child who went missing over Christmas.

The bodies, of course, are nowhere to be seen, but the bucolic settings, combined with knowledge of what has happened, bring to mind a recent se-ries of photographs in which they – the dead – are horribly present. In 2011 Fernando Brito won a World Press Photo Award for work from *Lost in the Landscape* showing victims of the drug wars in northern Mexico: corpses, of-ten mutilated, dumped in the middle of what might otherwise be beautiful scenery: fields of wheat, a river, ploughed earth. Particularly shocking in this context, the pictures taken either at sunrise or sunset subtly alter our percep-tion of the images in *Shot at Dawn* so that it seems as if the thing that gives a particular spot its meaning – a dead body – has been painstakingly removed.

That, of course, has been achieved not by the photographer or by digital manipulation, but by a burial party – and by time. A question naturally arises: how *much* time is there in these pictures? Shutter speeds may have been only a fraction of a second, showing what a particular place looked like at a certain time on a certain day in 2013, but the image resulting from that brief exposure sometimes contains the passage of time over the course of nearly a century: from the moment that the time of an individual life stopped, through the long aftermath of the catastrophe that engulfed the landscape, to a present that may or may not be steeped in forgetfulness. At which point the question of time becomes impossible to separate from that of memory.

Walking through the woods on her husband's estate – woods that had been

cut back 'during the war', a husband who had been paralysed by it – Connie, the Lady Chatterley of D.H. Lawrence's novel, becomes suddenly and gratefully conscious of 'How still the trees were, with their crinkly, innumerable twigs against the sky, and their grey, obstinate trunks rising from the brown bracken! How safely the birds flitted among them! . . . The place remembered, still remembered.'[3]

By reminding us of what had been forgotten in certain places, Dewe Mathews's photographs enable us to share Connie's momentary sense of vegetative memory. Rather than serving simply as memorials, in other words, the photographs may be documentary depictions *of* remembering. The things we are seeing – flowers, grass, walls, trees – may have a consciousness *of which they are oblivious*. Strongest in cultivated landscapes, this feeling of mute or dormant sentience is particularly acute at dawn or dusk, which in the daily life of the trenches were 'exactly the moments of heightened ritual anxiety'. [4] (The words are Paul Fussell's from his landmark study *The Great War and Modern Memory*. Among other things, these shots of dawns offer useful evidence with which to weigh Fussell's charge that 'dawn has never recovered from what the Great War did to it'.[5]) Dawn was the period of maximum potential danger, when soldiers on either side of No Man's Land had to stand to, either in anticipation of attack (going over the top) or of being attacked. In Wilfred Owen's poem 'Exposure' (a title that doubles the conceptual pun of Dewe Mathews's project), 'Dawn massing in the east her melancholy army/Attacks once more in ranks on shivering ranks of grey,/But nothing happens.'[6]

Except, in these particular places, at a particular moment, something did happen – namely that time stopped. After which, if we consider things slightly differently, nothing could ever happen again. While some pictures seem to contain almost a century's worth of time, others offer a stark alternative: that they contain none at all, that the places depicted exist in an atemporal present. We are used to the idea of photographs stopping time; in some of these photographs it seems that the landscape *itself* became arrested in time, that this is

what the photographs duly record. Siegfried Sassoon wrote of how 'time ticks blank and busy'[7] on the wrists of men about to go over the top in a dawn attack, about to die. What is left afterwards is what we see here: dead time.

Having survived the IRA bomb in the Grand Hotel, Brighton, in 1984, Margaret Thatcher spoke of 'the day I was not meant to see'. Joseph Brodsky in his 'Homage to Marcus Aurelius' writes that 'all one stands to lose by dying is the day when it happens – the day's remaining part, to be precise – and in time's eye still less'.[8] By these terms execution at dawn is designed to rob the individual of as much life – as much time – as possible, while those shot at dusk lose only the twilight of their lives. Either way, these pictures show what was lost – and what remains of that loss.

2014

Private Joseph Byers, Private Andrew Evans, time unknown/6.2.1915, Private George E. Collins, 07:30/15.2.1915, Six Farm, Laker, West-Vlaanderen by Chloe Dewe Mathews

PART TWO

EXPOSURES

Franco Pagetti:
Aleppo, Syria, 19 February 2013

Walking through the old neighbourhoods of any city with decent weather you suspect the sheets hung out to dry might be the unofficial national flags. Actually, the weather doesn't even need to be half-decent. Nothing is so depressingly expressive of my native land (England) than the sight of laundry hanging out wetly for days on end, going from soaking to soggy to damp – and back to soaking without having achieved the mythical goal of dryness. And then there are cities where the air pollution is so bad that drying quickly turns into its near-anagram, dirtying. Escape from the samsāra wash-cycle of cleaning and drying into the bliss of *wearing* is, in such circumstances, almost inconceivable. In both instances the hung-out washing stands as a billboard advertising humankind's amazing capacity for persistence.

So they strike multiple chords, Franco Pagetti's images from his series *Veiled Aleppo*, even though the sheets are no longer laundry at all. Perhaps they never were – and yet still they sway and blow as flimsy proof of the resilience of everyday life in the face of near-total ruination. The opposite of screens around a site where construction is in progress, these sheets demarcate areas of almost completed destruction. Their practical function is, presumably, to offer cover from sniper fire (the ever-present danger of which is suggested, in one image from the series, by an advertisement featuring a row of painted eyes). The flimsiness of the protection is in striking contrast to the sturdiness of buildings and metal shutters – except that, in the face of the sustained onslaught of modern weaponry, concrete and steel are scarcely more resilient than cloth. The

Salah Al-Din neighbourhood frontline, Aleppo, Syria, 19 February 2013, by Franco Pagetti

By kind permission of Franco Pagetti/VII

buildings are often reduced to bulky poles holding up the washing lines (which, I'm guessing, once served as phone or power lines).

Going back to the earlier mention of flags, it is a point of military honour never to lose or surrender the regimental standard or colours – but an immaculate flag is valued less highly than one that displays the price paid for its continued survival. Ideally the standard is reduced almost to rags as proof of valour, testament to sacrifices made in order to retain it. In some instances these ragged emblems are stained with the blood of those who died preserving them. Moving from the martial to the domestic, bloodied sheets are sometimes displayed after a wedding night as twin proofs: that the bride was a virgin and that the marriage has been consummated. Our thoughts are urged in this direction by Pagetti's deliberate use of the word 'veiled', hinting at both the lithe appeal of orientalist erotic fantasy – as in the dance of the seven veils – and the subordination of women that is an intractable feature of Islamic fundamentalism.

The difficulty posed by Syria for the United States is how to intervene and militarily support attempts to oust a dictator (and establish democracy) while not abetting that which is inimical to the continued progress of the species (militant Islam). The alternative – to do nothing – is, as the saying goes, to leave the rebels hanging out to dry. Amazingly, Pagetti's pictures seem to illustrate this difficulty: at first glance the viewer could be forgiven for thinking that one of the pictures shows an improvised version of the Stars and Stripes. But it's not, of course. It's the *stripes* and stripes, the visual equivalent of being stuck between a rock – of which there is no shortage – and a hard place.

So perhaps these veils are best regarded as symbols of the pictures themselves, of the death throes not of a city but of film, of the days when prints and contacts – contact *sheets* – hung in the studio so that the photographer could see what had been captured or missed: evidence of things seen and unseen.

Tomas van Houtryve:
Philadelphia, USA, 10 November 2013

Henri Cartier-Bresson preferred photographing under grey or cloudy skies. The absence of shadows and direct sunlight allowed him to stalk his subjects and shoot them unawares from any angle. For equally obvious reasons drone operators prefer clear skies. The grandson of a woman killed by a drone while picking okra outside her house in Pakistan told a group of lawmakers, 'I no longer love blue skies. In fact, I now prefer grey skies. The drones do not fly when the skies are grey.'

For the photographs in his *Blue Sky Days* series, Tomas van Houtryve attached a camera to a small drone and flew it, through blue American skies, over the kind of gatherings that might engage the attention of drone operators in other parts of the world. A number of related photographic elements converge on the project. First, the giddy bird's-eye views of early modernists such as Aleksandr Rodchenko and – less spectacularly – André Kertész, who were drawn to the combination of abstracted geometries and vertiginous human gestures. Second, the technology of remote or automated surveillance – the opposite of the kind of highly individualised stalking of which Cartier-Bresson was the master. Put these two together – and they have very often been put together – and you get numerous opportunities for spying, sneaking and peeping. But in the background – or at a higher altitude, as it were – there is the long-standing use of the camera for purely military uses: for aerial reconnaissance, to study potential bombing targets and assess the effectiveness of such operations.

So there's a lot of history at work here, especially if we go along with T.S.

Signature Behavior, Philadelphia, 2013, by Tomas van Houtryve

By kind permission of the artist and Agency VII

Eliot's famous gloss on a line of Emerson's: that history is the lengthened shadow of a man. People appear as counters on the patterned squares of an urban board: pawns in a geopolitical game. Lest we get overly anxious, however, there's nothing really sinister going on. This, after all, is a photographer's entirely non-lethal project. We have nothing to fear. The design is aesthetic (albeit ideologically loaded) rather than strategic and the results are summer-sky beautiful. Especially when seen vertically on a wall – or a computer screen – rather than horizontally on a page, from above. Viewed like this the shadows take on a life of their own, acquire again the human qualities lost to the barely visible 'counters'. The problem is that these shadow gestures are difficult to read or interpret with any accuracy. Playing looks like fighting. Clowning around becomes aggressive – and mistakes have consequences. Being shot by a camera becomes a prelude to being shot for real.

The more you look at these jet-black shapes, the deeper the temporal perspective becomes. The stretched silhouettes acquire not just the primal quality of Giacometti's etiolated sculptures. They start to loom like figures painted on a cave wall: humans vulnerable to the threat of beasts and forces they hope to keep at bay. In the caves that threat is always abundantly depicted. Here it is nowhere to be seen. It *is* the seeing.

Jason Reed:
Melbourne, Australia, 17 January 2014

In a boxing match the combatants are rarely more than a couple of feet apart. Even the thing that separates them absolutely – the moment marking the difference between victory and defeat – unites them in brutal intimacy. That's one of the reasons why boxing is relatively easy to photograph.

One-on-one sports where the players are separated by a net and by considerable physical distance, on the other hand, pose obvious challenges for the photographer. Pictures that show both participants in a tennis match, however closely contested, tend to make it look as though one person is *doing something* while the other is just blurrily waiting. The difficulty is exacerbated now that matches are fought out at maximum physical estrangement, from baseline to baseline. Hence the attraction of those increasingly rare exchanges when both players are at the net, within touching distance of each other. Not surprisingly, then, pictures of singles tennis matches tend to focus on just *one* player. The photographer's difficulties in this regard are nicely echoed by the audience, whose heads have to swivel constantly from left to right, from one player to another.

Faced, in addition, with a pretty standardised array of endlessly repeated strokes and poses, photographers rely on the changing background colours of the court for variety. A given player will appear stranded in the red desert of the clay of Roland Garros, or grazing the lush green grass of Wimbledon, or highlighted against a pink sea of faces watching from the stands.

In this picture these compositional contingencies elevate Serena Williams to a level of cosmic isolation. The strict blue rectangle of a court at the Aus-

Jason Reed (Reuters)

tralian Open is transformed into the blue curve of earth, surrounded by the darkness of outer space. Whereas the crucial points of a match are sometimes decided by distances so small that the human eye needs the kind of technological assistance that used to be the preserve of NASA, this game is unfolding at the interplanetary level of the Greek myths, where a god routinely grabs a passing comet to hurl at a rival who has slept with his sister and will thereafter be condemned to serve as a ballboy in forty-degree heat for the rest of eternity.

At the same time, and in keeping with the trend for tournament trailers to make top players – the stars – look as if they are computer-generated, it could pass for a shot for an ad campaign dreamed up by the manufacturer of new, reduced-gravity sneakers. The tag line? 'Serena Williams: Out of this World'. We even have the ball as a tiny yellow satellite of Planet Serena – which makes us suddenly conscious of how it would have been even better if it were her sister Venus floating there in zero-g. But whereas the celestial bodies rotate around each other with immensely slow reliability, sport is nothing if not unpredictable. Serena went out against Ana Ivanovic in her next match, was sent crashing down to earth.

Bullit Marquez:
Manila, Philippines, 27 January 2014

Photographer Bullit Marquez has really gone out on a limb with this one! A more violently animated example of still photography is difficult to imagine. Everything is at war (a tug of war) with everything else, which means that everything is connected to everything else as well. Out of this, a crazed and dynamic harmony prevails. The force of the picture is centrifugal and centripetal, simultaneously converging on the flailing knot of limbs at the centre and tugging – or being tugged – away from it. Those limbs – and at first blush it's very difficult to tell how many pairs there are, whose leg belongs to whom – are all, to differing degrees, disembodied. The bare leg is not being hauled by a full-bodied individual, only by an arm. The sole face to be seen is that of the person least involved in the action: the girl in profile at the far right of the frame. Her expression, appropriately, can be read in two quite contradictory ways.

One guesses (partly because of the gun) that the picture is of a drug bust in a favela. It's actually an eviction of residents of a slum in the Philippines, but ignore that unignorable gun and look at the girl. Presumably she's crying out in anguish, but from her face she could be enjoying what started out as a neighbourhood game of Twister that turned into something that involved trying to strip bare the opposing team before escalating into gun-toting violence. (An approximation of the score is perhaps indicated by the quality of footwear or lack of it: sneakers, a pair of white flip-flops, *one* flip-flop and a bare foot.) In this light, she's gleefully clutching a t-shirt as a trophy. The stripes of that shirt are in bunched opposition to the vertical stripes on the cop's shorts, one

Bullit Marquez (AP/Shutterstock)

of which serves to make his otherwise scary gun look as if it's drooping or dribbling. The big number 5 on his jersey, meanwhile, contributes to the hint of a team sport and connects with the numbered calendar page on the floor.

If that calendar occupies a place of surprising prominence, that's partly because the things you expect to be the centre of attention – faces! – have been forced beyond the edges. It's almost like a spatial version of a photographic negative, or as if the picture has somehow been turned inside out. To that extent, the eviction is already successful in that it's been anticipated by the composition of the photograph. There is perhaps a latent political point implied by this, about the way that the key people involved in the decisions being roughly executed here are nowhere to be seen, are comfortably out of eyeshot.

Oh, and bear in mind the way that photographers accidentally or, in the case of Lee Friedlander, deliberately include their shadows in pictures. In this one it looks like Marquez might have got in on the act, as it were. Could that be his blurred and denimed knee in the middle of the bottom of the frame? Or am I just pulling your leg?

Thomas Peter:
Perevalne, Ukraine, 5 March 2014

There's a nice mini-tradition of photos offering leg-eyed views of the world. Well, I can think of two at any rate: Elliott Erwitt's classic of two pairs of legs – one canine, one human – and a little pet dog in full view; and Matt Stuart's low-slung shot of a busy London street featuring the trousers and hurrying shoes of pedestrians and a pigeon gamely setting the pace. A gross discrepancy in power and height is rendered momentarily absurd – and thereby cancelled out – by the democratic power of the lens. Something similar is going on here in the Crimea.

We have become familiar with images from Russia of women baring their breasts in political protest. Here the opposite tactic seems to have been employed (and not only as a concession to what looks like pretty bleak weather): dressing up to the nines in entirely inappropriate footwear. Instead of the thing that most men are biologically programmed to want to see (women's breasts) our gaze fastens on a traditional accoutrement of femininity: a pair of high-heeled shoes.

For feminists in the 1970s the bra was the symbol of vestimentary oppression, but it might more sensibly have been high heels, since you can play sport and wage war in a bra but in heels you can only look seductive and totter from taxi to restaurant or photo shoot. As John Berger put it in his analysis of gender difference in art and society: Men act, women appear. These men are ready for action while the women appear to be doing nothing but appearing. But appearance, this picture suggests, can be a form of action – potentially a more effective one than that recorded in other recent photographs from the same part

Thomas Peter (Reuters)

of the world, of male soldiers confronting each other. Man-to-man stand-offs are a recipe for trouble, whereas the presence of women can be calming – in a provocative sort of way. And it looks to be working because while the soldiers are functionally equipped for war in a cold climate, they seem to be losing the battle of the footwear. The one on the left doesn't even *have* any feet! He seems to be shrinking, detumescing before our eyes, sinking into the ground, as though these leggy sorceresses possess the power to make the earth itself swallow up invaders, as happened back in the region's legendary past, before the coming of the tank rendered the mythic merely quaint.

Not that the picture makes it clear that we are seeing an act of resistance. Maybe these women just stepped out to take a look at the visiting soldier boys. In which case a kind of sexual and military détente has been achieved, with each side checking out the other. Either way, the eventual outcome of the situation is unclear. The camera is literally on the side of the women. If the distant highlands had been snow-covered, they would have been in formal alliance with the white fur of Ms Stiletto's booties. As it is, the camouflage-coloured hills are tacitly backing the troops.

Marko Djurica:
Donetsk, Ukraine, 22 April 2014

Compositionally there is nothing remarkable about this photograph. In the context of escalating violence in the region, the content is pretty mild too: pro-Russian protesters in Donetsk hurling eggs at supporters of Ukrainian presidential candidate Yulia Tymoshenko. If you're going to have stuff thrown at you, eggs are preferable to rocks. But there are a *lot* of eggs. The phrase 'hail of bullets' is almost a cliché; this is the first time I've ever had cause to write about a hail of eggs. Some have already hit, and lie, like shell casings, on the ground; some are in the process of exploding in a Pollock-splatter of yellow gore; three are mid-trajectory; more are about to come. They look rather good eggs – plentiful, richly yellow yolks – but we will have to await the report from forensics to ascertain whether they're factory-farmed or free-range (which, in turn, might yield evidence of a subtler, ideological nature). It would also be useful to know more about the contents of the male victim's shopping bag. I have a hunch, as detectives say, that by some hideous circumstantial irony there might be half-a-dozen eggs in there. I also note – that is, it's impossible not to be struck by – the way this fellow's hair is cut in a version of the pudding bowl or eggcup. Frankly, his face and head fit inside that hair in a way that could hardly be more egg-like. The expression 'egghead' refers to scientists or boffins, but the victim, far from looking like any kind of intellectual, is big and burly. And her husband's pretty hefty too!

Circumstantially, the picture joins a procession of shameful images: Robert Capa's 1944 shot from Chartres of a female collaborator, head shaved by the mob, clutching a baby fathered by a German soldier; numerous photos of the

Marko Djurica (Reuters)

Little Rock Nine pursued by louts when they attempted to integrate the Central High School in 1957. In each instance the victims' quietly placid expressions make their humiliation more horrible. History always reverses this: it's the horrible faces of the mob that end up suffering the deepest humiliation. These faces tend to be contorted by hatred (never a pretty sight), but in this picture a lot of them are grinning as if it's all, in Larkin's famous phrase, a holiday lark. The men are doing the throwing, but there are plenty of laughing women, egging them on. Needless to say, a couple of morons are taking pictures with their phones – and they, as we shall see, are not alone. Nor, for that matter, are the couple at the centre of the yolk-storm. Look closely and you'll notice a fifth leg; hidden almost entirely from view is a third victim. You can see this older man clearly in another photograph from the sequence, which shows the heavy-set guy lashing out at one of his tormentors – with the shopping bag. This comes as a surprise; that the extra picture reveals other press photographers, all doing their level best to eliminate each other from view, should not.

Nikolay Doychinov:
Draginovo, Bulgaria, 4 May 2014

Unlike yachting or tennis – inconceivable without fairly expensive equip-
ment – wrestling is a primal or elemental sport. In the sense that people were
trying to throttle each other when we lived in caves, it is not a sport at all,
though over the centuries it has regulated and formalised itself in various
ways in different parts of the world. I am not familiar with the precise codes
governing wrestling in Bulgaria, but a certain amount can be deduced from
this picture.

First, that it is extremely popular and, unlike dancing to electronic music,
this popularity is not age-specific. It really is a fun day out for all the family.
Some of the smiling old men still retain fond memories – even if only in the
form of permanently mangled vertebrae – of their own days in the ring. The
second thing, of course, is that there is no ring. (It's quite possible that cows or
sheep are grazing just out of shot.) In boxing the ring decrees that what goes on
within it has been granted a specially sanctioned exemption from the normal
rules of polite society. Here only a wobbly wire fence separates participants
from spectators (one of whom, just above the black trackpants of the wrestler
on the right, looks like he is about to clamber – more accurately *to slither* – tag-
style into the non-ring). Sticking with the pants, note the way that although
the wrestlers are wearing less than the audience, they are sporting the same
kind of bottom-of-the-range clothes and sneakers. Nike and Adidas are not
major sponsors of this event. In keeping with this, while the sculpted, waxed
and tattooed bodies of modern athletes seem designed as much for display
(see 'sponsors' above) as action, these two have physiques that are the product

Nikolay Doychinov/AFP via Getty Images

of years of hard labour, in fields or on construction sites, rather than of carefully monitored hours in a gym. They don't need to train in this way because wrestling is in their blood, part of the DNA of the region. So perhaps it's not quite accidental that they have grappled themselves into a shape that resembles that greatest of all fight sponsors: the human chromosome.

All of which confirms what was suggested at the outset – that this is more than just a sporting occasion. Change the skin tones and outfits and this could be a scene from an African country where wrestling often accompanies a larger ritual celebrating the transition to manhood. Same here, it turns out: the bout is part of a holiday marking the circumcision of young boys. While the two wrestlers are obviously too old to be trying to circumcise each other (with their teeth?), it is possible that rather than being in what looks to be a losing position, the guy in the red shorts is actually winning: that the face we can see belongs cartoonishly to the guy on the right in the black pants. Compared with the way his neck's going to feel in the morning, circumcision might seem preferable.

Finbarr O'Reilly:
Gaza Strip, 24 July 2014

What makes this picture stand out from the thousands of others showing the effects of Israel's assault on Gaza? It was taken by Finbarr O'Reilly on 24 July 2014 in a hospital after the shelling of a UN-run school, where sixteen people were killed. Other images were more heart-rending, showed more appalling scenes of injury and death or provided more comprehensive views of the scale and intensity of destruction. But I kept coming back to this one – partly *because* I couldn't work out why I kept coming back to it.

The answer came as soon as I stopped searching for it: Don McCullin! Specifically his picture of a Vietnamese man crouching with his back to a wall, holding a blood-soaked girl injured in the wake of a US attack in Hué in 1968. The resemblance between the pictures is extraordinary – and, on reflection, completely unextraordinary: when a civilian population is bombed, pictures like this are inevitable.

John Berger refers to the McCullin picture in his well-known essay 'Photographs of Agony' (1972). Berger claimed that publication of images like McCullin's could be taken either as a sign that people 'want to be shown the truth' or that growing familiarity with images of suffering was leading newspapers to compete 'in terms of ever more violent sensationalism'.

Rejecting both of these options, Berger concluded that such pictures place events – which are the product of politics – outside the realm of the political, where they become, instead, 'evidence of the human condition'. They accuse 'nobody and everybody'.[1]

It's a thesis that still merits consideration more than forty years after the

Finbarr O'Reilly (Reuters)

essay was written. Shortly after O'Reilly's picture was published, Israel announced that it was 'investigating' the accusation that it was responsible for the school shelling. This is to be expected. No government will readily admit that it bombed a school if this is in any way deniable – or even postponable. The calculation is that by the time responsibility is conceded, the degree of blame or temperature of outrage – and the attendant political consequences – will have somewhat diminished.

So in spite of the way that images can be disseminated ahead of state censorship, the situation today – with enhanced awareness both of the power of photography as an instrument of war and of how to neutralise that power – can induce a resignation deeper than that described by Berger. I became conscious of the result or paradox of impotent solidarity while watching *5 Broken Cameras*, about a Palestinian who filmed his village's resistance to occupation and to ever-encroaching settlements. It is a record of endless defeat and setbacks. How, I kept wondering, do Palestinians avoid sinking into despair? The answer might be found in another essay by Berger, about the Italian writer Giacomo Leopardi, where he invites us to suppose

> that we are not living in a world in which it is possible to construct something approaching heaven-on-earth, but, on the contrary, are living in a world whose nature is far closer to that of hell; what difference would this make to any single one of our political or moral choices? We would be obliged to accept the same obligations and participate in the same struggle as we are already engaged in; perhaps even our sense of solidarity with the exploited and suffering would be more single-minded. All that would have changed would be the enormity of our hopes and finally the bitterness of our disappointments.[2]

There is one crucial difference between the Gaza picture and McCullin's: whereas the eyes of the Vietnamese child are turned imploringly towards us, neither the Palestinian man nor the girl pay us any mind. Could it be that, in

spite of everything – in a situation that seems hopeless, when Palestinians are dependent on the political intervention of others – we are left looking to *them*, to the powerless, for hope?

Kim Ludbrook:
Pretoria, South Africa, 11 September 2014

Susan Sontag wrote that photographs are strong as evidence but weak in meaning. They prove that a person was in the place where he was photographed doing the thing he is shown doing. Oral testimony can be disputed because people are mistaken, they misremember or do the very thing the camera was held never to do: they lie. As a tool in the investigation of crimes and the determination of innocence or guilt, the camera was therefore invaluable. Even in the shifting sands of the digital era our faith in photographic proof remains broadly intact. CCTV footage from an elevator insisted that NFL player Ray Rice knocked his then girlfriend unconscious even after she decided to forget the whole thing.

But photographs or films of faces, what do they tell us? If you are an actor you invest massively in the belief that they can reveal a great deal about a character, even if that character is, ultimately, unknowable. Typically this unknowability is achieved by doing as little as possible so that the face invites a scrutiny that is never repaid – but is, as a consequence, endlessly rewarded.

Issues such as these swirled constantly around the long trial – by judge and camera – of Oscar Pistorius. Lacking the equivalent of elevator footage or any first-hand testimony except his own, we were compelled to study his voice and face – his *performance* – and were, as a consequence, endlessly frustrated. In contrast to an iconic minimalist such as Steve McQueen, Pistorius overflowed with emotion. His voice quavered and broke, he howled and puked, stuffed his fingers in his ears. He looked like he was going to crack completely under some combination of horrified memory of what had happened, conscious-

Kim Ludbrook (Shutterstock)

ness of his own guilt or the double tragedy of accidentally killing his girlfriend Reeva Steenkamp in the process of trying to defend her and then having to stand trial for her murder. We looked at Pistorius as he came and went and reacted to what was said in court, though we were not permitted – a crucial lack – to observe his own testimony. Still, with such an overwhelming quantity of emotion and liquid coming out of his mouth and face it was hard to fathom what we *did* see. One thing seems highly likely. From a certain point – possibly from the moment of the shooting – Pistorius believed passionately in his own innocence, completely inhabited his preferred version of events. From that point on he was, as they say, so deeply in character that contradictions in his story came not from evasiveness or mendacity but from outrage that the prosecutor sought to question the authenticity of his script.

What we've ended up with is this: a photograph of the verdict, or of his reaction to it, which we hoped might reveal whether that verdict was correct. It didn't and couldn't. If he had a gold medal round his neck rather than a shirt collar, he could be standing on the winner's podium, overcome with emotion as he listens to the South African national anthem. As it is, we are faced – in profile – with a complete reversal of Sontag's claim: an image that is worthless as evidence but dripping with meaning.

Justin Sullivan:
Dellwood, Missouri, USA, 26 November 2014

Two related questions: How long do we have to go back to trace the origins of the unrest in Ferguson, Missouri? And when does the aftermath of what happened begin? In terms of narrative history, origins and aftermath – causes and effects – are continuous, capable of being lengthily extended in either direction so that 'what happened' *is* the aftermath. While there were many strong images capturing protests, unrest, rioting and the way the police provoked or responded to them, Justin Sullivan's picture seems especially telling in this regard.

What it lacks in photojournalistic immediacy is compensated for by its reach. (Since it was taken in Dellwood, Missouri, that reach is geographical as well as historical.) Given the number of camera crews and press photographers camped out in Ferguson, waiting for the verdict on the killing of Michael Brown by police officer Darren Wilson, hoping for photogenic trouble, it serves the useful function of reminding us that there was a time when reported events went *un*photographed. In showing the aftermath of a demonstration, Sullivan harks back to a time when the machinery of photography was too cumbersome and slow to capture events as they occurred. Unable to record a cavalry charge in the Crimea, Roger Fenton photographed cannonballs lying in the Valley of Death. What was absent could only be suggested or implied by what was present. So it is here – except the implication is, so to speak, explicit.

Back in the 1960s the phrase 'Black Is Beautiful' was more than a slogan; it was a movement and force for change. During the Ferguson protests the main message on placards was 'Black Lives Matter', which seems a more rudimentary or even humble claim – a throwback to the days when the contrary belief

Riots after Grand Jury Decision Rip Apart Ferguson, Missouri, by Justin Sullivan

Getty Images

was respectably upheld. In this photograph all that remains of the militant 1960s assertion is 'BEAUTY' – a plea rendered not just meaningless but visibly contradicted by the ruination of which it is part and to which it provides a wanly ironic caption.

The extent of the damage done is exacerbated by another aspect of the photograph's reach. This is almost spelled out, since the damaged BEAUTY sign cannot but recall another self-captioning image, possibly the most famous one of all.

In about 1929 Walker Evans (born, incidentally, in St Louis, Missouri) photographed workers loading a long neon 'DAMAGED' sign on to the back of a truck. The two signs are tilted at exactly the same angle (twenty degrees, I'm guessing) but it is, of course, the differences that make the resemblance so effective. The DAMAGED picture is anything but. On the contrary, it's pristine and perfect – a thing of such obvious beauty as to instantly label itself *as* an Evans, as an *American Photograph*! Sullivan's is altogether less assured of its standing and status. Sure, it's an impressive picture (that's why we're looking at it), but it lacks the capacity to assert and define – as Evans did, again and again – both the centrality of the medium and the photographer's instantly eminent place in its history. One might almost say that it stands amid the rubble of that tradition and history: in the long aftermath of the original.

New York, 1930, by Walker Evans

PART THREE

WRITERS

Roland Barthes: *Camera Lucida*

In 1914 Alfred Stieglitz responded indignantly to a reader who had cancelled his subscription to *Camera Work*, the journal in which he had sought to 'establish once and for all, the *meaning* of the *idea* photography'. Roland Barthes claimed to be delighted by only one of Stieglitz's photographs, but the book in which he made this confession addresses the very issue that had obsessed Stieglitz to the point of mania. For many readers the effect of *Camera Lucida* was exactly the one Stieglitz claimed for *Camera Work*: 'photography suddenly assumed a new meaning'.[1]

Barthes had long been fascinated by photographs, but his exploration of 'the phenomenon of photography in its absolute novelty in world history'[2] had its specific origin in a request from *Les Cahiers du Cinéma* to write something about film. The idea did not appeal. As he told friends, 'I've got nothing to say about film, but photography, on the other hand . . .'[3] Having agreed to write a short piece for *Les Cahiers*, Barthes's reflections on photography (photography '*against* film'[4]) grew into a book written – according to his biographer Louis-Jean Calvet – 'at one go, or almost, during the period between 15 April and 3 June 1979'.[5] His mother had died in October 1977 and the book became bound up with his grief over her death. Barthes himself said in an interview that the book was 'symmetrical to *A Lover's Discourse,* in the realm of mourning'.[6] The whole of the second half of *Camera Lucida*, in fact, is based around a photograph of his mother – the so-called Winter Garden photograph – taken when she was five: 'Something like an essence of the Photograph floated in

* In the three essays in this section, page references for quotations from *Camera Lucida, Why Photography Matters* and *Understanding a Photograph* are given in square brackets.

this particular picture' [73].* Just how profoundly Barthes's private grief and the subject of his professional scrutiny had become intermingled was made poignantly clear by the publication of *Mourning Diary* in 2010.

Barthes liked 'to write beginnings'[7] and multiplied this pleasure by writing books of fragments, of repeated beginnings; he also liked pre-beginnings: 'introductions, sketches', ideas for projected books, books he planned one day to write. So when Nathalie Léger, editor of *Mourning Diary*, describes it as 'the hypothesis of a book desired by him',[8] she is accurate in that it was neither finished nor intended for publication, but she is also describing the typical or ideal condition of the books that *were* published. In a sense *Camera Lucida* is the desired book of which the *Mourning Diary* is the mere hypothesis, while itself being a more elaborately formulated series of hypotheses – not a definitive account, but a 'Note sur la photographie' as the French edition was modestly (and confidently) subtitled. Barthes's preferred way of presenting his hypotheses was in the form of linked aphorisms, and, as Susan Sontag noted, 'it is the nature of aphoristic thinking to be always in a state of concluding'.[9] The paradox, then, is that this man who liked first words (and adored paradoxes) offered his provisional findings as if they were the *last* word. Needless to say, this last word was always susceptible to further elaboration and refinement, to further beginnings. This is how Barthes's prose acquires its signature style of compression and flow, a summing up that is also a perpetual setting forth. The result, an ever-increasing subtleness or delicacy of assertion, approximates the defining quality of his mother, as captured, uniquely, in the Winter Garden photograph: 'the assertion of a gentleness' [69]. If there is a consoling appropriateness about this then, by the same token, there was a cruel inevitability about Barthes's work being curtailed by his early death (less than two months after the French publication of *Camera Lucida*). He was one of those writers whose life's work was destined, by increments, to remain unfinished.

In a way, the death of the mother was fortuitous in that it confirmed something Barthes had suspected: that his fascination with the medium – as he glib-

ly admitted in a radio interview in early 1977 – 'probably has to do with death. Perhaps it's an interest that is tinged with necrophilia, to be honest, a fascination with what has died but is represented as wanting to be alive.'[10] By the end of the year his tone had changed. 'If photography is to be discussed on a serious level, it must be described in relation to death,' he told another interviewer. 'It's true that a photograph is a witness, but a witness of something that is no more.'[11] This is classic Barthes: an insight into the nature of an event or thing – 'text' was his consistently preferred term – is also a comment on his own determinedly personal experience. While Barthes emphasised photography's indexical relation to the world, its 'evidential force' [89], he also believed that, ultimately, 'the photographer bears witness essentially to his own subjectivity'. In keeping with this, the book *about* photography is a mediated portrait of the workings of his own mind. Michel Foucault made a similar if more generalised point in the eulogy delivered at the Collège de France in April 1980, praising Barthes's 'paradoxical power of understanding things as they are and of inventing them with amazing freshness'.[12] Barthes's method, in other words, worked exactly like the element of the photograph that he famously termed the '*punctum*': 'what I add to the photograph and *what is nonetheless already there*'. [55]

The extent to which this way of proceeding could involve remaking photography in Barthes's own image is nicely brought out by his discussion of Robert Mapplethorpe's photograph of a young man, at the far left of the frame, with his left arm extended across to the opposite border. Entranced by the 'blissful eroticism' of the image, Barthes likes the way 'the photographer has caught the boy's hand (the boy is Mapplethorpe himself, I believe) at just the right degree of openness'. [59] The last of the prefatory photographs in *Roland Barthes by Roland Barthes* is a full-page portrait of the author lighting a cigarette, captioned – with gorgeous brevity and vanity – 'Left-handed'. So there is a gorgeous vanity and irony in the fact that the Mapplethorpe is actu-

* I am grateful to David Campany for pointing this out.

ally printed back to front.* It should be the *right* arm that is extended across to the left hand of the frame, but through this felicitous accident, the projected ideal of desire has turned into a representation of Barthes himself!

The increasingly autobiographical tilt and lilt of Barthes's writing was regarded, in some quarters, as symptomatic of a diminution of the rigour that had marked his first incarnation as systematiser and semiologist. By the mid-1980s, the work of Barthes, Lacan, Foucault, Derrida *et al* had been absorbed wholesale into the English-speaking academy. 'Theory' became an indispensable part of the cultural studies mainstream. The excitement and energy generated by these challenging new ways of reading texts was matched by a corresponding indignation and resistance, particularly in England, but the ease with which the European challenge to traditional academic orthodoxy installed itself as a new orthodoxy was shocking to behold. Cowper's famous jibe about Pope – that he 'Made poetry a mere mechanick art;/And ev'ry warbler has his tune by heart' – was rendered suddenly contemporary by the clutch of sub-Barthesian, Foucault-drenched academics discoursing and signified-and-signifying away for all they were worth. Subsumed in a general mass of cultural theory, the works in which Barthes most clearly revealed himself as a *writer* were the least valued. An article in the *New Statesman* assessing Barthes's importance ten years after his death dwelt almost exclusively on his semiotics, on works like *Image, Music, Text* and *Mythologies,* while dismissing the later, more personal works as 'marginal, lacking the satisfying stamp of authority'.

All of which was in sharp contrast to Sontag's approving observation of the way that 'his voice became more and more personal', that he derived pleasure from 'the dismantling of his own authority', and that the marginal would come to seem absolutely central to Barthes's achievement. In time, Sontag rightly predicted, the theorist who had famously proclaimed the death of the author would come to appear as 'a rather traditional *promeneur solitaire*'[13] (one of

* See particularly, 'Soirées de Paris' in *Incidents,* Berkeley: University of California Press, 1992.

whose preoccupations, incidentally, would be his abiding loneliness).* Writing in the immediate aftermath of Barthes's death, Italo Calvino offered a similarly nuanced view of two Barthes: 'the one who subordinated everything to the rigour of a method, and the one whose only sure criterion was pleasure (the pleasure of the intelligence and the intelligence of pleasure). The truth is that these two Barthes are really one.'[14]

Between them, Sontag and Calvino accurately mapped the territory in which Barthes's posthumous reputation would come to reside. The earlier, much-anthologised essays in which Barthes first wrote about photography – 'Rhetoric of the Image' and 'The Photographic Message' – today seem intensely reader-resistant. But while Barthes, in *Camera Lucida,* explicitly distanced himself from 'sociologists and semiologists' [88] one can discern the residue of the earlier systematising efforts, like the ghostly imprint of scaffolding, a grid on which he is no longer reliant. And even when Barthes is at his least theoretical one still senses what Perry Anderson calls 'the formative role of rhetoric' in his style – a formation shared by most of his illustrious contemporaries. The potential costs of this, Anderson goes on, are obvious: 'arguments freed from logic, propositions from evidence.'[15]

Nevertheless, a programmatic approach *can* be extracted from the book. In this respect *Camera Lucida* has become a victim of its own success. The *punctum* is an apparently irrelevant detail, extraneous to a picture's intended purpose or composition and yet, once noticed, essential to it. This idea proved so seductive that a *punctum* – which, crucially, was not there in all photographs, which snagged Barthes's attention almost accidentally – became almost a necessity. As the search for a picture's *punctum* took on the quality of a critical dragnet – we know it's in there somewhere! – so this surprising detail lost its capacity to surprise, offered the same kind of unconcealed or overt satisfaction as the *studium* to which it had originally been opposed: something

* For more on how the opposition between *punctum* and *studium* is 'blurred' within *Camera Lucida* itself, see Jacques Ranciere, *The Future of the Image*, New York: Verso, 2007, pp.110-16

that any photograph provided and that we expected to find, as of right.*

A related problem is that Barthes's thought is inseparable from the elegance and cunning with which it is formulated. Style, as Martin Amis rightly insists, 'is not something grappled on to regular prose; it is intrinsic to perception'.[16] In *The Pleasure of the Text* – a useful guide, naturally, to his own work – Barthes had asked 'what if knowledge itself were *delicious*?'[17] The corollary is what if that knowledge were robbed of all that made it so tasty? The tone of 'sustained astonishment' with which Barthes discovers that photography represents the advent of the self as other; or articulates the strange tense of Alexander Gardner's portrait of Lewis Payne: 'He is dead and he is going to die' [9]; or notices 'that rather terrible thing which is there in every photograph: the return of the dead' [9] . . . None of this lends itself to bald summary. To copy out and formalise his argument is not simply to diminish it, but to rob it of so many subtleties as to misrepresent it entirely (all in the name of representing it more clearly and rigorously).

Full of what Anderson calls 'eclectic coquetries' and flourishes of 'flamboyant eloquence', Barthes's prose is all the time delighting in its own refinement. This is not to everyone's taste. As he asked (again in *The Pleasure of the Text*): 'Why, in a text, all this verbal display?' He goes on to say that the 'prattle of the text is merely that foam of language'.[18] For his detractors this is not the foam of a tide or stream but the foam of an over-scented bubble bath to which one can develop an allergic reaction; for his admirers it is something in which to luxuriate. This is crucial to Barthes's appeal: a prose built around complex ideas, which somehow manages to *pamper* the reader. Part of the fun of reading him is in seeing rhetoric brought to a point of exquisite jotting – and vice versa.

By the time of *Camera Lucida*, Barthes's ornate sentences with all their colons and semi-colons, italics, hyphens, ellipses and parentheses came quite naturally to him. Where one might remember particular scenes or sentences in a novel, with Barthes the focus narrows to favourite deployments or permutations of punctuation. To take just one example: the most famous

bracket in post-war literature is probably the one in *Lolita* where Humbert Humbert provides details of the death of his mother: '(picnic, lightning)'. It's proof, in spectacular miniature, of Nabokov's exuberant facility. But the moment when Barthes, remembering *his* dead mother's ivory powder box, adds, almost inaudibly, '(I loved the sound of its lid)' [64] is intensely moving and just as expressive of his own style. It also reminds us that, for all his extravagancies, there is often something understated about Barthes. Everything about the prose is so personalised that even the printed page seems handwritten with a favourite pen. And not only that: thanks to the delicacy and skill of his translator, Richard Howard, English-speaking readers can enjoy the delusion that they suddenly have the ability to read French.

In *Roland Barthes,* Barthes had warned readers that 'it must all be considered as if spoken by a character in a novel'[19] and, in his last years, talked about the possibility of writing a novel. Whether he would ever have realised this ambition is impossible to say, but it bears emphasising that a knowledge of or even interest in photography is no more a precondition for reading *Camera Lucida* than an interest in young girls is necessary for embarking on *Lolita*. *Camera Lucida* is a glimpse of the world as rendered by a master stylist; as such it offers a version of the pleasures derived from the best discursive fiction. 'For me the noise of Time is not sad: I love bells, clocks, watches – and I recall that at first photographic implements were related to techniques of cabinetmaking and the machinery of precision: cameras, in short, were clocks for seeing, and perhaps in me someone very old still hears in the photographic mechanism the living sound of the wood.' [15] In such passages Barthes seems like the true heir – in modishly abbreviated style – of Proust.

Barthes entertained few doubts as to his literary gifts and, in interviews, was suavely sure of the 'entirely subjective' method whereby a few 'arbitrarily chosen photographs' would suffice to examine the 'new type of image' that came into existence 'all at once, around 1822'. 'Whether this will please photographers,' he conceded, 'remains to be seen.'[20] In Britain, particularly for

those pursuing a double life as photographers and academics teaching on cultural or media studies courses, Barthes's work provided a framework that was creative as well theoretical. For the most part, though, the best American photographers were not so much hostile as indifferent to Barthes's efforts. The business of making images was dominated, as it always had been, by photographers looking at each other's pictures and swapping advice and experience about technical matters: lenses, films, papers. Looking back on the period in the 1970s when many of the photos in his book *Passing Through Eden* were made, Tod Papageorge remembered that 'unlike most of the photographers I knew, I bothered to acquaint myself with the major books' by Barthes, Sontag and others. Not that any of this 'intellectual commotion' found its way into the pictures. For the record, Papageorge is adamant that 'Garry Winogrand never read Roland Barthes, and found whatever he'd seen of [Janet] Malcolm's and Sontag's original articles about photography in the *New Yorker* and the *New York Review of Books* grimly laughable'. Papageorge, then, was an unusually sympathetic reader-practitioner, but he 'was more interested in what other photographers had to say about the state of our common medium'.[21] And while Barthes's whole purpose was to define the 'newness' of photographic images (i.e. what made them different from paintings) some of the people most deeply involved in the medium were not convinced. As Mark Haworth-Booth, former curator of photography at the Victoria & Albert Museum in London, mischievously remarked, 'I recently hung up a painting in our new dining room and realized for the first time that my mother must have picked the sweet peas in it'.[22] *

Another irony is that this 'newness' – almost 150 years old by the time Barthes wrote his book! – now seems almost obsolete. For Barthes the photograph was not just a record of something that is absent but of 'reality in a

* At the risk of nationalist carping, it is worth mentioning, too, that Barthes's account of the origins of photography is wilfully Franco-centric: a competitive collaboration between Niépce and Daguerre; the Englishman William Henry Fox Talbot does not merit even a mention!

past state' [82], a record of '*what has been*' [85]. Much of what Barthes says about photography rings true only if we are thinking of its traditional chemical/mechanical phase. Polaroids provided instant *memories* but digital photography seems entirely devoid of any qualities of past time. The digital tense is a self-fuelling, self-consuming present – never more obviously so than when a crowd of paparazzi are busy 'chimping' – consulting the images they have snatched only moments earlier. Far from invalidating Barthes's arguments, the current ubiquity of the digital means that *Camera Lucida* has acquired the internal glow of its own preoccupation with photography as a technology in the process of becoming past, part of what has been.

It is ironic, then, that one of the most memorable tributes to Barthes comes in the form of an image that would have been inconceivable without the benefits of digital technology. In 2004 Idris Khan photographed *Every Page from Roland Barthes's Camera Lucida* and combined them in a single image in which Barthes's text and the pictures reproduced in the book peer at the viewer through a dense fog of their own making. The return of the read! It is as if decaying and enduring memories of the book's successive pleasures – first words and last – have been compacted into a ghostly blur of almost impenetrable purity.

2010

Michael Fried: *Why Photography Matters as Art as Never Before*

In this essay I want to look at a not uncommon way of writing and structuring books. This approach, I will argue, involves the writer announcing at the outset what he or she will be doing in the pages that follow. The default format of academic research papers and textbooks, it serves the dual purpose of enabling the reader to skip to the bits that are of particular interest and – in keeping with the prerogatives of scholarship – preventing an authorial personality from intruding on the material being presented. But what happens when this basically plodding method seeps so deeply into a writer's make-up as to constitute a stylistic signature, even a kind of ongoing flourish or extravagance?

Before going on, I will say something here about how I was drawn to this area of research. In the course of writing an article about the photographer Thomas Struth, I remembered that the highly regarded art historian Michael Fried had a chapter on Struth in his book *Why Photography Matters as Art as Never Before* (henceforth *WP*) published by Yale University Press. I'd read only a little of Fried before, but I knew that his earlier *Absorption and Theatricality: Painting and Beholder in the Age of Diderot* was regularly referred to and quoted by art historians. I will show later that one of those art historians is Fried himself, but as soon as I started to consult *WP* I realised I was reading something quite extraordinary: a masterpiece of its kind in that it takes the style of perpetual announcement of what is about to happen to extremes of deferment that have never been seen before. Imminence here becomes immanent.

I'll come to the rest of the book later. Here I will simply remark that the first page of Fried's introduction summarises what he intends to do and ends with a summary of this summary: 'This is what I have tried to do in *WP*.' The second page begins with another look ahead: 'The basic idea behind what follows . . .' Fair enough, that's what introductions are for, and it's no bad thing to be reassured that the way in which the overall argument will manifest itself 'in individual cases will become clear in the course of this book'. Page three begins: 'The organization of *WP* is as follows . . .' Well, OK again, even if it is a bit like watching a rolling news programme: *Coming up on CNN . . . A look ahead to what's coming up on CNN . . .* More striking is the way that even though we have only just got going – even though, strictly speaking, we have *not* got going – Fried is already looking back (*Previously on NYPD Blue . . .*) on what he did in earlier books such as *Art and Objecthood* and *Absorption and Theatricality*. The present book will not be like those earlier ones, however, 'as the reader of *WP* is about to discover . . .'[4].

What the reader discovers, however, is that Fried will continue to announce what he's about to do right to the end: 'Late on in this book I shall examine . . .' [115]; 'I shall discuss both of these after considering . . .' [116]; 'I shall also be relating . . .' [119] By the end there is, naturally, a lot to look back on, both in terms of what has been said in the present book – 'I have already offered a few suggestions about . . .' [122] – and how all of this relates to the earlier magnum opus: 'as I remark in *Absorption and Theatricality . . .*' [192] The brilliance of Fried, however, is that in spite of all the time spent looking ahead and harking back he also – and it's this that I want to emphasise here – finds the time to tell you what he's doing *now, as* he is doing it: 'Fine, but again, I ask . . .' [344]; 'let me try to clarify matters by noting . . .' [202]; 'What I want to call attention to . . .' [226]. But that's not all: the touch of genius is that on top of everything else he somehow manages to tell you what he is *not* doing ('I am not claiming that . . .' [351]), what he has not done ('What I have not said . . .' [79]) and what he is not *going* to do: 'This is not the place for . . .' [238] On occa-

sions he combines several of these tropes in dazzling permutations such as the negative-implied-forward and the double-backward – 'So far I have said nothing in this conclusion about Barthes's *Camera Lucida*, which in Chapter Four I interpreted as a consistently antitheatrical text even as I also suggested...' – before reverting, in the next paragraph, to the tense endeavour of the present (i.e. telling us what he's still got to do): 'One further aspect of Barthes's text remains to be dealt with.' [345]

There is, I would remark here, a kind of zero-sum perfection about the way that the theatricality of the flamboyant, future-oriented signposting is matched by the ongoing retrospection. The depths of self-absorption that makes this possible are hard to fathom. As is the fact that someone can pump out this kind of froth and still enjoy a measure of critical respectability.

It could be argued – I allowed such a possibility at the outset – that this is essentially an academic habit, and that Fried is faithfully observing the expected conventions so faithfully that he has become an unconscious apostate. If academia elevates scholarly and impersonal inquiry above the kind of nutty, fictional, navel-gazing monologues of Nicholson Baker, then Fried's work is at once its high-camp apotheosis and its disintegration into mere manner.

Lest you think I have been quoting unfairly, take a break here and run your eyes over a couple of pages of *WP* in a library or bookshop. You'll be amazed. You'll see that, if anything, this essay *understates* the pathology on display. You'll see that this is some of the most self-worshipping – or, more accurately, self-serving – prose ever written. A potential objection: isn't all prose self-serving? No: any prose of value serves – however extravagantly and indirectly – the *reader*. For long stretches this reader's brain felt like it had been fried by its engagement with a book that was being consulted not for its style but its presumed content. I kept wondering why an editor at Yale University Press had not scribbled 'GET ON WITH IT!' in huge red letters on every page of the manuscript – and then I realised that the cumulative flim-flam *was* the it! And at that moment, as I hope to show, everything changed.

Suppose you meet someone who is a compulsive name-dropper. At first it's irritating, then it's boring. Once you have identified it as a defining characteristic, however, you long for the individual concerned to manifest this trait at every opportunity – whereupon it becomes a source of hilarity and delight. And so, having been brought to a crescendo of frustration, I now look forward to a new book in which Fried advances his habit of recessive deferral to the extent that he doesn't get round to what he wants to say until *after* it's finished, until it's time to start the next one (which will be spent entirely on looking back on what was said in the previous volume). At that point he will cross the border from criticism to the creation of a real work of art (fiction, if you will) called *Kiss Marks on the Mirror*: *Why Michael Fried Matters as a Writer Even More Than He Did Before.*

2011

John Berger: *Understanding a Photograph*

I became interested in photography not by taking or looking at photographs but by reading about them. The names of the three writers who served as guides will come as no surprise: Roland Barthes, Susan Sontag and John Berger. I read Sontag on Diane Arbus before I'd seen any photographs by Arbus (there are no pictures in *On Photography*), and Barthes on André Kertész, and Berger on August Sander without knowing any photographs other than the few reproduced in *Camera Lucida* and *About Looking*. (The fact that the photo on the cover of *About Looking* was credited to someone called Garry Winogrand meant nothing to me.)

Berger was indebted to both of the others. Dedicated to Sontag, the 1978 essay 'Uses of Photography' is offered as a series of 'responses' to *On Photography*: 'The thoughts are sometimes my own, but all originate in the experience of reading her book.' [49] In a 1976 review of *The Pleasure of the Text,* he described Barthes as 'the only living critic or theorist of literature and language whom I, as a writer, recognise'.[1]

For his part, Barthes included Sontag's *On Photography* in the list of books – omitted from the English edition – at the end of *Camera Lucida*. Sontag, in turn, had been profoundly shaped by her reading of Barthes. All three had been influenced by Walter Benjamin, whose 'A Short History of Photography' reads like the oldest surviving part of a map this later trio tried – in their different ways, using customised projections – to extend, enhance and improve. Benjamin is a constantly flickering presence in much of Barthes's writing. The anthology of quotations at the end of *On Photography* is dedicated – with the kind of intimate relation to greatness that Sontag cultivated, adored and be-

lieved to be her due – 'to W.B.'. At the end of the first part of *Ways of Seeing* Berger acknowledges that 'many of the ideas' had been taken from an essay of Benjamin's called 'The Work of Art in the Age of Mechanical Reproduction'. (This was 1972, remember, before Benjamin's essay became one of the most mechanically reproduced and quoted ever written.)

Photography, for all four, was an area of special interest, but not a specialism. They approached photography not with the authority of curators or historians of the medium but as essayists, writers. Their writings on the subject were less the product of accumulated knowledge than active records of how knowledge and understanding had been acquired or was in the process of being acquired.

This is particularly evident in the case of Berger, who did not devote an entire book to the subject until *Another Way of Telling* in 1982. In a sense, though, he was the one whose training and career led most directly to photography. Sontag had followed a fairly established path of academic study before becoming a freelance writer, and Barthes remained in academia for his entire career. Berger's creative life was rooted in the visual arts. He attended the Chelsea and Central Schools of Art and began writing about art in the early 1950s before becoming a regular critic – iconoclastic, Marxist, much admired, often derided – for the *New Statesman.* His first novel, *A Painter of Our Time* (1958), was a direct result of his immersion in the worlds of art and the politics of the left. By the mid-1960s he had widened his scope far beyond art *and* the novel to become a writer unhindered by category and genre. Crucially for the current discussion, he had begun collaborating with a photographer, Jean Mohr. Their first book, *A Fortunate Man* (1967), made a significant step beyond the pioneering work of Walker Evans and James Agee in *Let Us Now Praise Famous Men.* (*A Fortunate Man* is subtitled 'The Story of a Country Doctor', in homage, presumably, to the great photo essay by W. Eugene Smith, 'Country Doctor', published in *Life* in 1948.) This was followed by their study of migrant labour *A Seventh Man* (1975) and, eventually, *Another Way of Tell-*

ing. The important thing, in all three books, is that the photographs are not there to illustrate the text, and, conversely, the text is not intended to serve as any kind of extended caption for the images. Words and image exist on equal terms in an integrated, mutually enhancing relationship. A new form was being forged and refined.

A side effect of this ongoing relationship with Mohr was that Berger had, for many years, not only observed Mohr at work, he had also been the subject of that work. Berger lacked the training as a photographer that he'd enjoyed as an artist, but he became very familiar with the other side of the experience, of being photographed. With the exception of one picture, by another friend – Henri Cartier-Bresson! – the author photographs on his books have almost always been by Mohr; they constitute Mohr's visual biography of his friend. His writings on drawing speak with the authority of one who draws; his writing on photography often concentrates on the experience, the depicted lives, of those photographed. Barthes expressed the initial impetus for *Camera Lucida* as photography '*against* film'; Berger's writing on photography hinges on its relationship to painting and drawing. As Berger grew older his early training – in drawing – rather than fading in importance became a more and more trusted tool of investigation and enquiry. A representative passage in 'My Beautiful' records how, in a museum in Florence, he came across the porcelain head of an angel by Luca della Robbia. 'I did a drawing to try to understand better the expression of her face.' [200] Could this be part of the fascination of photography for Berger? Not just that it is a wholly different form of image production, but that it is immune to explication by drawing? A photograph *can* be drawn, obviously, but how can its meaning best be drawn out?

This was the goal Barthes and Berger shared: to articulate the essence of photography. While this ambition fed, naturally enough, into photographic theory, Berger's method was always too personal, the habits of the autodidact too ingrained, to succumb to the kind of discourse- and semiotics-mania that seized cultural studies in the 1970s and 1980s. Victor Burgin – to take a rep-

resentative figure of the time – had much to learn from Berger; Berger comparatively little from Burgin. After all, by the time of *About Looking* (1980), the collection that contained some of his most important essays on photography, Berger had been living in the Haute-Savoie for the best part of a decade. His researches – I let the word stand in spite of being so thoroughly inappropriate – into photography proceeded in tandem with the struggle to gain a different kind of knowledge and understanding: of the peasants he had been living among and was writing about in the trilogy *Into their Labours*. Except, of course, the knowledge and methods were not so distinct after all. Writing the fictional lives of Lucie Cabrol or Boris – in *Pig Earth*, and *Once in Europa*, the first two volumes of the trilogy – or about Paul Strand's photograph of Mr Bennett, both required the kind of attentiveness celebrated by D.H. Lawrence in his poem 'Thought':

> Thought is gazing on to the face of life, and reading what can be read,
> Thought is pondering over experience, and coming to a conclusion.
> Thought is not a trick, or an exercise, or a set of dodges,
> Thought is a man in his wholeness wholly attending.[2]

In Berger's case, the habit of thought is like a sustained and disciplined version of something that had come instinctively to him as a boy. In *Here Is Where We Meet*, the author's mother remembers him as a child on a tram in Croydon: 'I never saw anyone look as hard as you did, sitting on the edge of the seat.'[3] If the boy ended up becoming a 'theorist', then, it is by adherence to the method described by Goethe, quoted by Benjamin (in 'A Short History of Photography') and re-quoted by Berger in 'The Suit and the Photograph': 'There is a delicate form of the empirical which identifies itself so closely with the object under consideration that it thereby becomes theory.' [36]

This is what makes Berger such an effective practical critic and reader of individual photographs ('gazing on to the face of life, and reading what can be read'), questioning them with his signature intensity of attention – and, often, tenderness. (See, for example, the analysis of Kertész's picture of *A Red Hussar*

Leaving, June 1919, Budapest in *Another Way of Telling* [74].) To that extent, his writing on photography continues the interrogation of the visible that characterised his writing on painting. As he explained at the beginning of a printed conversation with Sebastião Salgado, 'I try to put into words what I see.' [169]

In 1960 Berger had defined his aesthetic criteria simply and confidently: 'Does this work help or encourage men to know and claim their social rights?'[4] Consistent with this, his writing on photography was from the start avowedly and unavoidably political. (Which meant, in 'Photographs of Agony', he could argue that pictures of war and famine that *seemed* political often served to remove the suffering depicted from the political decisions that brought it about into an unchangeable and apparently permanent realm of the human condition.) Naturally, he has gravitated towards political, documentary or 'campaigning' photographers, but the range is wide and the notion of political never reducible to what Raghubir Singh called 'the abject as subject'.[5]

In 'The Suit and the Photograph' Sander's image of three peasants going to a dance becomes the starting point for the history of the suit as an idealisation of 'purely *sedentary* power' and an illustration of Antonio Gramsci's notion of hegemony [41]. (As with Benjamin's 'Work of Art', remember that this was the 1970s, almost twenty years before Gore Vidal informed Michael Foot that 'the young, even in America, are reading Gramsci'.[6]) Lee Friedlander, the least theory-driven of photographers, once commented on how much stuff – how much unintended information – accidentally ended up in his pictures. 'The Suit and the Photograph' is an object lesson in how much information is there to be discovered and revealed even in photographs lacking the visual density of Friedlander's. It's also exemplary in that it reminds us of how many of the best essays are also journeys, epistemological journeys, that take us beyond the moment depicted, often beyond photography – and sometimes back again.

In 'Between Here and Then', written for an exhibition by Marc Trivier, Berger mentions the photographs only briefly before telling a story about an old and beloved clock, how the sound of its ticking makes the kitchen where

he lives breathe. The clock breaks (is actually broken by the author in what must have been a furious moment of temporal slapstick), Berger takes it to a mender only to find . . . Well, that would spoil the story, and Berger's writing on photography must be seen in the wider context of his skill as a storyteller (in his preferred formulation) or as the author of a substantial body of fiction. As Berger examines and coaxes out a photograph's stories – both the ones it reveals and those that lie concealed – so the task of the critic and interrogator of images gives way to the vocation and embrace of the storyteller. And it does not stop there because, as he reminds us in *And Our Faces, My Heart, Brief as Photos*, 'the traffic between storytelling and metaphysics is continuous.'[7]

2013

Geoff Dyer and John Berger, Turin, 2004, by Jean Mohr

CHRONOLOGICAL LIST OF PHOTOGRAPHERS DISCUSSED IN PART ONE

Eugène Atget (1857–1927)

August Sander (1876–1964)

Alvin Langdon Coburn (1882–1966)

Ilse Bing (1899–1998)

Eli Weinberg (1908–81)

Helen Levitt (1913–2009)

Roy DeCarava (1919–2009)

Vivian Maier (1926–2009)

Andy Warhol (1928–87)

Fred Herzog (1930–2019)

Lee Friedlander (b. 1934)

Dennis Hopper (1936–2010)

William Eggleston (b. 1939)

Bevan Davies (b. 1941)

Luigi Ghirri (1943–92)

Peter Mitchell (b. 1943)

Nicholas Nixon (b. 1947)

Lynn Saville (b. 1950)

Philip-Lorca diCorcia (b. 1951)

Alex Webb (b. 1952)

Fred Sigman (b. 1953)

Thomas Struth (b. 1954)

Michael Wolf (1954–2019)

Andreas Gursky (b. 1955)

Prabuddha Dasgupta (1956–2012)

Pavel Maria Smejkal (b. 1957)

Thomas Ruff (b. 1958)

Chris Dorley-Brown (b. 1958)

Dayanita Singh (b. 1961)

Oliver Curtis (b. 1963)

Gary Knight (b. 1964)

Tom Hunter (b. 1965)

Fernando Maquieira (b. 1966)

Doug Rickard (b. 1968)

Elisa Sighicelli (b. 1968)

Zoe Strauss (b. 1970)

Matt Stuart (b. 1974)

Jon Rafman (b. 1981)

Chloe Dewe Mathews (b. 1982)

Mike Brodie (b. 1985)

ACKNOWLEDGEMENTS

Part One: Encounters

Eugène Atget's Paris: Originally published in *Atget,* Madrid: Fundación MAPFRE, 2011; reprinted in *Aperture* 206, spring 2012. Thanks to Carlos Gollonet.

Alvin Langdon Coburn's *London* and *New York*: Originally published in the facsimile reissue of *London* and *New York* by the Folio Society, London, 2019. Thanks to James Rose.

August Sander's People: Originally published in *Bookforum* April/May 2014; the section on Otto Brües was part of a presentation given at the August Sander Project in New York, September 2019. Thanks to Michael Miller and Sarah Meister.

Ilse Bing's Garbo: Originally published in Judy Bloch and Suzanne Stein (eds), *San Francisco Museum of Modern Art 360°: Views on the Collection*, San Francisco: San Francisco Museum of Modern Art, 2016. All rights reserved.

Helen Levitt's Streets: Originally published in Carlos Gollonet, *The Pulse of Life: Portraits,* Madrid: Fundación MAPFRE, 2015; reprinted in Helen Levitt, *One, Two, Three, More,* New York: power-House Books, 2017. Thanks to Craig Cohen and Marvin Hoshino.

Vivian Maier: Originally published in John Maloof (ed.), *Vivian Maier: Street Photographer,* power-House, New York 2011. Thanks to Craig Cohen and John Maloof.

The Boy in a Photograph by Eli Weinberg: Originally published in *New York Times Magazine,* September 2016. Thanks to Sasha Weiss for this and all other pieces from the *New York Times Magazine.*

Roy DeCarava: John Coltrane, Ben Webster and Elvin Jones: First part originally published in the *New York Times Magazine,* May 2017; second part originally published in *Aperture* 224, Fall 2016. Thanks to Michael Famighetti for this and all other pieces from *Aperture.*

Old Sparky: Andy Warhol: Originally published in Douglas Fogle (ed.), *Andy Warhol: Dark Star,* Munich and New York: Museo Jumex, Mexico City/DelMonico Prestel, 2017. Thanks to Douglas Fogle.

Dennis Hopper: Originally published in the *Guardian*, July 2014.

They: William Eggleston in Black and White: Originally published in Portuguese in Thyago Nogueira (ed.), *William Eggleston, a cor Americana*, Rio de Janeiro: Instituto Moreira Salles, 2015. Thanks to Thyago Nogueira.

Fred Herzog: Originally published in *New York Times Magazine*, December 2017.

Lee Friedlander's American Monuments: Originally published in *New York Times Magazine,* October 2017.

Bevan Davies's *Los Angeles, 1976*: Originally published in *Aperture* 232, Fall 2018.

Luigi Ghirri: Originally published as introduction to Luigi Ghirri, *Lessons in Photography*, Macerata: Quodlibet, 2021.

Peter Mitchell's Scarecrows: Originally published in *New York Times Magazine*, April 2016.

Nicholas Nixon: The Brown Sisters: Originally published in *The Pulse of Life*, Madrid: Fundación MAPFRE, 2015. Thanks to Carlos Gollonet.

Lynn Saville and the Archaeology of Overnight: Originally published in Lynn Saville, *Dark City*, Bologna: Damiani, 2015. Thanks to Lynn Saville.

Philip-Lorca diCorcia's Magic: Originally published in Katharina Dohm and Max Hollein (eds), *Philip-Lorca diCorcia,* Bielefeld: Kerber Verlag, 2013.

Alex Webb: Originally published in Alex Webb, *The Suffering of Light*, New York: Aperture, 2011. Thanks to Alex Webb and Lesley A. Martin.

Vegas Dreamtime: Fred Sigman's Motels: Originally published in *The Spectator*, June 2019. Thanks to Igor Toronyi-Lalic.

The Undeniable Struth: Originally published in the *Guardian,* July 2011.

Andreas Gursky: Originally published in Joanne Heyler (ed.), *The Broad Collection*, Munich and New York: The Broad/DelMonico Prestel, 2015. Thanks to Ed Schad.

Thomas Ruff: Originally published in *Thomas Ruff: nudes/ma.r.s.,* London: Gagosian, 2012; reprinted in the *Guardian,* March 2012. Thanks to Mark Francis.

Prabuddha Dasgupta's *Longing*: Originally excerpted in *The Paris Review* 200, Spring 2012; published in full in *Prabuddha Dasgupta 1956–2012,* Hyderabad, 2015. Thanks to Tania Sethi.

Photojournalism and History Painting: Gary Knight: Originally published in *Los Angeles Times*, April 2013.

Pavel Maria Smejkal's *Fatescapes*: Originally published in *Photoworks*, Autumn/Winter 2011. Thanks to Ben Burbridge.

Chris Dorley-Brown's Corners: Originally published in *New York Times Magazine*, July 2018.

Dayanita Singh: Now We Can See: Originally published in Dayanita Singh, *Go Away Closer,* London: Hayward Gallery, 2013. Thanks to Dayanita Singh and Ralph Rugoff.

Oliver Curtis: *Volte-face*: Originally published in Oliver Curtis, *Volte-face,* Stockport: Dewi Lewis, 2016. Thanks to Oliver Curtis and Dewi Lewis.

Tom Hunter: The Persistence of Elegy: Originally published in Tom Hunter, *The Way Home*, Berlin and London: Hatje Kantz, 2012. Thanks to Tom Hunter and Nicola Shane at Purdy Hicks.

Fernando Maquieira and the Maja at Night: Originally published in *The Pulse of Life*, Madrid: Fundación MAPFRE, 2015. Thanks to Carlos Gollonet.

Spirit and Flesh in Naples: Originally published in *The Spectator*, September 2019. Thanks to Igor Toronyi-Lalic and Gianluigi Ricuperati.

Zoe Strauss: Originally published on the Zum website in Portuguese; published in English in The Miami Rail, 18 June 2014, https://miamirail.org/visual-arts/zoe-strauss/.

Matt Stuart: Why He Does This Every Day: Originally published in Matt Stuart, *All That Life Can Afford,* London: Plaque Press, 2016. Thanks to Matt Stuart.

Stay-at-Home Street Photographers: Originally published in Portuguese in *Zum* no. 1, October 2011; published in English in *The Believer* 90, June 2012 and reprinted in the *Observer*, July 2012. Thanks to Thyago Nogueira.

Mike Brodie: *A Period of Juvenile Prosperity*: Originally published in *Bookforum,* June/July/August 2013. Thanks to Michael Miller.

Chloe Dewe Mathews: *Shot at Dawn*: originally published in Paul Bonaventura (ed.), Chloe Dewe Mathews: *Shot at Dawn,* Madrid: Ivorypress, 2014. *Shot at Dawn* was commissioned by the Ruskin School of Art at the University of Oxford as part of 14–18 NOW, WW1 Centenary Art Commissions. Thanks to Paul Bonaventura.

Part Two: Exposures

All pieces originally published in *The New Republic* between February 2013 and September 2014 except the last, about Justin Sullivan's photograph, which was published in *Dornsife Magazine*, Fall 2015/Winter 2016. Thanks to Ben Crair, Greg Veis and Maia Booker.

Part Three: Writers

Roland Barthes: *Camera Lucida*: Originally published as the introduction to Roland Barthes, *Camera Lucida,* New York: Hill & Wang, 2010. Thanks to Marion Duvert.

Michael Fried: *Why Photography Matters as Art as Never Before*: Originally published in a slightly shorter version in *New York Times Book Review,* July 2011. Thanks to Alex Star.

John Berger: *Understanding a Photograph*: Originally published as the introduction to John Berger, *Understanding a Photograph,* Geoff Dyer (ed.), London: Penguin, and New York: Aperture, 2013. Thanks to Alexis Kirschbaum.

I am especially grateful to all the artists, photographers and gallerists – many of whom have become friends – for their help in allowing me to reproduce their work in these pages.

ENDNOTES

Introduction
1 Rilke, Rainer Maria, *Selected Letters 1902–1926*, London: Quartet, 1988, p. 155.

Eugène Atget's Paris
1 Evans, Walker, quoted in Trachtenberg, Alan, *Reading American Photographs*, New York: Hill & Wang, 1989, p. 237.

2 Lane, Anthony, *Nobody's Perfect*, New York: Knopf, 2002, p. 536.

3 Lane, *Nobody's Perfect*, p. 535.

4 Brodsky, Joseph, from 'Lullaby of Cape Cod', *Collected Poems in English*, New York: Farrar, Straus and Giroux, 2000, p. 122.

5 Wharton, Edith, *The House of Mirth*, Harmondsworth: Penguin, 1986, p. 14.

6 Szarkowski, John, *Atget*, New York: Metropolitan Museum of Art/Callaway, 2000, p. 30.

7 Benjamin, Walter, 'Little History of Photography', *Selected Writings Volume 2, 1927–1934*, Michael W. Jennings, Howard Eiland and Gary Smith (eds), Cambridge: Belknap, 1999, p. 527.

8 Westerbeck, Colin, *Bystander*, London: Thames and Hudson, 1994, p. 110.

9 Benjamin, 'Little History of Photography', *Selected Writings Volume 2*, p. 519.

10 Lane, *Nobody's Perfect*, p. 536.

11 Barthes, Roland, *Camera Lucida*, New York: Hill & Wang, 1981, p. 16 and p. 15.

12 Yourcenar, Marguerite, 'Reflections on the Composition of *Memoirs of Hadrian*', *Memoirs of Hadrian*, Harmondsworth: Penguin, 1986, p. 270.

13 McCarthy, Mary, *Stones of Florence and Venice Observed*, Harmondsworth: Penguin, 1972, p. 32.

14 Szarkowski, John, quoted in Gilles Mora and John Hill, *Walker Evans: The Hungry Eye*, London: Thames and Hudson, 1993, p. 10.

15 Cartier-Bresson, Henri, quoted in *American Photo*, Vol. 8, No. 5 (September/October 1997), p. 76.

16 Benjamin, 'Little History of Photography', *Selected Writings Volume 2*, pp. 510–12.

Alvin Langdon Coburn's *London* and *New York*
1 Coburn, Alvin Langdon, on Hilaire Belloc, quoted in Jane M. Rabb (ed.), *Literature and Photography*, Albuquerque: University of New Mexico Press, 1995, p. 175.

2 Shaw, George Bernard on Coburn, quoted by Pamela Glasson Roberts in *Alvin Langdon Coburn*, Madrid: Fundación MAPFRE, 2014, p. 52.

3 James, Henry, Preface to *The Golden Bowl*, Harmondsworth: Penguin, 1966, pp. 12–14.

4 Coburn on Henry James, quoted in Rabb, *Literature and Photography*, p. 172.

5 James, Preface to *The Golden Bowl*, pp. 12–14.

6 Quoted by Roberts in *Alvin Langdon Coburn*, p. 41.

7 Kozloff, Max, *New York: Capital of Photography*, New Haven: Yale University Press, 2002, pp. 12–13.

8 Stieglitz, Alfred, quoted in Sarah Greenough, *Alfred Stieglitz, The Key Set*, Vol. 1, Washington: National Gallery of Art/Abrams, 2002, p. 287.

9 Quoted in Trachtenberg, *Reading American Photographs*, p. 215 and in Keith F. Davis, *An American Century of Photography*, 2nd edition, New York: Hallmark/Abrams, 1999, p. 65.

10 Coburn on 'The Octopus', quoted by Roberts in *Alvin Langdon Coburn*, p. 37.

11 Hambourg, Maria Morris, *Paul Strand: Circa 1916*, New York: Metropolitan Museum of Art/Abrams, 1998, p. 24.

August Sander's People

1 Arbus, Diane, *Revelations*, New York: Random House, 2003, p. 165.

2 Arbus, *Revelations*, p. 147.

3 Sander, August in Die Photographische Sammlung/SK Stiftung Kultur (eds), *People of the 20th Century*, Munich: Schirmer/Mosel, 2013, p. 11.

4 Sander in *People of the 20th Century*, p. 12.

5 Smith, W. Eugene, quoted in Sam Stephenson, *Dream Street: W. Eugene Smith's Pittsburgh Project*, New York: Norton, 2001, p. 20.

6 Barthes, *Camera Lucida*, p. 36.

7 Borges, Jorge Luis, *Selected Non-Fictions*, Eliot Weinberger (ed.), New York: Viking, 1999, p. 231.

8 West, Rebecca, *Selected Letters of Rebecca West*, Bonnie Kime Scott (ed.), New Haven: Yale University Press, 2000, p. 169.

9 Amis, Martin, *The Information*, London: Flamingo, 1995, p. 405.

10 Dickinson, Emily, *The Complete Poems*, Thomas H. Johnson (ed.), London: Faber & Faber, 1970, p. 288.

Ilse Bing's Garbo

1 Barthes, Roland, *Mythologies*, New York: Hill & Wang, 1972, p. 57.

2 Thomson, David, *The New Biographical Dictionary of Film*, 6th edition, New York: Knopf, 2014, p. 392.

Helen Levitt's Streets

1 Agee, James, Introduction to Helen Levitt, *A Way of Seeing*, Durham: Duke University Press, 1989, p. viii.

Vivian Maier

1 Szymborska, Wisława, *Poems New and Collected, 1957–1997*, London: Faber & Faber, 1999, p. 82.

The Boy in a Photograph by Eli Weinberg

1 Sultan, Larry, wall caption at San Francisco Museum of Modern Art retrospective, 2017.

2 Coetzee, J.M., *Waiting for the Barbarians*, Harmondsworth: Penguin, 1982, p. 104.

Roy DeCarava: John Coltrane, Ben Webster and Elvin Jones

1 DeCarava, Roy, quoted by Peter Galassi in *Roy DeCarava: A Retrospective*, New York: Museum of Modern Art, 1996, p. 26 and p. 19.

2 Friedlander, Lee, *American Musicians*, New York: Distributed Art Publishers, 1998, pp. 291–2.

3 Tolliver, Charles, quoted in Ben Ratliff, *Coltrane: The Story of a Sound*, London: Faber & Faber, 2007, p. 149.

4 Decarava, Roy, quoted by Sherry Turner DeCarava in 'Celebration' in Robert G. O'Meally (ed.), *The Jazz Cadence of American Culture*, New York: Columbia University Press, 1998, p. 261.

Old Sparky: Andy Warhol

1 Warhol, Andy, and Pat Hackett, *POPism: The Warhol '60s*, San Diego: Harcourt Brace Jovanovich, 1980, p. 50.

2 Giorno, John, quoted by Victor Bockris in *The Life and Death of Andy Warhol*, London: Fourth Estate, 1988, p. 171.

3 Sontag, Susan, *Against Interpretation and Other Essays*, New York: Farrar, Straus and Giroux, 1966, p. 213.

4 Quoted by David Magarshack in introduction to his translation of *The Idiot*, Harmondsworth: Penguin, 1955, p. 7.

5 Dostoevsky, Fyodor, *The Idiot*, p. 210.

6 Kristeva, Julia, *Black Sun*, New York: Columbia University Press, 1992, p. 188.

7 Capote, Truman, *In Cold Blood*, Harmondsworth: Penguin, 1966, p. 189.

8 DeLillo, Don, *White Noise*, London: Picador, 1985, pp. 217 and 208.

9 Warhol, Andy, quoted in G.R. Swenson, 'What is Pop Art? Answers From 8 Painters, Part 1', *Art News* 62, November 1963, p. 60.

10 DeLillo, *White Noise*, p. 70.

11 Warhol, Andy, quoted in *The Life and Death of Andy Warhol*, p. 169 and p. 205.

12 Quoted in *The Life and Death of Andy Warhol*, p. 154.

13 Szarkowski, *Atget*, p. 136.

Dennis Hopper

1 Hayward, Brooke, quoted by Peter Biskind in *Easy Riders, Raging Bulls*, London: Bloomsbury Publishing, 1999, pp. 43–4.

2 Auden, W.H., 'In Time of War', in Edward Mendelson (ed.), *The English Auden*, London: Faber & Faber, 1977, p. 269.

3 Thomson, *The New Biographical Dictionary of Film*, p. 496.

4 Warhol and Hackett, *POPism*, p. 53.

5 Bockris, *The Life and Death of Andy Warhol*, p. 178.

6 Barthes, *Camera Lucida*, p. 47.

They: William Eggleston in black and white

1 Eggleston, William, quoted in Michael Almereyda (ed.), *William Eggleston: For Now*, Santa Fe: Twin Palms, 2011 (unpaginated).

2 Sternfeld, Joel, quoted in *Sunday Telegraph Magazine*, 28 March 2004, p. 29.

3 Benjamin, 'Little History of Photography', *Selected Writings Volume 2*, p. 507.

4 Jameson, Fredric, *Marxism and Form*, Princeton: Princeton University Press, 1974, p. 39.

5 Arbus, *Revelations*, p. 342.

6 Quoted in Almereyda, *William Eggleston: For Now* (unpaginated).

7 Sokal, Jason, *There Goes My Everything*, New York: Knopf, 2006, p. 335.

8 Szarkowski, John, quoted by Thomas Weski in 'The Tender-Cruel Camera' in *The Hasselblad Award 1998: William Eggleston*, Gothenburg: Hasselblad, 1999 (unpaginated).

9 Szarkowski, John, essay in *William Eggleston's Guide*, New York: Museum of Modern Art, 1976, p. 9.

10 Quoted by Walter Hopps in 'Eggleston's World' in *The Hasselblad Award 1998* (unpaginated).

11 Evans, Walker, in an interview with Leslie Katz in Peninah R. Petruck (ed.), *The Camera Viewed: Writings on Twentieth Century Photography*, Vol. 1, New York: Dutton, 1979, p. 122.

12 Ward, Jesmyn, *The Men We Reaped*, London: Bloomsbury Publishing, 2014, p. 38.

Fred Herzog

1 Auden, W.H., 'In Praise of Limestone' in Edward Mendelson (ed.), *Collected Poems*, London: Faber & Faber, 1991, p. 540.

2 Evans in Petruck (ed.), *The Camera Viewed*, p. 128.

3 Wall, Jeff, in Fred Herzog, *Modern Color*, Berlin: Hatje Cantz, 2017, p. 35.

Lee Friedlander's American Monuments

1 Friedlander, Lee, *Friedlander*, New York: Museum of Modern Art, 2005, p. 14.

2 Katz, Leslie George, *The American Monument*, New York: Eakins Press, 2017 (unpaginated).

3 Sassoon, Siegfried, *Collected Poems 1908–1956*, London: Faber & Faber, 1961, p. 201.

Bevan Davies's *Los Angeles, 1976*

1 Babitz, Eve, *Slow Days, Fast Company*, New York: NYRB Classics, 2016, p. 81.

2 Babitz, Eve, *I Used to Be Charming*, New York: NYRB Classics, 2019, p. 225.

3 Babitz, Eve, *L.A. Woman*, Edinburgh: Canongate, 2019, p. 132.

4 Babitz, Eve, 'Self-Enchanted City' in *Black Swans*, Berkeley: Counterpoint, 2018, p. 54.

5 Lawrence, D.H., *Twilight in Italy*, Harmondsworth: Penguin, 1997, p. 154.

Luigi Ghirri

1 Ghirri, Luigi, *The Complete Essays 1973–1991*, London: Mack, 2017, p. 42.

2 Ghirri, *The Complete Essays*, p. 164.

3 Ghirri, Luigi, *Lessons in Photography*, Macerata: Quodlibet, 2020, p. 44.

4 Ghirri, *Lessons in Photography*, p. 21.

5 Ghirri, *The Complete Essays*, p. 42.

6 Ghirri, *Lessons in Photography*, pp. 149–50.

7 Ghirri, *Lessons in Photography*, pp. 154.

8 Ghirri, *The Complete Essays*, p. 174.

9 Ghirri, *Lessons in Photography*, p. 136.

10 Ghirri, *The Complete Essays*, p. 42.

Peter Mitchell's Scarecrows

1 Weston, Edward, *The Daybooks of Edward Weston: Volume 1*, New York: Aperture, 1990, p. 55.

2 Mitchell, Peter, *Some Thing means Everything to Somebody*, Bristol: RRB Photobooks, 2015, p. 165.

3 Mitchell, *Some Thing means Everything to Somebody*, p. 165.

4 Unpublished Q & A with Rudi Thoemmes, publisher of *Some Thing means Everything to Somebody*.

5 Kierkegaard, Søren, *Either/Or* in Howard V. Hong and Edna H. Hong (eds), *The Essential Kierkegaard*, Princeton: Princeton University Press, 2000, p. 40.

Nicholas Nixon: The Brown Sisters

1 Dillard, Annie, *Teaching a Stone to Talk*, New York: Harper Perennial, 2008, p. 174.
2 Larkin, Philip, 'Aubade' in Anthony Thwaite (ed.), *Collected Poems*, London: Faber & Faber, 1990, p. 208.

Lynn Saville and the Archaeology of Overnight

1 Arbus, Diane, quoted in Patricia Bosworth, *Diane Arbus: A Biography*, New York: Norton, 1984, p. 307.
2 Szarkowski, John, quoted in Margaret Sartor (ed.), *What Was True: The Photographs and Notebooks of William Gedney*, New York: Norton, 2000, p. 176.

Philip-Lorca diCorcia's Magic

1 Arbus, Diane, *Diane Arbus: An Aperture Monograph*, New York: Aperture Books, 1972, p. 13.
2 Arbus, *Revelations*, p. 148.
3 diCorcia, Philip-Lorca, Conversation with Nan Richardson in *Conversations with Contemporary Photographers*, New York: Umbrage Editions, 2005, p. 176.
4 Strand, Mark, *Hopper*, New York: Knopf, 2001, p. 51.
5 Arbus, *Revelations*, p. 154.
6 Williams, Raymond, *Problems in Materialism and Culture*, London: Verso Books, 1980, p. 189.
7 Collins, Billy, 'The Revenant' in *Aimless Love: New and Selected Poems*, New York: Random House, 2013, p. 70.

Alex Webb

1 Unless otherwise indicated all quotations from Alex Webb or Max Kozloff are from their conversation in *Conversations with Contemporary Photographers*, New York: Umbrage Editions, 2005, pp. 195–217.
2 Lévi-Strauss, Claude, *Tristes Tropiques*, London: Picador Classics, 1989, p. 173.
3 Winogrand, Garry, quoted by Ben Lifson in *The Man in the Crowd: The Uneasy Streets of Garry Winogrand*, San Francisco: Fraenkel Gallery, 1999, p. 153.
4 Webb, Alex, *Under a Grudging Sun*, New York: Thames & Hudson, 1989, p. 11.
5 Iyer, Pico, in Webb, Alex, *Violet Isle*, Santa Fe: Radius Books, 2009, p. 134.
6 Césaire, Aimé, *Return to My Native Land*, John Berger and Anna Bostock (trans), Harmondsworth: Penguin, 1969, p. 38.
7 Iyer in Webb, *Violet Isle*, p. 134.
8 Webb, *Under a Grudging Sun*, p. 10.
9 Pound, Ezra, *ABC of Reading*, London: Faber & Faber, 1961, p. 29.
10 Auden, W.H., 'Museé des Beaux Arts', in Edward Mendelson (ed.), *Collected Poems*, London: Faber & Faber, 1991, p. 179.
11 Blake, William, 'The Marriage of Heaven and Hell', *The Complete Poems*, London: Longman, 1989, p. 114.

12 Kapuściński, Ryszard, *The Shadow of the Sun*, London: Allen Lane, 2001, p. 163.

13 Lange, Dorothea, quoted by Milton Meltzer in *Dorothea Lange: A Photographer's Life*, New York: Farrar, Straus and Giroux, 1978, p. 335.

14 Kapuściński, Ryszard, *Imperium*, London: Granta Books, 1994, p. 193.

15 Jacobs, Jane, *The Death and Life of Great American Cities*, New York: Library of America, 1993, p. 45.

16 Jacobs, *The Death and Life of Great American Cities*, p. 49.

Vegas Dreamtime: Fred Sigman's Motels

1 Johnson, Denis, *The Stars at Noon*, New York: Harper Perennial, 1998, p. 174.

2 Wolfe, Tom, *The Right Stuff*, London: Jonathan Cape, 1980, p. 146.

The Undeniable Struth

1 Struth, Thomas, *Photographs 1978–2010*, Munich: Schirmer/Mosel, 2010, p. 204.

2 Struth, Thomas, *Thomas Struth 1977–2002*, New Haven: Dallas Museum of Art/Yale University Press, 2002, pp. 169 and 171.

3 Struth, *Photographs 1978–2010*, p. 190.

4 Berger, John, *Ways of Seeing*, Harmondsworth: Penguin, 1972, p. 16.

5 Evans, Walker, quoted by Belinda Rathbone in *Walker Evans: A Biography*, London Thames & Hudson, 1995, p. 69.

6 Glavinic, Thomas, *Night Work*, Edinburgh: Canongate, 2008, pp. 4–5.

7 Struth, *Photographs 1978–2010*, p. 194.

8 Struth, *Photographs 1978–2010*, p. 188.

9 Schjeldahl, Peter, *Columns and Catalogues*, Great Barrington: The Figures, 1994, p. 85.

10 Struth, *Photographs 1978–2010*, p. 198.

11 DeLillo, Don, *White Noise*, London: Picador, 1985, p. 12.

12 Struth, *Thomas Struth 1977–2002*, p. 160.

13 Nietzsche, Friedrich, *Human, All Too Human*, Cambridge: Cambridge University Press, 1986, p. 323.

Andreas Gursky

1 Evans, Walker, *Walker Evans at Work*, London: Thames & Hudson, 1984, p. 112.

2 Steiner, George, *At the New Yorker*, New York: New Directions, 2009, p. 165.

3 Augé, Marc, *Non-Places*, London: Verso Books, 1995, p. 94.

4 DeLillo, Don, *The Names*, Brighton: Harvester Press, 1983, p. 251.

5 Stjernfelt, Frederik, *Andreas Gursky at Louisiana*, Ostfildern: Hatje Cantz, 2012, p. 113.

6 Stjernfelt, *Andreas Gursky at Louisiana*, p. 112.

Thomas Ruff

1 Amis, Martin, *The Rub of Time*, London: Cape, 2017, p. 161.

2 Kundera, Milan, *The Unbearable Lightness of Being*, London: Faber & Faber, 1984, p. 247.

3 Žižek, Slavoj, *Welcome to the Desert of the Real*, London: Verso Books, 2002, p. 6.

4 Moravia, Alberto, in David Markson, *Vanishing Point*, Washington DC: Shoemaker & Hoard, 2004, p. 166.

5 Flaubert, Gustave, in Robert Baldick (ed.), Edmond and Jules de Goncourt, *Pages from the Goncourt Journal*, New York: New York Review Books, 2007, p. 48.

6 Berger, John, *Selected Essays*, Geoff Dyer (ed.), London: Bloomsbury Publishing, 2001, p. 559.

7 Herschel, John, quoted by Richard Holmes in *The Age of Wonder*, London: Harper Press, 2008, p. 440.

Prabuddha Dasgupta's *Longing*

1 Nelson, Maggie, *Bluets*, Seattle: Wave Books, 2009, p. 95.

Photojournalism and History Painting: Gary Knight

1 Sontag, Susan, *Regarding the Pain of Others*, New York: Farrar, Straus and Giroux, 2003, p. 123.

2 Shaw, George Bernard, and Philip Jones Griffiths, quoted by Susan D. Moeller in *Shooting War*, New York: Basic Books, 1990 p. 414.

3 Knight, Gary, in 'The shot that nearly killed me: War photographers – a special report', *Guardian*, 18 June 2011, https://www.theguardian.com/media/2011/jun/18/war-photographers-special-report.

4 Honour, Hugh, *Neo-Classicism*, Harmondsworth: Pelican Books, 1968, p. 35.

Pavel Maria Smejkal's *Fatescapes*

1 Kundera, Milan, *The Book of Laughter and Forgetting*, Harmondsworth: Penguin Books, 1983, p. 3.

2 Sontag, Susan, *Regarding the Pain of Others*, New York: Farrar, Straus and Giroux, 2003, p. 50.

3 Sontag, *Regarding the Pain of Others*, p. 53.

Chris Dorley-Brown's Corners

1 Dorley-Brown, Chris, *The East End in Colour 1960–1980*, London: Hoxton Mini Press, 2018 (unpaginated).

2 Dorley-Brown, Chris, *The Corners*, London: Hoxton Mini Press, 2018 (unpaginated).

3 Dorley-Brown, Chris, in Diane Smyth, 'Chris Dorley-Brown's singular vision of East End London', *British Journal of Photography*, 29 May 2018, https://www.bjp-online.com/2018/05/dorley-brown-corners/.

4 West, Rebecca, *Black Lamb and Grey Falcon*, Edinburgh: Canongate, 1993, p. 825.

5 Michaels, Leonard, *The Essays of Leonard Michaels*, New York: Farrar, Straus and Giroux, 2009, p. 93.

Dayanita Singh: Now We Can See

1 Laswell, Bill, quoted by Peter Lavezzoli in *The Dawn of Indian Music in the West: Bhairavi*, New York: Continuum, 2006, p. 350.

2 Singh, Dayanita, *Privacy*, Göttingen: Steidl, 2003 (unpaginated).

3 Collins, Billy, 'The Chairs That No One Sits In' in *Aimless Love: New and Selected Poems*, New York: Random House, 2013, p. 149.

4 Evans, Walker, quoted by Rathbone in *Walker Evans: A Biography*, p. 252.

5 Fox Talbot, William Henry, 'Some Account of the Art of Photogenic Drawing' (1839) in Vicki Goldberg (ed.), *Photography in Print*, Albuquerque: University of New Mexico Press, 1981, p. 46.

6 Singh, Raghubir, *River of Colour: The India of Raghubir Singh*, London: Phaidon, 1998, p. 8.

7 Moholy-Nagy, László, 'From Pigment to Light' (1936) in Goldberg, *Photography in Print*, p. 342.

8 Singh, Dayanita, *Zakir Hussain*, New Delhi: Himalyan Books, 1987, p. 75.

9 Ackerman, Michael, *Fiction*, Munich: Kehayoff, 2001 (unpaginated).

10 Wenders, Wim, *The Act of Seeing*, London: Faber & Faber, 1996, p. 137.

Oliver Curtis: *Volte-face*

1 Plath, Sylvia, 'Mirror' in *Collected Poems*, London: Faber & Faber, 1981, p. 173.

Spirit and Flesh in Naples

1 Avedon, Richard, 'Borrowed Dogs', *Portraits*, New York: Museum of Modern Art, 2002 (unpaginated).

2 Kerouac, Jack, *Selected Letters 1957–1969*, Ann Charters (ed.), London: Viking, 1999, p. 288.

Zoe Strauss

1 Strauss, Zoe, *Zoe Strauss: 10 Years*, Peter Barberie (ed.), New Haven: Philadelphia Museum of Art/ Yale University Press, 2012, p. 60.

Matt Stuart: Why He Does This Every Day

1 Reid, Christopher, *The Song of Lunch*, London: CB Editions, 2009, p. 5.

2 Reid, *The Song of Lunch*, p. 5.

3 Smith, Zadie, *Changing My Mind*, London: Hamish Hamilton, 2009, p. 218.

4 Wessel, Henry, *Odd Photos*, Göttingen: Steidl, 2006, p. 5.

Stay-at-Home Street Photographers

1 Larkin, Philip, 'Ambulances', *Collected Poems*, London: Faber & Faber, 1990, p. 132.

2 Houellebecq, Michel, *Platform*, New York: Knopf, 2003, p. 148.

3 Arbus, Diane, quoted by William Todd Schultz in *An Emergency in Slow Motion: The Inner Life of Diane Arbus*, London: Bloomsbury Publishing, 2011, p. 15.

Mike Brodie: *A Period of Juvenile Prosperity*

1 Sante, Luc, in *Nan Goldin: I'll Be Your Mirror*, New York: Whitney Museum of Art/Scalo, 1996, p. 101.

2 Evans, Walker, quoted by Rathbone in *Walker Evans: A Biography*, p. 8.

Chloe Dewe Mathews: *Shot at Dawn*

1 Winogrand, Garry, quoted in Gilles Mora and John Hill, *Walker Evans: The Hungry Eye*, London: Thames and Hudson, 1993, p. 12.
2 Wordsworth, William, *The Prelude: A Parallel Text*, Harmondsworth: Penguin, 1971, p. 480.
3 Lawrence, D.H., *Lady Chatterley's Lover*, Harmondsworth: Penguin, 1960, p. 44.
4 Fussell, Paul, *The Great War and Modern Memory*, Oxford: Oxford University Press, 1975, p. 52.
5 Fussell, *The Great War and Modern Memory*, p. 63.
6 Owen, Wilfred, *Collected Poems*, London: Chatto & Windus, 1963, p. 48.
7 Sassoon, Siegfried, 'Attack' in *Collected Poems 1908–1956*, London: Faber & Faber, 1961, p. 71.
8 Brodsky, Joseph, *On Grief and Reason*, New York: Farrar, Straus and Giroux, 1995, p. 291.

Finbarr O'Reilly: *Gaza Strip, 24 July 2014*

1 Berger, John, *Selected Essays*, Geoff Dyer (ed.), London: Bloomsbury Publishing, 2001, p. 280–1.
2 Berger, *Selected Essays*, p. 456.

Roland Barthes: *Camera Lucida*

1 Stieglitz, Alfred, *Photographs and Writings*, Sarah Greenough (ed.), Washington: National Gallery of Art/Bulfinch, 1999, p. 197.
2 Barthes, Roland, *The Grain of the Voice*, London: Jonathan Cape, 1985, p. 357.
3 Calvet, Louis-Jean, *Barthes: A Biography*, Cambridge: Polity Press, 1994, p. 236.
4 Barthes, *The Grain of the Voice*, p. 359.
5 Calvet, *Barthes: A Biography*, p. 235.
6 Barthes, *The Grain of the Voice*, p. 352.
7 Barthes, Roland, *Roland Barthes by Roland Barthes*, New York: Hill & Wang, 1977, p. 94.
8 Léger, Nathalie, Introduction to Barthes, Roland, *Mourning Diary*, Nathalie Léger (ed.), New York: Hill & Wang, 2010, p. x.
9 Sontag, Susan, Introduction to *A Barthes Reader*, New York: Hill & Wang, 1982, p. xii.
10 Calvet, *Barthes: A Biography*, p. 220.
11 Barthes, *The Grain of the Voice*, p. 356.
12 Foucault, Michel, quoted by Didier Eribon in *Michel Foucault*, London: Faber & Faber, 1992, p. 82.
13 Sontag, Introduction to *A Barthes Reader*, pp. xvii, xxx and viii.
14 Calvino, Italo, *The Literature Machine*, London: Secker & Warburg, 1987, p. 302.
15 Anderson, Perry, *The New Old World*, New York: Verso Books, 2009, p. 143.
16 Amis, Martin, *The War Against Cliché*, London: Jonathan Cape, 2001, p. 467.
17 Barthes, Roland, *The Pleasure of the Text*, New York: Hill & Wang, 1975, p. 23.
18 Barthes, *The Pleasure of the Text*, p. 23 and p. 4.
19 Barthes, *Roland Barthes by Roland Barthes*, p. v.
20 Barthes, *The Grain of the Voice*, pp. 351–7.
21 Papageorge, Tod, *Passing Through Eden*, Göttingen: Steidl, 2007, p. iv.
22 Haworth-Booth, Mark, email to G.D.

John Berger: *Understanding a Photograph*

1 Berger, John, on Roland Barthes, *New Society*, 26 February 1976, p. 445.

2 Lawrence, D.H., 'Thought' in *The Complete Poems*, Vivian De Sola Pinto and F. Warren Roberts (eds), Harmondsworth: Penguin, 1977, p. 673.

3 Berger, John, *Here Is Where We Meet*, London: Bloomsbury Publishing, 2005, p. 8.

4 Berger, John, *Selected Essays*, Geoff Dyer (ed.), London: Bloomsbury Publishing, 2001, p. 7.

5 Singh, Raghubir, *River of Colour: The India of Raghubir Singh*, London: Phaidon, 1998, p. 12.

6 Vidal, Gore, *The Last Empire*, New York: Doubleday, 2001, p. 304.

7 Berger, John, *And Our Faces, My Heart, Brief as Photos*, New York: Pantheon Books, 1984, p. 30.

PERMISSION CREDITS

GEOFF DYER's many books include *Out of Sheer Rage, But Beautiful, The Ongoing Moment, Zona,* and *Jeff in Venice, Death in Varanasi.* He won the National Book Critics Circle Award for Criticism for the essay collection *Otherwise Known as the Human Condition* and has also won the Somerset Maugham Prize, the Bollinger Everyman Wodehouse Prize for Comic Fiction, a Lannan Literary Award, the International Center for Photography's 2006 Infinity Award for writing on photography, the American Academy of Arts and Letters' E. M. Forster Award, and a Windham-Campbell Prize for Nonfiction. He currently lives in Los Angeles where he teaches at University of Southern California.

The text of *See/Saw* is set in Clarika Pro and Minion by Sharon McTeir.
Manufactured by Versa Press on acid-free paper.